LEE FROST'S
LANDSCAPE
PHOTOGRAPHY

LEE FROST'S
LANDSCAPE
PHOTOGRAPHY

HOW TO TAKE SPECTACULAR PHOTOGRAPHS IN ALL ENVIRONMENTS

D&C
David and Charles

A DAVID & CHARLES BOOK
Copyright © David & Charles Limited 2007

David & Charles is an F+W Publications Inc. company
4700 East Galbraith Road
Cincinnati, OH 45236

First published in the UK in 2007
First US paperback edition 2007

Text and illustrations copyright
© Lee Frost

A catalogue record for this book is available from the
British Library.

ISBN-13: 978-0-7153-2563-6 hardback
ISBN-10: 0-7153-2563-9
ISBN-13: 978-0-7153-2564-3 paperback
ISBN-10: 0-7153-2564-7

Printed in China by R. R. Donnelly
for David & Charles
Brunel House, Newton Abbot, Devon

Commissioning Editor: Neil Baber
Editor: Emily Pitcher
Assistant Editor: Demelza Hookway
Project Editor: Constance Novis
Art Editor: Marieclare Mayne
Production Controller: Beverley Richardson
Indexer: Lisa Footitt

Visit our website at www.davidandcharles.co.uk

David & Charles books are available from all
good bookshops; alternatively you can contact
our Orderline on 0870 9908222 or write to us at
FREEPOST EX2 110, D&C Direct, Newton Abbot,
TQ12 4ZZ (no stamp required UK only);
US customers call 800-289-0963 and
Canadian customers call 800-840-5220.

CONTENTS

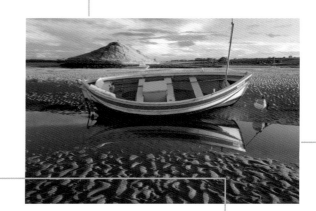

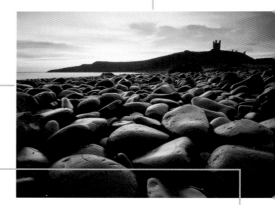

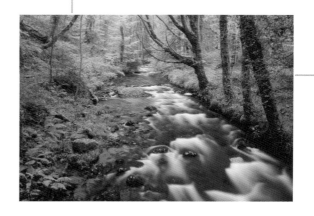

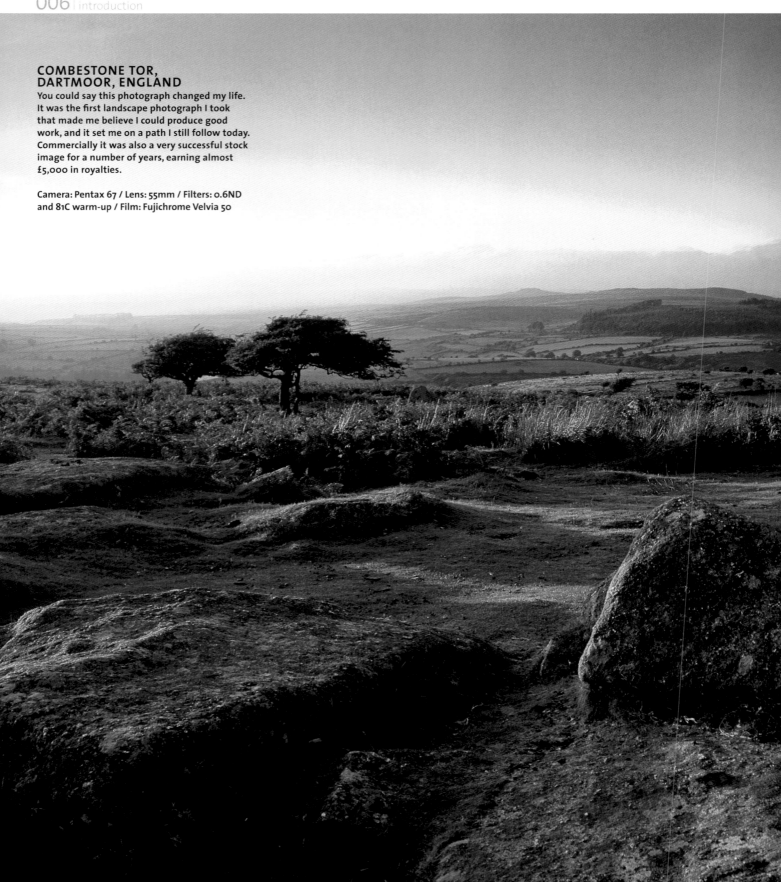

**COMBESTONE TOR,
DARTMOOR, ENGLAND**
You could say this photograph changed my life.
It was the first landscape photograph I took
that made me believe I could produce good
work, and it set me on a path I still follow today.
Commercially it was also a very successful stock
image for a number of years, earning almost
£5,000 in royalties.

Camera: Pentax 67 / Lens: 55mm / Filters: 0.6ND
and 81C warm-up / Film: Fujichrome Velvia 50

INTRODUCTION

Ever since I became the proud owner of my first camera at the age of 15, photography has been an abiding passion, and although I have never liked to label myself as a specialist in any particular area (simply because I enjoy the art of making great pictures, regardless of the subject) it's in the landscape that I feel most at home.

This stems in part from a love of the great outdoors that was forged during my early teens, when, as a keen member of the Boy Scouts, I spent many memorable weekends camping, rock climbing, canoeing and fellwalking in regions such as the English Lake District, Pennines and north Yorkshire Moors. I felt more at home in those wild and beautiful places than I ever did in a town or city. The sense of space and freedom was exhilarating. I relished the challenge of the elements. I became more observant and grew to appreciate the way light and weather influence the character of a scene, and how with each season the landscape is transformed.

Once I acquired a camera it became a constant companion on my expeditions into the countryside. I tried to harness the beauty around me with it – much to the annoyance of friends who would be forced to wait impatiently while a cloud moved or the sun dropped a little lower in the sky. Some things never change.

Those early efforts left a lot to be desired. I knew little about photography so mistakes were common, but slowly I was learning. Above all, I was enjoying myself.

A turning point came in the middle of the 1980s when my family moved from south Yorkshire to south Devon and settled in the seaside town of Torquay. Inspired by the unfamiliarity of new surroundings, my passion for photography took hold. I saved hard and bought an old 50cc motorcycle and suddenly the world was at my feet – even if it took a while to get there.

The wilds of Dartmoor were only 20 miles away, so at every opportunity I would head off alone in search of inspiration among the ancient granite tors and desolate moorland. I discovered tumbling streams in the heart of secluded valleys, standing stones, hut circles and other relics of prehistory. Being alone was never a problem. On the contrary, I enjoyed every second, lost in thought and purpose.

Dartmoor became my backyard, and it was there I took my first magnificent landscape. It was a revelatory moment. I didn't need to see the processed film, I just knew the second the shutter was released that

magic was taking place. Everything just came together at the right time. I headed off one autumnal afternoon because good light seemed likely. It was a blustery day but in the distance I could see the cloud lifting over the moors. I decided to take a chance. I also knew exactly which location to head for from previous visits, and knew late afternoon would be the prime time to shoot it. When I arrived, my hunch was correct. Warm light from the lowering sun was side-striking weathered granite rocks scattered at the base of the Tor and knarled old trees that had grown at a strange angle due to the strength of the winds that constantly battered the high, exposed ground from the moment they emerged from the shallow, peaty soil.

Fitting a wide-angle lens to my camera I moved in, looking for a composition that would do the scene justice. Within seconds I found it – a group of interesting rocks, a couple of old trees, the sun just out of frame and a clear view to the distant hills. The foreground rocks added perspective and scale, as well as an important sense of place. The light was perfect. The two trees counter-balanced the higher rocks on the right. Everything in the viewfinder looked just right.

I stopped the lens down to f/16 and used the depth-of-field scale to ensure front-to-back sharpness. I needed to hold detail and colour in the sky to pull the whole thing together, so I reached for a 0.6 neutral density grad and carefully slipped it onto the lens, along with an 81C

warm-up to enhance the light. Finally, a spotmeter reading was taken from the sunlit rocks, the shutter speed set and the shutter tripped. Then again, and again.

Being new to hand-held meters and not very confident in my ability, I bracketed exposures over and under the metered exposure, just to be on the safe side. A fresh roll of film was loaded and exposed. Then a third. I shot until the light had faded from the foreground then slumped back, exhausted but joyous.

My initiation was over. For the first time ever I had pooled the knowledge and experience amassed over five years of trial and error, sweat and tears, joy and frustration – and applied it all at once. The result astounded me.

Almost 20 years on, I still get a huge feeling of satisfaction when I look at that photograph. From then on I knew what was required to repeat the success again and again and again: a combination of planning, risk taking, passion, intuition, timing, creativity, and technical know-how.

This latter factor is often given priority by photography enthusiasts, but in reality it's probably the least important. I don't actually think I've learned anything new technically that has helped me produce better work since that day on Dartmoor, because if you understand how to control and maximize depth-of-field, how to use graduated filters to balance the sky and land, and how to meter to achieve the correct

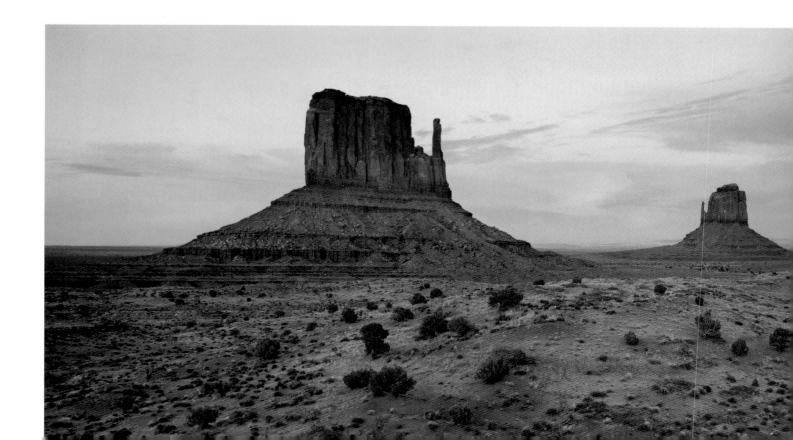

exposure, then you are aware of all that you need to know.

Far more important is passion and drive. You're not going to produce stunning landscape photographs if your heart isn't in it, and if you don't really want to do it more than anything else. Because if you don't, then you won't crawl out of bed at 5am, day after day, or trek a mile or more over boggy ground on a cold, dark morning on the off-chance you may be greeted by a wonderful sunrise. If you're not committed, you won't risk staying outdoors when foul weather threatens, or return to the same location time after time until you get the shot you want.

This is what makes the difference. Yes, you need technical skill. Yes, you need to know how to compose a photograph in a visually stimulating way. But above all you need to be there, in the right place at the right time, when the light is magnificent. Do that and everything else will fall into place. You'll develop the required technical skills through practice, and your eye for composition – your creative voice – will develop at the same time as a direct result of witnessing wonder and having the desire to capture it to share with those who didn't make it out of bed that morning.

In writing this book, my aim is to put you on the same road that I discovered one windy afternoon high on Dartmoor two decades ago, so you can experience your own revelatory moment.

The first chapters deal with technical considerations, such as choosing and using equipment, the pros and cons of different image formats, and the benefits of film over digital and vice versa.

Next we look at technique, including planning a trip, and understanding light, exposure and metering, and composition, before applying this information to specific types of scenery, such as the wilderness, deserts, rolling landscapes, canyons and valleys, the landscape in detail, and land, water, and coastal views.

Finally, we explore the manmade landscape and take a look at the opportunities presented by urban landscapes, such as city streets, ancient villages, famous landmarks, and man himself.

Writing this book has been a wonderful journey, reminding me why I picked up a camera to record the landscape in the first place, and helping me to understand why I continue to do so.

I'd be the first to say it hasn't been easy; there have been many times over the last 20 years when I questioned my sanity as I stood cold, wet and thoroughly miserable in the middle of a boggy field. But then I think about the magnificent sunrises, the biblical storms, the golden sunsets, and velvet twilights; the ones that didn't get away, and I have the answer – I see the light.

Lee Frost
Northumberland

◁ THE MITTENS, MONUMENT VALLEY, ARIZONA, USA
I count myself very fortunate that I am able to travel all over the world, photographing amazing scenery, and call it work. That said, it's not always easy. The weather doesn't always play ball, the long days take their toll, and sometimes I feel I spend more time away from my family than I do with them. Ultimately, however, I suppose I'm living the dream – making a living by pursuing my hobby – and I wouldn't change it for anything.

Camera: Fuji GX617 / Lens: 90mm / Filters: 0.9ND hard grad / Film: Fujichrome Velvia 50

EQUIPMENT

"What's the best equipment for landscape photography?" I'm probably asked this question more than any other by photography enthusiasts. The reality is that there's no definitive answer because so many factors come in to play when deciding which camera and lens to use to capture a scene on film.

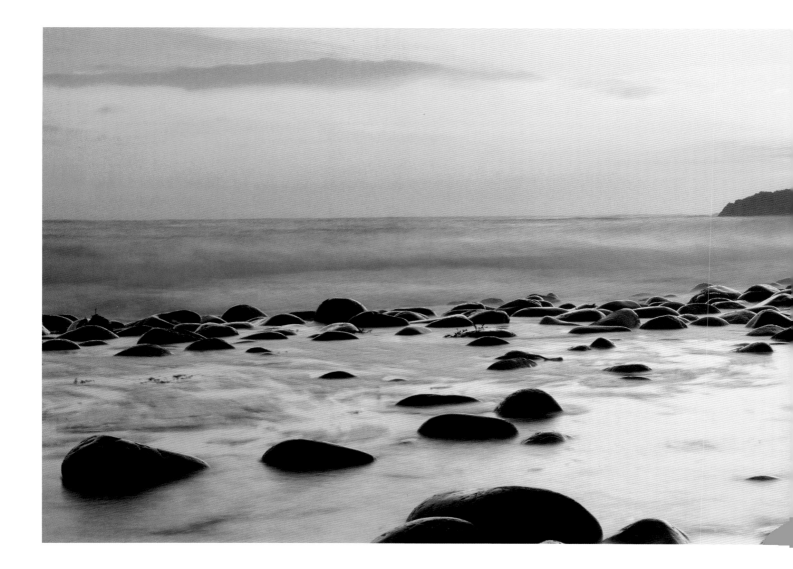

In my case, much depends on the nature of the locations I'm planning to photograph, where in the world I'm traveling to, whether I'm going to work in black and white or colour, the type of photographs I hope to take, and in some cases, how I'm feeling at the time. To me, landscape photography encompasses both rural and urban locations, and covers a broad range of subjects on both a large or small scale.

To that end, over the last 20 years I have amassed a range of camera systems, from 35mm to 5x4in and 6x17cm panoramic. More recently, I have started to work with plastic 'toy' cameras, handmade pinhole cameras, and Polaroid instant cameras. Each type of camera has a role to play in my life as a photographer, allowing me to experiment with new ideas and techniques, in an attempt to push the boundaries of landscape photography a little further.

What I will stress is that I have never been interested in cameras and lenses as

EMBLETON BAY, NORTHUMBERLAND, ENGLAND
It doesn't matter what brand or format of camera you use for landscape photography, providing it allows you to make the most of a scene. That said, it's also important not to carry so much equipment that you end-up spoiled for choice and miss the moment, or so bogged down by the physical weight that carrying it becomes a chore. My two main choices are 6x7cm and 6x17cm. Both accept 120 rollfilm, which keeps life simple, and the formats complement each other so I can use them side-by-side with ease.

Camera: Fuji GX617 / Lens: 180mm / Filters: 0.6ND hard grad / Film: Fujichrome Velvia 50
▽

objects of desire. They're tools and they have to earn their keep, so if I find that I'm no longer using a particular item I have no qualms about selling it. Equally, if I feel that a different camera or lens could be beneficial to my work, either commercially or creatively, then I will invest in it.

35MM: SPEED AND PORTABILITY

My very first camera was a 35mm SLR, in the form of an all-manual Zenith EM. Ever since I became interested in photography almost 25 years ago, I have never been without a 35mm SLR of some description. It's the most versatile camera for general use.

From the Zenith, I moved on to an Olympus OM1n, the forerunner of the modern 35mm SLR, then OM2ns and latterly OM4-Tis. I stuck with the Olympus brand for more than a decade, preferring the compactness, simplicity, and robustness of the cameras. It was only when disaster struck in the early 1990s and I lost the entire system during a shoot in Andalucia that I decided to switch to Nikon.

Since then my 35mm camera system has remained consistent – two bodies (an F90x and an F5) with 20mm, 28mm, 50mm and 80-200mm lenses and a 1.4x teleconverter. I also have a 105mm macro lens but rarely use it away from home. For general travel photography this is my outfit of choice and I've used it all over the world, in places such as Morocco, Cuba, Zanzibar, Namibia, Turkey, and throughout western Europe. The cameras are quite big and bulky (the F5 is powered by 8 AA batteries), but I can comfortably carry both around all day long with the four lenses. More importantly they're reliable and robust. The Matrix metering system is superb and neither has ever let me down, despite the fact that they're getting a little rough around the edges through heavy use, often in demanding environments such as deserts.

What I love most about 35mm is its portability, versatility, and

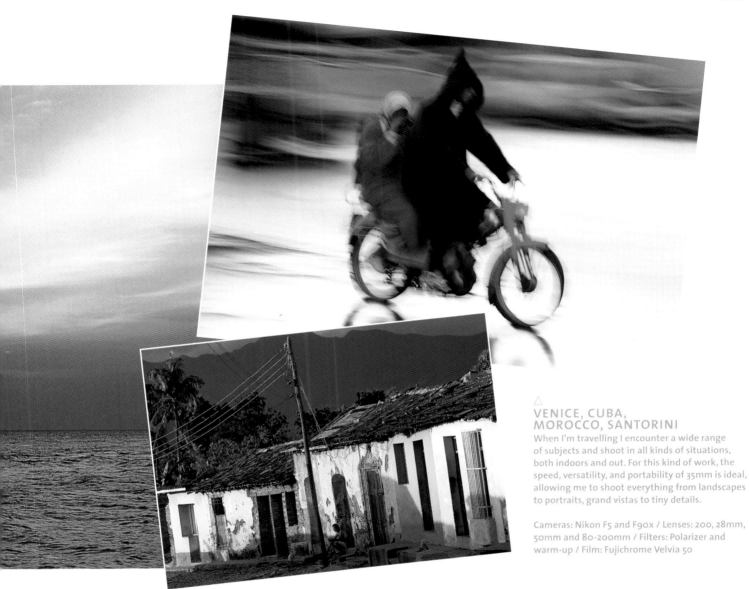

△
VENICE, CUBA,
MOROCCO, SANTORINI
When I'm travelling I encounter a wide range
of subjects and shoot in all kinds of situations,
both indoors and out. For this kind of work, the
speed, versatility, and portability of 35mm is ideal,
allowing me to shoot everything from landscapes
to portraits, grand vistas to tiny details.

Cameras: Nikon F5 and F90x / Lenses: 200, 28mm,
50mm and 80-200mm / Filters: Polarizer and
warm-up / Film: Fujichrome Velvia 50

speed of use. For trips where I know I will be shooting a wide variety of subjects, often hand-held, in changeable conditions, this combination is unbeatable. The 3:2 image ratio is ideal for creating dramatic compositions especially when you turn the camera on its side to take upright shots, while the vast lens range available means you can squite conservative, but it suits me fine and I never wish I had something wider or longer. More lenses means more weight and more decisions.

There's a certain psychology involved here too. Because 35mm SLRs are small, lightweight, and quick to use, they allow a more reactive approach to landscape photography. Fleeting moments that would perhaps be lost while setting up a larger-format camera and tripod can be captured instinctively, handheld if necessary.

I'm more adventurous when shooting landscapes with 35mm. Instead of staying rooted to the spot, I cover more ground, exploring a scene from different angles, being more ambitious with composition, and exposing more film. The worst-case scenario is that I waste a few frames of film, but I could also capture a stunning shot to be proud of.

Creatively, this also provides me with a welcome break from the slower, more considered approach that medium and large-format cameras demand – not only due too their bigger size and weight, which almost always makes a tripod essential, but also the fact that I have 36 exposures to play with per roll of film, which makes the cost per shot low compared to my 6x7cm medium-format camera giving ten shots on a roll of 120 film and my 6x17cm panoramic camera which gives a paltry four shots per 120 roll! From a technical point of view, the 35mm format is also extremely versatile for landscape photography as you can achieve huge depth-of-field even with moderate wide-angle lenses.

The main drawback of the 35mm SLR for landscape photography is the small image size, which is just 24x36mm. Realistically, 16x12in is about the limit for blow-ups before image quality starts to tail off, which is why most purist landscapers tend to dismiss it. However, if you're a fan of grain, the small format can be a boon and I for one like shooting 35mm landscapes on fast film (ISO400 or ISO1600) then blowing up the negatives to produce gritty, grainy prints.

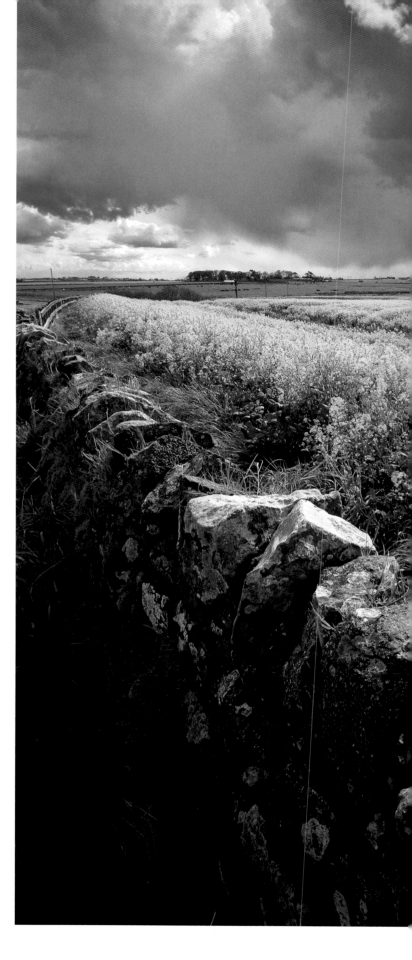

6X7CM – THE IDEAL COMPROMISE?

When I shoot rural landscapes my preferred format (6x7cm) has remained consistent for 15 years or more. It has always offered the ideal compromise between 35mm and 5x4in, being portable and quick to use while at the same time producing images that are sharp enough to enlarge to 16x20in and beyond. For most of my freelance career I have remained faithful to the same camera system, but two years ago I decided to sell off my entire Pentax 67 kit, replacing it with a Mamiya 7II rangefinder system.

The Mamiya 7II is a superb camera. It is hardly bigger than the latest professional 35mm and digital SLRs, and is lightweight and quick to use. For hand-held medium-format photography it has no equal. But, other than lightening my landscape-photography load and freeing up a little backpack space, I see no benefit to it over the Pentax.

I don't regret making the change. I love using the Mamiya and the optical quality of its lenses is superb. I use the 43mm mainly, plus 80mm and 150mm. But are my pictures any better? No. Do I use a tripod less? No. If anything, I've lost out by making the switch because the Pentax 67 is an SLR with through-the-lens viewing, so it's easier to align ND grad filters and use polarizers, whereas the Mamiya is a rangefinder with no TTL viewing. The Pentax also has an integral metering system so good that you could almost dispense with a hand-held meter, whereas the metering of the Mamiya is nowhere near as clever or reliable.

What both cameras share is the same format (6x7cm) and that for me is the most important factor. It's not far off being square, but that extra centimetre on its length compared to

NEAR SEAHOUSES, NORTHUMBERLAND, ENGLAND

For me, the 6x7cm format offers the perfect compromise between quality and convenience. My current choice of system is the Mamiya 7II with 43mm, 80mm and 150mm lenses. It's compact, lightweight, quick to use and very robust. The lenses are also superb and I can comfortably enlarge the images to 20x16in or bigger.

Camera: Mamiya 7I / Lens: 43mm / Filters: 0.6ND hard grad / Film: Fujichrome Velvia 50

▽ ▷

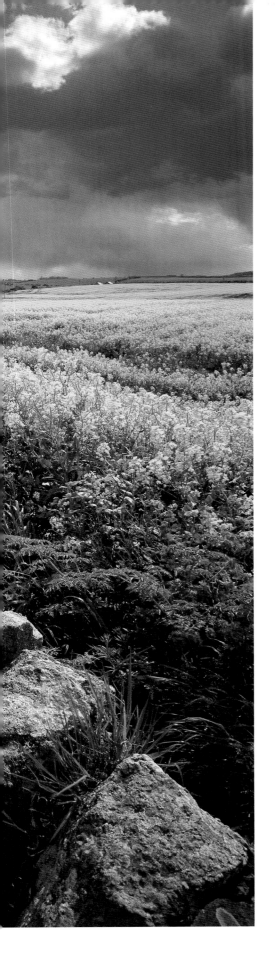

6x6cm is enough to make a huge difference to the feel of the final composition. I love using a 43mm lens on the Mamiya (equivalent to around 22mm in 35mm format) to emphasize the foreground and create a sense of depth and scale. The amount of detail resolved by the lenses and Fujichrome Velvia is phenomenal.

A smaller option is 6x4.5cm, but I have never preferred this for landscape because the difference in size between it and 35mm isn't big enough to make the leap worthwhile. If you're going to upgrade to medium-format you might as well make it count, and 6x7cm produces images that are 5x bigger than 35mm, whereas 6x4.5cm negatives and transparencies are only three times bigger.

RECTANGLE OR SQUARE

As soon as I could afford it, I upgraded to a Pentax 67 and for the next two decades I wouldn't have taken a square picture for love nor money. Square was, well, square.

Recently, however, I had a change of heart and picked up another Mamiya TLR (a C220) from Ebay. I'm really excited about using it, especially for black & white work. Maybe I'm just getting older and maturing, but square pictures have a tranquillity and simplicity that I find inspiring. They speak in a whisper rather than being brash and in your face. The square format is also steady and solid and lends itself to more 'designed' compositions, so it's ideal for abstract and graphic images that make use of colour, shape, and form. Maybe this will be a flight of fancy and before long you'll see the camera up for sale again. But for now it has opened up another creative door and the view looks great.

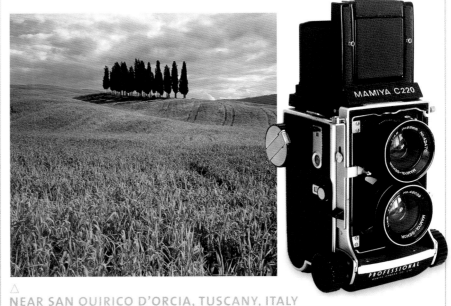

△
NEAR SAN QUIRICO D'ORCIA, TUSCANY, ITALY
The square format is simple and easy on the eye, so it's ideal for tranquil subjects such as this Tuscan landscape. The symmetry of the format also suited the scene perfectly.

Camera: Pentax 67 II (cropped) / Lens: 45mm / Film: Fujichrome Velvia 50

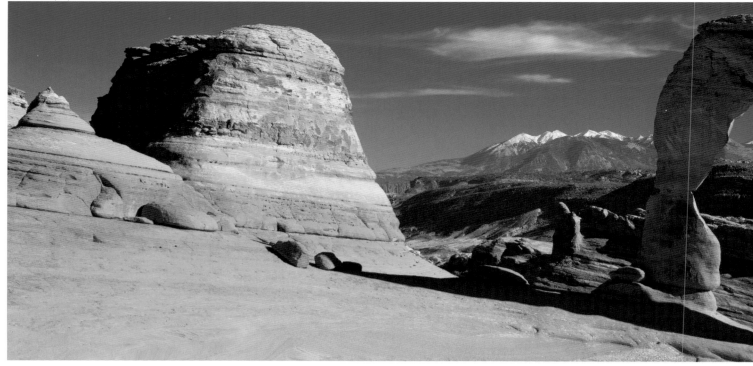

5X4IN – QUALITY AND CONTROL

I've always like the idea of working in a large format and for a while a few years ago I used a 5x4in camera instead of 6x7cm for landscape work. However, before long the novelty wore off. I was taking far fewer pictures, I was missing great shots, and I didn't see any improvement in my work. So, I called it a day, sold the complete kit and put the money towards a Fuji GX617 panoramic camera.

That was a wise investment, but the desire to use 5x4in never went away and a few years later I bought a non-folding Ebony RSW camera.

The main attraction of 5x4in for me is the image quality, which is quite breathtaking. Even when enlarged to 20x24in or bigger the crispness of the image is staggering thanks to each image being 15x bigger than 35mm. The 'movements' offered by 5x4in cameras also mean that depth-of-field can be maximized at moderate apertures and perspective

controlled and corrected. However, it takes several minutes to set up a large-format camera, so a totally different approach to photography is required. Instead of reacting to the light, you have to learn to anticipate it, otherwise the moment will be lost. Large-format devotees cite this as a great benefit, saying that the slow, considered approach leads to better-quality work because they think more about each image.

I've worked alongside large-format photographers. I've seen them flapping around, sweating profusely, and muttering expletives under their breath as they fight with the camera and try not to panic. In them I see myself, but going slightly mad.

PANORAMIC: STRETCHING THE TRUTH

Ever since the day I used my first panoramic camera – a second-hand Fuji G617 – I've been hooked on the letterbox format.

My first choice of panoramic cameras for landscapes these days is the Fuji GX617 which, as the name implies, produces images measuring a whopping 6x17cm on 120 and 220 rollfilm. I prefer 120 film. It only gives four shots per roll, but lenses on the GX617 can't be changed mid-roll, so it's handy having so few frames to expose. I use the GX mainly with a 90mm lens for grand views, but the 180mm and 300mm telephoto lenses are also ideal for isolating details in a scene.

My alternative panoramic kit is a Hasselblad Xpan with 30mm, 45mm, and 90mm lenses. It produces 24x65mm images on 35mm film – giving 21 frames per roll – and though the image size is much smaller than that of the Fuji, the lenses are incredibly sharp. I prefer the Xpan when I'm travelling because it's small enough to use hand-held and has a coupled rangefinder. This means I can focus accurately by sight. The Fuji GX617 lacks this facility so focusing is done hyperfocally, using the distance scales and depth-of-field scale on the lens, though a ground-glass screen can be fitted for more accurate focusing.

When we stand to admire a beautiful scene we tend to scan it with our

Camera: Fuji GX617 /
Lens: 90mm / Filters: 0.3
centre ND and polarizer /
Film: Fujichrome Velvia 50
▽

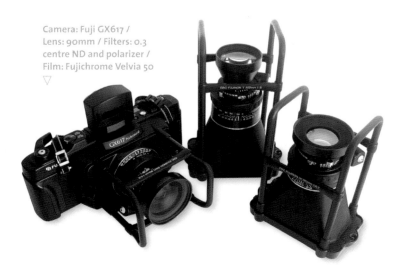

My camera of choice for landscapes is the Fuji
GX617 panoramic. I love the 3:1 image format –
it suits my way of seeing – and the quality of the
images it produces is astounding.

Camera: Fuji GX617 / Lens: 90mm /
Filters: 0.3 centre ND and polarizer /
Film: Fujichrome Velvia 50

PERFECT PARTNERS

The two panoramic systems outlined above streamline well with my
Mamiya 7 and Nikon systems, and form two versatile outfits I use for
90 per cent of my work.

For 'pure' landscape trips, where I know I'll be spending time in each
location and my subject range is limited to coastal or urban scenes,
I always take my rollfilm pack (Fuji GX617 with 90mm, 180mm
and 300mm lens, plus Mamiya 7II with 43mm, 80mm and 150mm
lenses). Both systems are based around rangefinder cameras so I can
switch between the two quite happily.

For travel-based trips where my subject range is broader and I'm
on the move and often working hand-held, I take the 35mm pack
(Hasselblad Xpan with 30mm, 45mm and 90mm lenses, plus two
Nikon bodies and 20mm, 28mm, 50mm and 80-200mm lenses).

When I say 'pack' I refer to my Lowepro backpacks. I have a Photo
Trekker Classic for the 35mm kits and a Photo Trekker All Weather
for the rollfilm cameras. Both are carried on as hand luggage when
flying and comply with airline regulations.

eyes, moving from left to right. We take in a broad sweep and our senses
are stimulated. Panoramic photographs work in the same way, and the
sense of really being there is greater than with any other format.

I have a large panoramic print hanging on my office wall, and
whenever I glance up at it the effect is almost hypnotic. I find myself
being drawn in to the scene, tracing the shape of the rolling hills,
discovering small details I'd never seen before. I lose track of time and
even though my attention is only distracted for a few seconds it might
as well be hours.

To achieve this, panoramas need to be printed big, almost to the point
they envelope you, so they are too big to take in in a single glance.

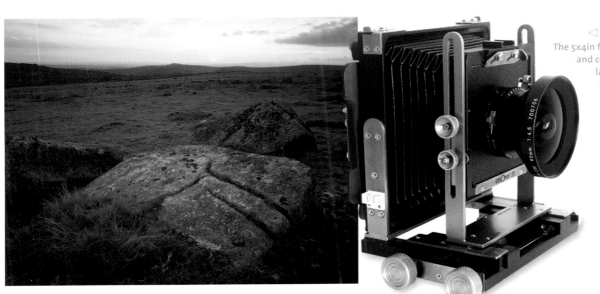

The 5x4in format provides all the quality
and control you could ever need for
landscape photography, but its
slowness requires a change of
approach that I haven't been
able to manage so far.

Camera: Horseman Woodman
5x4in field camera / Lens:
90mm / Filters: 0.6ND grad
and 81B warm-up / Film:
Fujichrome Velvia 50

CREATIVE CAMERAS

2006 was an interesting year for me photographically because it has seen a distinct shift away from conventional landscape photography and a move towards more contemporary, experimental techniques. This all started back in the spring when I started working with Holga 'toy' cameras and has since progressed to include pinhole cameras and old Polaroid instant cameras.

TOY STORY

For those of you who have never heard of the Holga, it's a cheap, plastic, mass-produced 6x6cm rollfilm camera from China that costs £20 brand new (about the same in $US).

It's hardly bristling with sophisticated features. There's just one shutter speed (around 1/100sec) and an f/11 apertrue. Focusing is manual, aided by dubious distance symbols on the barrel of the fixed 60mm lens, and image quality is, to be quite honest, appalling. Aberrations such as barrel distortion, colour fringing, and flare are almost guaranteed, along with vignetting at the image corners and possible light leaks, and while the lens is actually quite sharp in the centre it blurs badly outside this sweet spot. But all these things added

together make the Holga such a joy to use. The dubious lens quality produces images with a wonderful dreamlike feel and the simplicity of the camera makes it incredibly liberating to use. You just point and shoot, hoping the wide exposure latitude of colour-print film will yield a decent negative, which it usually does.

This freedom from anything remotely technical proved to be a real breath of fresh air, allowing me to concentrate solely on the creative side of making images. It also opened my eyes to the fact that you really don't need expensive cameras, super-sharp lenses and complicated metering systems to create wonderful pictures. All you need is imagination. But don't get me wrong – I've got no plans to part with my 'proper' cameras, but the Holga is now a constant companion on my travels. It provides the perfect antidote to digital technology and megapixels, and I get a great deal of pleasure out of using it. See what the Holga is capable of at www.toycamera.com.

PHOTOGRAPHY WITHOUT LENSES

Feeling inspired and refreshed, I decided to try out the pinhole, another camera I'd always been intrigued by. The Holga is capable of amazing results with its low-tech lens, but how would I cope with no lens whatsoever?

Eager to find out, I bought a Zero Imaging 5x4in pinhole camera (see www.zeroimage.com). The basic camera is only 25mm (1in) deep and has a focal length of just 25mm (around 8mm in 35mm format) but extension frames can be added and each one increases the focal length by 25mm. I acquired a kit with two additional frames so I have the choice of 25, 50, and 75mm focal lengths. I've only used 75mm (equivalent to around 24mm in 35mm format) because it's wide enough for my needs. The main appeal of pinhole cameras is their

TRINIDAD, CUBA
Toy cameras have opened my mind to a whole new world of creativity I didn't know existed. I love the freedom their simplicity encourages. They have definitely brought the fun and innocence back into my photography.

Camera: Holga 120GN / Lens: Fixed 60mm / Film: Fuji Pro160S
▽▷

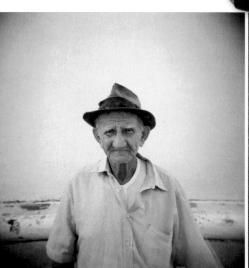

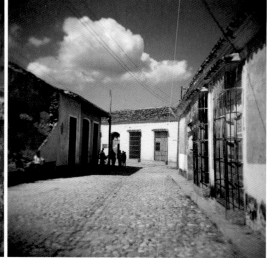

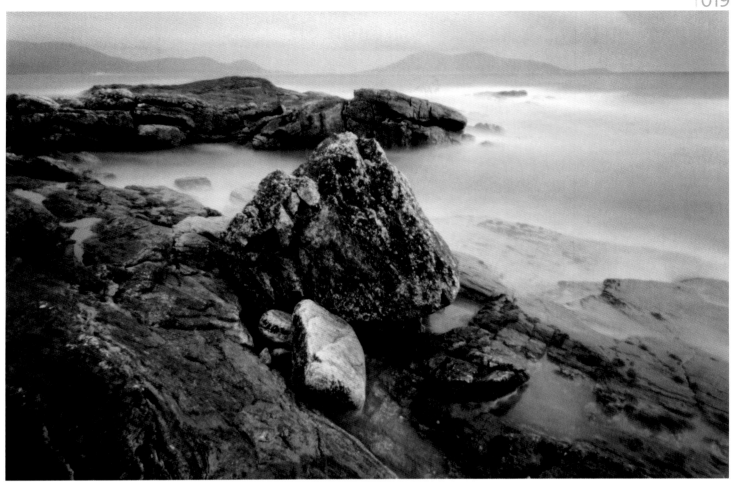

simplicity. They strip photography down to its bare bones, where an image is made by light rays passing through a small hole and striking a light-sensitive material. And there are other factors that make pinhole photography exciting. First, the pinhole is not only the lens, but also the sole aperture, and being very small it makes the effective f/number huge (f/218 on my camera when set up to give a 75mm focal length). Consequently, depth-of-field is limitless – just a few centimetres to infinity – and exposure times are usually several minutes. This latter factor means that any moving elements in a scene record as a blur.

My pinhole experiments so far have been limited to a series of black and white seascapes, using long exposures to record the motion of the sea, but I'm excited by the possibilities. It can be somewhat disconcerting initially to attempt to compose a scene when there are no viewing aids to help you. Your only option is to mount the camera on a tripod and take a guess that you've got what you want in shot. However, I was actually very surprised indeed by how accurately this can be achieved based solely on experience, and with the assistance of a spirit level. Most importantly, I love the dreamy feel of the images. They have a natural softness, but at the same time are surprisingly sharp considering the lens is just a tiny hole in a brass panel, especially when working from 5x4in negatives.

As well as the 5x4in model, Zero Imaging manufactures smaller 6x6cm and even 35mm pinhole cameras. You can also convert any camera – film or digital – into a pinhole camera by having a spare body cap fitted with a laser-drilled pinhole (see www.pinholesolution.co.uk).

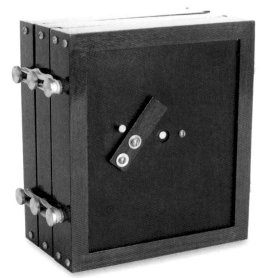

◁△
VIEW FROM TARANSAY, WESTERN ISLES, SCOTLAND
I've only been working with pinhole cameras for a short time, but they're great fun and capable of surprisingly good results.

Camera: Zero Image 45 Focal length 75mm / Film: Fuji Acros 100 Quickload

FILM OR DIGITAL?

Digital technology has changed the face of photography forever – creatively, technically, and commercially. Sophisticated digital SLRs offering high resolution are now available at affordable prices. And those of us who just a few years ago scoffed at the whole concept of taking high-quality pictures with a filmless camera are now eating our words. Digital is here to stay, like it or not, and film, sadly, is an endangered species.

So have I gone digital? At the time of writing, no I haven't. But by the time you read this my answer may be different – at least for some of the work I do.

I have nothing against digital photography. Part of me admires those photographers who have taken the plunge. However, at this moment in time I don't see how it will benefit me.

Over the years I have invested many thousands of pounds in film cameras that would be worth a fraction of their original value, if rendered redundant by a switch to digital capture. So, from a financial point of view I can't justify a change. I would need to invest a five-figure sum to equip myself with digital equipment

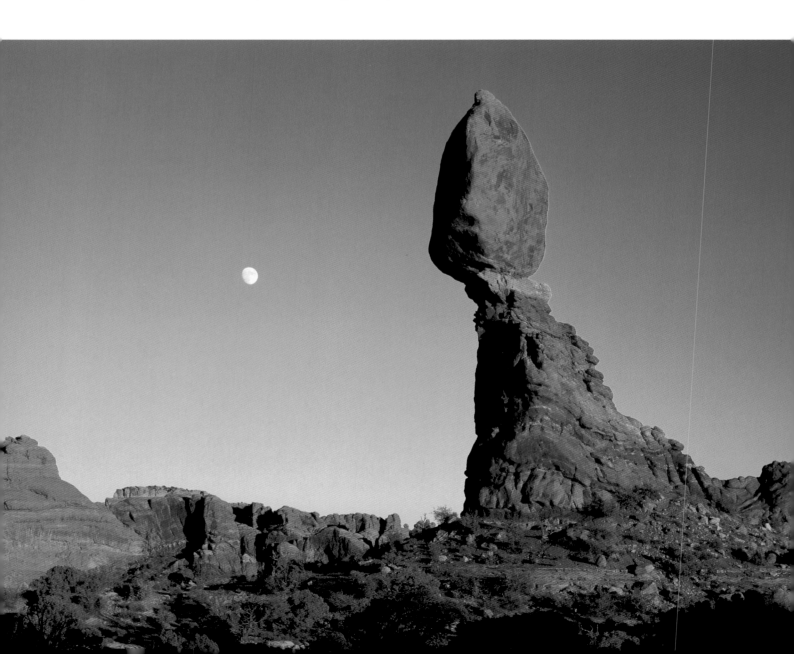

that could match the quality of the cameras I use – and that's
a lot of film and processing. More importantly, I like using film.
I relish the challenge of getting a picture right the moment it's
taken, and I enjoy the anticipation of having to wait to see the
results. Like a kid waiting for Christmas Day to come, I get excited
at the prospect of processed film dropping onto the doormat,
and nervously taking the package to my office so I can inspect
the results on a lightbox. It's all part of the fun. Even if I made a
rule not to inspect digital images until I was back home and they
were downloaded onto a computer so the anticipation was still
there (a rule I would struggle to abide by) imagine how much
time it would take to go through them! If I shoot 50 rolls of 35mm
film (1,800 images), I can inspect them in a matter of minutes
with the aid of a lightbox. A few hours later I can have a selection
of transparencies mounted and captioned and ready to mail to
a client or one of my picture libraries. If I had 1,800 RAW files to
process I'd still be working on them when I headed off on the next
trip, and my life between trips would be spent at a computer.

There's also the question of permanence. Film has a physical
existence whereas digital images are basically millions of
coloured dots floating around in cyberspace. I can touch
film, see it, feel it. I know that if it they're cared for, my colour
transparencies will last well beyond my lifetime and look as
good in 100 years as they do today. But what of digital images?
How long will a DVD last, or a portable hard drive? How many
times should each image be copied to ensure that if disaster
strikes and a computer goes down or a disc corrupts it will
always exist somewhere, safe and sound? What happens when
technology changes and all those images have to be copied to
another format so they can be viewed on a computer screen?

Considering it's state-of-the-art, digital imaging still poses
many unanswered questions. Yet film, in its simple, strictly old
technology is a sure bet. And I like a sure bet.

So what would it take to make me have a change of heart?
Well, for a start, you can't use film if it isn't available, and the
point at which my preferred emulsions become difficult to get
hold of or prohibitively expensive I'll have to have a rethink. For
now that isn't an issue. Fujichrome Velvia 50 (the film I have
used almost exclusively for landscapes since it was launched)

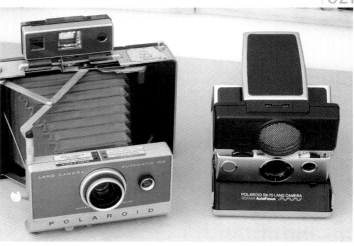

△ **POLAROID 100 AND SX70**
At the moment I'm having a lot of fun with some old Polaroid instant cameras.
For the first time in history they allowed us to take a picture and see the results just
minutes later. The Land Camera 100 (left) originates from the 1960s, while the SX-70
(right) was way ahead of its time for the 1970s, boasting not only through-the-lens
(TTL) viewing but integral metering, exposure compensation, and even autofocus.
The quality isn't up to today's digital SLRs, but then, sharpness isn't everything.

is no longer manufactured. Fortunately, I have at least 700 rolls of it in
120 format, carefully stored in a fridge, that should keep me going until
around the end of 2007. After that, I can turn to Velvia 100, which is its
replacement. So, for the next few years I have nothing to worry about.

Another factor that would sway me would be if the picture libraries
and clients I supply all suddenly insisted on work being supplied in
digital format. At the moment that doesn't happen. The libraries accept
film and scan it, and although some libraries charge for scanning, the
cost to me is quite low for now.

THE CASE FOR DIGITAL
Despite my own feelings, I can clearly see the allure of digital imaging,
and understand completely why to many photographers it has been life-
changing – ironically for all the reasons why I choose to shun it.

Although the outlay is high initially (as well as the camera, you need a
computer and software, memory cards, a back-up storage device, spare
battery packs, and so on) the long-term saving on film and processing
will also be high. So, for anyone interested in investing in a new camera
system, especially if their purpose is to upgrade a 35mm film SLR, it
makes sense to go down the digital route.

Image quality was initially one of the main stumbling blocks of digital
cameras. Not that long ago you needed to spend perhaps five times more
on a digital camera than a comparable film camera and the film images
would beat the digital files hands down in terms of sharpness and clarity,
especially when they were enlarged. Fortunately, this is no longer the case,
and though digital SLRs are still a little more expensive than film SLRs
offering a similar specification, models with a resolution of 6 megapixels
or higher will match the sharpest 35mm colour transparency for quality.
Meanwhile, models boasting 12 megapixels or more are getting close to
the quality of roll film cameras, such as my Mamiya 7II.

The immediacy of digital can only be a good thing for less experienced
photographers. I enjoy the wait to see my results because I'm

confident that everything will be okay. For anyone lacking confidence and experience, being able to take a photograph and then check it straightaway is an amazing benefit because common problems and mistakes can be rectified immediately. It also means when you're getting to grips with filters, you can compare the effect on the spot, perhaps photographing the same scene with different strengths of neutral density graduate, or with and without filters to see what difference the filter makes.

The EXIF data recorded each time you take a picture (time, date, aperture, shutter speed, ISO and lens focal length) is invaluable because if you make a mistake it will help you understand what went wrong. If you produce an amazing shot, some of that data may help you fathom exactly how you did it, so you can repeat it again.

I see the benefits of digital technology all the time when leading photographic workshops and holidays. Those who come equipped with digital cameras seem to progress at a faster rate than the film shooters because of the benefits it offers them. I can demonstrate composition or use of filters in the field, for example, and they see the results there and then. Instead of waiting a week for their films to be processed – by which time they've maybe forgotten a lot of what was explained – they can put the advice into practice immediately, knowing why they need to do certain things and what the outcomes will be.

Others benefit too. It has become a ritual each evening during my longer photographic tours for someone to load their digital images of the day onto a laptop and show them to the rest of the group. For those shooting film it provides a tantalizing insight into what they may have got themselves, but it also gives everyone the chance to see how someone else has interpreted a scene or subject, and this can be hugely informative and inspiring. Often I'll be asked if we're going back to a certain location the next day because the photographs shown by one photographer have inspired others to try something different. This can only be a good thing.

DIGITAL PRINTING

Recently, I have upgraded my printer to an Epson Stylus Pro 4800. This unit can produce prints up to 23x16½in and panoramics up to 17in wide (48in long from a 6x17cm original). Rather than scan my own images now, I pay to have them done commercially on a high-end Imacon scanner.

Once the scans are received, supplied on DVD, I immediately copy them to a 160Gb portable hard drive that's connected to my Apple Mac G4 computer and make another DVD copy. This means that each scan is copied three times. I then make a fourth copy, which is cleaned up and prepared for scanning.

I like to keep the digital version as true to the original as I can, so I rarely do more than make small adjustments to colour balance. I will remove the odd distracting element using Photoshop's clone tool if I feel that it will improve the final print. Some photographers are dead against this, but I see no problem with getting rid of a blurred sheep in the middle of a field.

Once I'm happy with everything, this version of the scan is placed in a folder labelled 'Print Ready Scans' and whenever I make a print I always work from this copy. The Tiff files average 135Mb from a 6x17cm

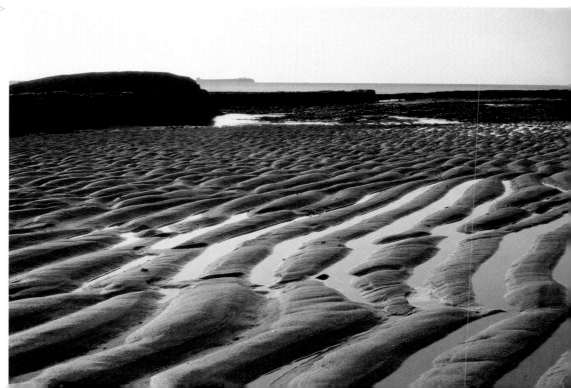

BAMBURGH CASTLE, ▷ NORTHUMBERLAND, ENGLAND

Landscapes are seen at their best when blown up nice and big. For panoramics I find that 12x36in is an ideal size. It is big enough to be impressive, but not so big that they would look out of place on the wall of an average-sized room. Consequently, this size is proving popular among buyers of my limited edition prints.

Camera: Fuji GX617 / Lens: 90mm / Filters: 0.6ND hard grad / Film: Fujichrome Velvia 50

transparency and the maximum output size at 300dpi is around 12x36in. This is the standard size I tend to work to on a regular basis, though I have produced prints at 16x48in and they still look superb.

I use Epson K3 Ultrachrome Inks which are designed for use with the 4800 printer. For final works I use Hahnemuhle PhotoRag, an archival matte paper that's prefered by photographers and painters alike, though for proofing I use Epson Archival Matte paper in A3+ size.

To ensure I get the best results from the printer when using Hahnemuhle PhotoRag and Epsom K3 inks, I have a custom profile that was made by Robert White Ltd (www.robertwhite.co.uk). This involves printing out various test targets, which are then analyzed to determine optimum printer settings. For example, just because you're using archival matte paper, the archival matte media setting on the printer may not give the best results. You may need to select watercolour paper or one of the other options. I also calibrate my computer monitor every 14 days using a ColorVision Spyder2 calibration unit to ensure perfect colour balance.

The main reason I invested in a bigger, better printer was so that I could produce limited-edition fine-art prints of my work. I now do this, and market them through local galleries and an online gallery. Panoramic prints measuring 12x36in are hand titled, signed, and numbered, then window-mounted behind archival board and framed in 20x44in plain wood frames. They look very impressive at that size and are proving popular.

Not only is it great fun – photographs are seen at their best when printed big and hung on a wall – but knowing that someone likes your work so much they are willing to pay good money for it and display it in their home has to be the ultimate achievement.

EPSON STYLUS PRO 4800 PRINTER

Even if you decide to continue shooting landscapes on film, there's nothing to stop you from scanning your best images and turning them into high-quality prints. Inkjet printers now offer superb quality at an affordable price, and though I use a large-format Epson 4800 printer capable of A2 output, smaller A3+ models such as the Epson 2400 utilize the same technology but cost far less.

▽

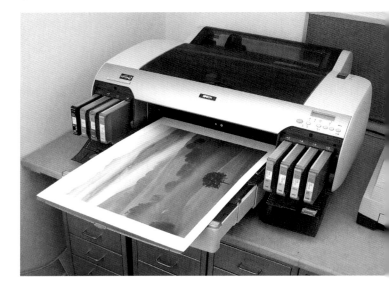

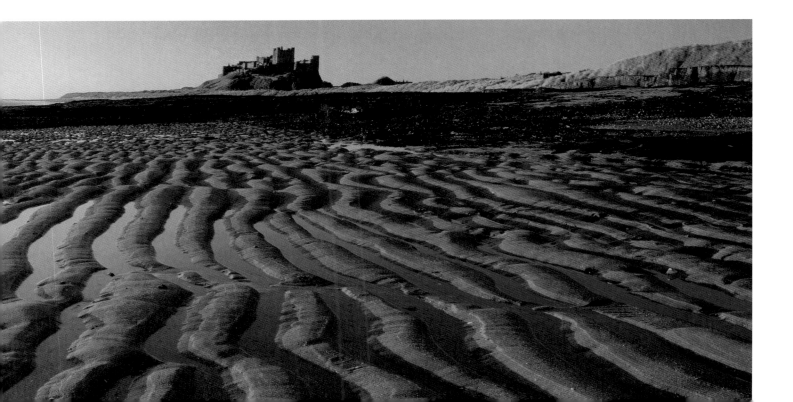

USING FILTERS

Filters are an essential part of any landscape photographer's kit, for both colour and black and white work. Digital camera users have less need for them because some of the jobs that filters do can be replicated digitally at a later stage. If you're like me and still working with film however, they just can't be avoided.

I carry three basic filter types for colour work – a polarizer, one or two warm-up filters from the 81-series, and a selection of neutral density (ND) grads.

The filter system I've used for many years is made by Lee Filters. It's based around a versatile 100mm-wide holder which comes as a do-it-yourself kit (Foundation Kit) and can be customized to suit your needs.

My holder has two slots plus a 105mm threaded ring attached to the front for a screw-in polarizer, so I can use warm-up and ND grad filters plus a polarizer or two ND grads with a polarizer. (I rarely use more than two filters at once.) Attaching the polarizer this way I can rotate it to align an ND grad diagonally. Configuring the Lee holder this way gives me all the options I need. The holder is shallow to avoid vignetting with my widest lenses (a 43mm for the Mamiya 7 and 20mm for the Nikons) when attached using Lee wide-angle adaptor rings, which sit back on the lens.

When I'm using filters on the Fuji and Hasselblad panoramic cameras, I dispense with the holder altogether and tend to hold the filters in place using reusable adhesive putty. This may seem strange, but with the Fuji GX617, for example, each lens has protective bars that extend beyond the front element, and the gap between them isn't wide enough to get a holder through. With the Xpan, the large holder obscures the camera's viewfinder so I find it quicker and easier to attach a Cokin P system adaptor ring to the lens, place small blobs of putty on the flat face of the adaptor ring, securing the filters in place when I've composed the picture.

The Lee warm-up and ND grad filters I use are 100mm wide and made from high-quality resin, while the polarizer is glass. Optically they are manufactured to a very high standard. The ND grads are also perfectly neutral so that skies come out looking normal. This isn't always the case with less expensive ND grads.

I carry my collection in a zipped pouch with individual velvet pockets. This prevents the filters from coming into contact (which would lead to scratching) and I always check them prior to use to made sure they're free of dust and fingermarks.

Every couple of years the grads and warm-ups are replaced. Being made of resin, they do scratch. While I can cope with a few fine scratches, once they begin to look tatty, which is inevitable with heavy use, often in hostile environments such as windy beaches, I invest in a new set. The polarizer, being made of glass, is more durable and I've been using the same ones for many years, although it's also more fragile, and while a grad or warm-up filter will survive a drop, a polarizer is usually smashed to smithereens!

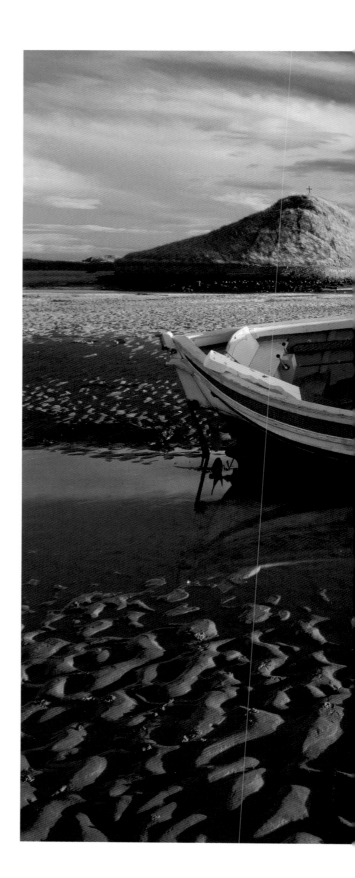

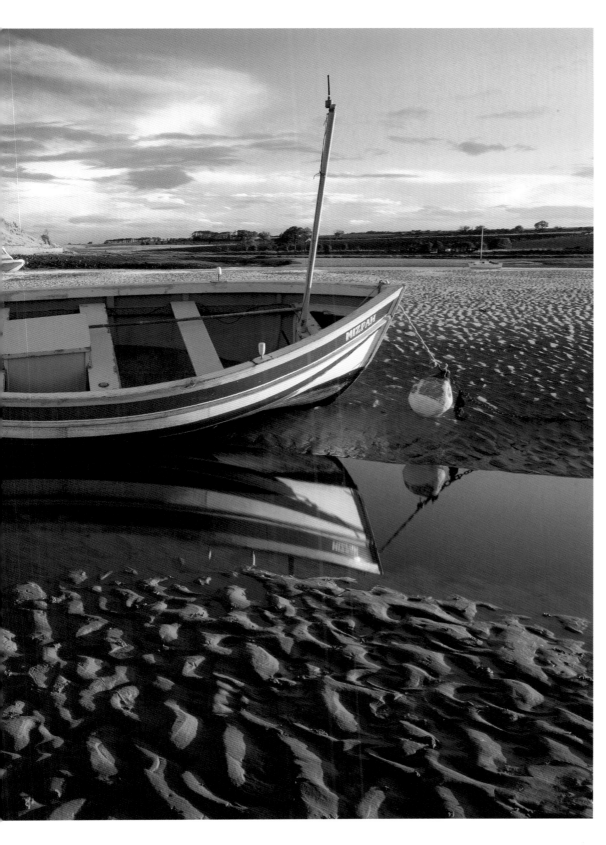

ALN ESTUARY, ALNMOUTH, NORTHUMBERLAND, ENGLAND

This photograph is a good example of how filters can be used to get the very best from a situation – and a rare example of where I used three filters in combination. First, a polarizer was chosen to increase colour saturation and enhance the sky. Second, a 0.6ND hard grad was added to ensure the sky and foreground were balanced. Third, an 81B warm-up was chosen to ensure the final image had a nice warm glow. All three filters were attached to the lens using a Lee Filter holder.

Camera: Walker Titan 5x4in field camera / Lens: 90mm / Filters: Polarizer and 0.6ND hard grad / Film: Fujichrome Velvia 50

◁

NEUTRAL DENSITY (ND) GRADS

When shooting landscapes, the difference in brightness between the sky and landscape is often too great for film or digital sensors to record. So, if you correctly expose the landscape itself the sky is overexposed and records as a wishy-washy colour, with no depth and little detail. If you expose the sky correctly, the landscape comes out too dark.

DO IT DIGITALLY

If you're a digital photographer, an alternative to using ND grad filters is to take two shots of the same scene, one correctly exposing the sky, the other correctly exposing the foreground, and then either to combine the two in Photoshop or to use a third-party plug-in, such as those available from Fred Miranda at www.fredmiranda.com.

ND grads allow you to overcome this by darkening the sky so it falls within the contrast range of the film you're using, or the sensor of your digital camera. By doing this, you can correctly expose the whole scene. Different densities of ND grad are available so you can darken the sky by a precise amount. A 0.3 ND grad will give a one-stop reduction in sky brightness; a 0.45 11/2 stops; 0.6 two stops; 0.75 21/2 stops, 0.9 three stops and 1.2 four stops. The most useful are 0.3, 0.6, and 0.9. You can also combine two to achieve a stronger effect. For example, 0.3 and 0.6 grads combined will reduce the brightness of the sky by three stops, the same as a 0.9 density grad.

CHOOSING YOUR GRAD

As a general rule, I find that for daytime shooting a 0.6ND grad is usually fine, while a stronger 0.9 grad is required at dawn and dusk, when there's no direct light on the landscape but the sky is very bright.

Working alongside digital photographers, however, it seems that stronger grads are required to achieve the desired effect with a digital SLR than with a film camera, possibly because digital sensors have a more limited brightness range. So, while I rarely use a grad stronger than 0.9, I have known digital photographers to combine 0.9 and 0.6

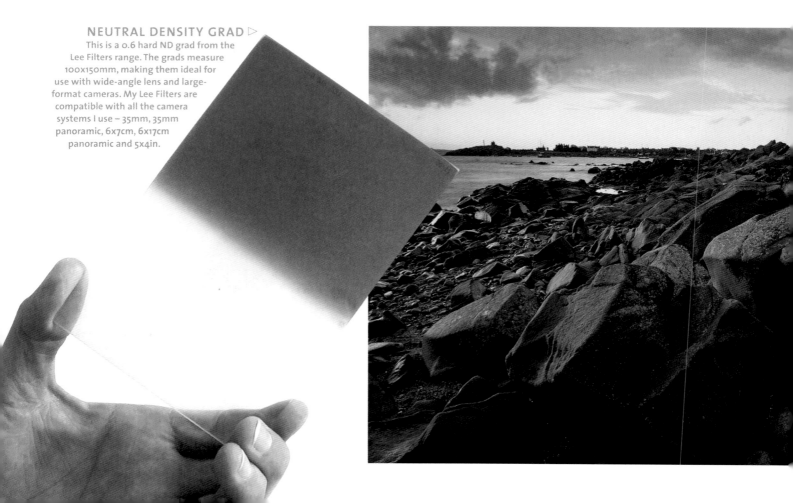

NEUTRAL DENSITY GRAD ▷
This is a 0.6 hard ND grad from the Lee Filters range. The grads measure 100x150mm, making them ideal for use with wide-angle lens and large-format cameras. My Lee Filters are compatible with all the camera systems I use – 35mm, 35mm panoramic, 6x7cm, 6x17cm panoramic and 5x4in.

HARD OR SOFT?

Professional ND grads often come in two forms – hard or soft. All that differs is how gently the ND part of the filter graduates to the clear area. Soft grads are very subtle, while hard grads are much more obvious.

Given this, you'd think that soft grads are easier to use because they're more forgiving. However, I find that hard grads are preferable because the strength of the neutral density is more consistent. The sky is often at its brightest close to the horizon, and that's where soft grads are at their weakest.

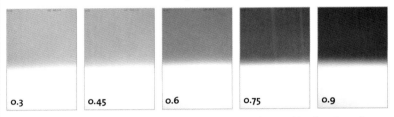

| 0.3 | 0.45 | 0.6 | 0.75 | 0.9 |

Here's the range of Lee ND grads I carry. Used singularly and in combination, they allow me to take successful photographs in any situation.

◁ **VIEW TOWARDS ST MARY'S, LINDISFARNE, NORTHUMBERLAND, ENGLAND**
This comparison shows the difference a neutral-density grad filter can make. The unfiltered version lacks impact and colour because the dusk sky has been totally washed out. However, by using a 0.9 density ND grad I was able to reduce the contrast between the sky and foreground by three stops and record the sky as it appeared to my eye. (Left: With 0.9ND hard grad/Above: Unfiltered).

Camera: Mamiya 7II / Lens: 43mm / Filters: Lee 0.9 hard ND grad / Film: Fujichrome Velvia 50

ND grads to give a combined reduction of five stops when capturing the same scene.

Knowing which density of grad to use is something that will come with experience – I can usually tell just by looking at the scene. However, you can also establish this by taking spotmeter readings – one from a midtone in the sky and a second from a midtone in the landscape. The difference between the two is the density of grad you need.

Digital shooters can also check the image on their camera's preview screen to see if the chosen grad is giving the desired effect. If not, it's a simple job to select a weaker or stronger one and reshoot the image.

USING YOUR GRAD

To use an ND graduate your camera ideally needs to be on a tripod so its position is fixed. Slide the filter down into the holder until the dark part of the filter is covering the required amount of sky. You can do this by eye, though pressing your camera's depth-of-field preview so the viewfinder darkens makes accurate alignment easier if you give your eye a few seconds to adjust to the darkness of the viewfinder.

Another option is to compose your shot, imagine that the front element of the lens is the picture area, and align the grad accordingly. If the top third of the composition is sky, set the grad so it covers the top third of the front element. This is the technique I use with rangefinder cameras that don't offer the benefit of through-the-lens (TTL) viewing, but it works just as well with SLR cameras.

When it comes to determining correct exposure with ND grads, there are two schools of thought. One is to meter from the landscape with no grad on the lens by tilting the camera down to exclude sky from the frame, set the exposure manually, and don't change it when the grad is placed on the lens. The other is to compose the shot, align the grad on your lens, then take a general meter reading for the whole scene using your camera's integral metering system. This second approach is viable these days thanks to sophisticated metering systems that measure brightness levels in numerous zones. In theory, by metering with a grad on the lens your camera should be less likely to give inaccurate exposures because the filter has reduced the contrast range that has to be measured – making it easier to interpret.

This approach works well if you're shooting with a digital SLR, because you can instantly check the effect of the grad and make any necessary adjustments to the exposure and/or grad filter density.

As I still work exclusively with film, I tend to use a handheld spotmeter to determine correct exposure when using ND grad filters. This means that I can compose the photograph, position the grad correctly, then take a meter reading from a mid-tone in the scene and set the correct exposure manually.

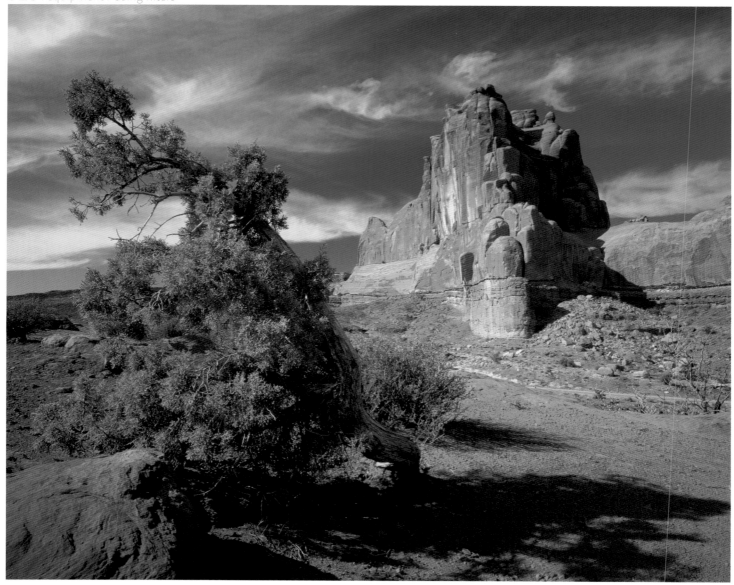

△
ARCHES NATIONAL PARK, UTAH, USA
Here's a perfect example of a situation where a polarizer is invaluable. There is strong sunlight, a good sky, and colour in the foreground. By carefully aligning the polarizer I was able to deepen the blue of the sky so the wispy white clouds were emphasized and also increase colour saturation in the tree in the foreground by eliminating glare on the leaves.

Camera: Mamiya 7II / Lens: 43mm / Filter: Polarizer / Film: Fujichrome Velvia 50

POLARIZERS
Light rays normally travel in all directions, but when they strike a surface, some of the reflected rays travel only in one direction and are said to be 'polarized'. Polarizing filters block out polarized light and produce three distinct effects. Blue sky is deepened, glare is reduced on non-metallic surfaces, and reflections can be reduced or eliminated.

Place the polarizer on your lens. Peer through the camera's viewfinder, and slowly rotate the filter. You will notice the sky go darker or lighter as reflections come and go, and colours appear stronger or weaker. Polarizers are constructed using a special foil between two sheets of glass, and change the amount of polarized light being blocked out. Because the foil is aligned to block out all polarized light, the maximum effect is achieved when the sky is at its darkest or colours at their strongest.

BEST EFFECT
When shooting blue sky, I find that the most dramatic results are obtained during early morning and late afternoon, when the sun is low in the sky, and by keeping the sun at right angles (90°) to the camera, whereas if the scene is frontally lit, or I'm shooting into the light, a polarizer will make little, if any, difference to the sky. The same applies in dull weather, when the sky is cloudy or overcast.

Glare is caused when light bouncing off a surface becomes polarized, and it creates what's best described as a 'sheen,' which makes colours appear weaker. A polarizer cuts through glare so this sheen is removed

and the colours appear more deeply saturated. To eliminate reflections, you need to position the camera so the angle between the lens axis and the reflective surface is around 30°. A polarizer may improve the sky but spoil the reflection. Equally, in some cases, it can remove surface glare so the reflection appears clearer.

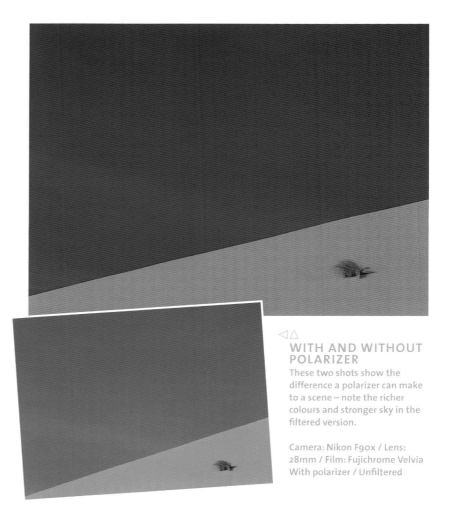

LIGHT LOSS

Polarizers reduce the light by about two stops. On the one hand this is a nuisance, because it increases the risk of camera shake. On the other it can also be a benefit, allowing you to use your polarizer like a two-stop (0.6) ND filter, to force an exposure increase. I often use a polarizer when shooting waterfalls or seascapes. The exposure increase emphasizes the motion of moving water. If your camera has TTL metering, you can take meter readings with the filter in place. If you meter without the polarizer, increase the exposure by two stops when you fit it to the lens.

◁△
WITH AND WITHOUT POLARIZER
These two shots show the difference a polarizer can make to a scene – note the richer colours and stronger sky in the filtered version.

Camera: Nikon F90x / Lens: 28mm / Film: Fujichrome Velvia With polarizer / Unfiltered

CIRCULAR POLARIZER
This is my 105mm Lee Filters polarizer. Having an oversized polarizer like this eliminates problems with vignetting, even when it's used on ultra wide-angle lenses. It's looking rather battered now after several years of hard service, but still delivers the goods.
▽

CIRCULAR OR LINEAR?

Autofocus SLRs (film or digital), plus cameras with spot metering or semi-silvered mirrors, require a circular polarizer, otherwise exposure error will result if you take exposure readings with the filter on your lens. Other types of camera can be used with a linear polarizer. The reason for this is that AF SLRs, plus the other types mentioned, polarize some of the light inside the camera.

If you're unsure which type you need, fit a linear polarizer to your lens and aim it at an evenly lit surface. If the exposure reading doesn't change as you rotate the filter, a linear polarizer will be okay. If the exposure fluctuates you need to use a circular polarizer. Both types give exactly the same effect, so don't be misled into thinking one type is better than the other. I use a circular polarizer with my Nikons because they are AF SLRs, but for the Mamiya 7II, Fuji GX617 and Hasselblad Xpan I use linear polarizers.

WARM-UP FILTERS

The amber-coloured filters from the 81-series come in six different strengths - 81, 81A, 81B, 81C, 81D and 81EF, with 81 being the weakest and 81EF the strongest. I carry four strengths – 81B, C, D and EF. They're mainly designed to correct minor blue deficiencies in the light which are often present when shooting in dull, cloudy weather, deep shade, or in the middle of the day under clear blue sky. Our eyes adjust to these shifts in the colour temperature of the light, but film can't, so pictures taken in such conditions may exhibit an unattractive coolness – especially if you're also using a polarizer, which seems to emphasise the effect. By shooting with an 81B filter on your lens, any coolness will be cancelled out so colours record naturally. More commonly, I use warm-up filters to make natural daylight seem warmer than it really is. This is no bad thing, because warm light is almost always attractive, and during early morning or late afternoon an 81C or 81D will enhance the light and any warm colours in a scene such as old stonework, or autumnal woodland. Taking this one step further, I occasionally use an 81EF or even combine an 81EF with a second, weaker warm-up to pep-up a muted sunrise or sunset, or woodland scenes captured in misty weather at dawn and dusk.

81C WARM-UP FILTER

My Lee warm-up filters measure 100x100m. They can be used individually or in combination to achieve a warmer colour cast, and can also be used with other filter types such as polarizers and ND grads.
▽

GETTING WARMER

The 81-series of warm-up filters come in different strengths and can be used individually or together.

| 81B | 81C | 81D | 81EF |

This is the set of warm-up filters I carry at all times. The 81B is handy for balancing cool light while the stronger filters are mainly used at dawn and dusk to enhance the natural light.

FILTERS FOR BLACK AND WHITE

Coloured filters are used by black & white photographers to increase contrast. The most popular colours are yellow, yellow/green, green, orange and red. Each filter lightens its own colour and darkens its complementary colour, so yellow, orange and red filters convert warm colours to a lighter grey tone and cool colours – such as blue and green – to darker grey tones.

Yellow increases contrast slightly so skies are emphasized, while yellow/green and green give better separation of green tones. Orange and red both give rise to a dramatic increase in contrast and both are ideal for adding drama to skies as they darken blue so lighter clouds stand out and emphasize dark, stormy skies. Red gives the most obvious effect of the two, and I often combine red and a polarizing filter to make the most of amazing skies.

BRENTOR, DARTMOOR, DEVON, ENGLAND

I used a deep red filter and a polarizer together for this shot, to emphasize the sky and boost contrast to give the image more impact.

Camera: Pentax 67 / Lens: 45mm / Filters: Red and polarizer / Film: Ilford HP5 Plus

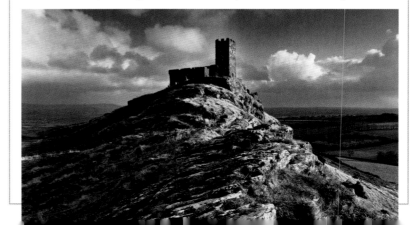

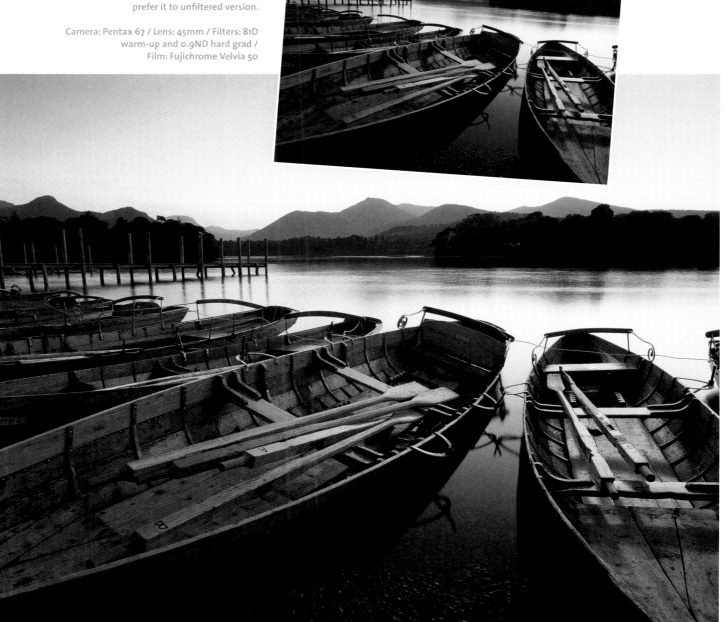

DERWENTWATER, LAKE DISTRICT, ▷ CUMBRIA, ENGLAND
This comparison shows the effect a relatively strong warm-up filter has. The natural light was attractive enough so initially I used only an ND grad filter on the lens to hold colour in the sky (see inset pic). However, I then decided to warm-up the scene using an 81D filter and **actually prefer it to unfiltered version.**

Camera: Pentax 67 / Lens: 45mm / Filters: 81D warm-up and 0.9ND hard grad / Film: Fujichrome Velvia 50

WHICH WARM-UP?
The key is making sure the effect looks natural. To neutralize cool light you should rarely need a filter stronger than an 81B. If you use an 81C or 81D, colours in the scene will take on an unnatural cast – such as white clouds coming out yellow and blue sky turning a muddy grey/blue tone. It's more difficult to overdo things at sunrise and sunset, but you should not automatically reach for a warm-up filter when shooting at either end of the day. I tended to use one on almost every shot I took, but over the years I've come to realize that when the light's good it doesn't need any help, and at sunrise and sunset I rarely bother with warm-ups at all these days – and if I do, it's usually after taking a series of shots unfiltered first, then adding a filter to see if it improves on what's already there.

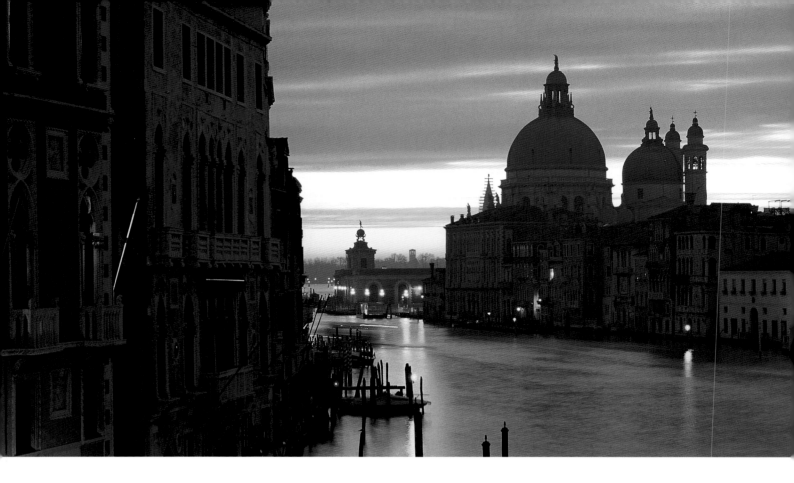

USEFUL ACCESSORIES

Although cameras, lenses and filters form the heart of any photographic kit, it's never complete without a few essential accessories to aid your work in the field.

TRIPOD

Top of the list is a solid, sturdy tripod to provide a stable support for your camera, so slow shutter speeds can be used without fear of shake. This means you can concentrate on setting a small lens aperture to maximize depth-of-field, use long exposures in low light, and take pictures on slow speed.

To put this into perspective, my preferred film stock for landscapes is Fujichrome Velvia 50, which at ISO50 is the slowest colour transparency film available. If I use a polarizing filter, which loses two stops of light, that film speed effectively drops to ISO12. More often than not, I'm working at a maximum aperture of f/16 to provide sufficient depth-of-field for front-to-back sharpness. Even in bright sunlight, this means the fastest shutter speed I can manage is around 1/8sec – far

too slow for taking hand-held pictures. More commonly, however, I find myself working at exposures of many seconds. Without using a tripod this would be impossible.

Another benefit to using a tripod is that it slows everything down, which in turn makes you a more thoughtful photographer. You're not going to bother setting up the damned thing unless it's worth the effort, and once the tripod is erected, it makes composing a landscape picture much easier – you can make small, careful adjustments, then leave the camera in position while you wait for the light to improve, or while you check out other possible viewpoints nearby.

I use one of two tripods, each fitted with a different head. If I'm travelling and working with 35mm equipment (Nikons and Xpan), my I use a Manfrotto 190. It's relatively small and light, so I'm happy to trudge city streets with it. Fully extended it reaches chest height without the centre column in use, and extends to eye level when using the central column. This tripod is fitted with a Manfrotto ball and socket head.

For everything else, my tripod of choice is a Gitzo 1348 carbon-fiber model. It's much bigger than the 190, and relatively heavy despite being carbon fiber (3.5kg with the head attached), but it's also incredibly sturdy and will support any of the camera systems I use, including 617 panoramic. I can also extend it to well beyond my own head height without the need for a centre column, which is supplied as an optional extra. The twist-action locks on the lower leg sections have a habit of jamming but periodical cleaning and greasing solves this.

The tripod is fitted with a Gitzo Levelling Base. This allows me to level the head quickly, even if the tripod itself isn't perfectly level, and is topped with a Manfrotto 410 head, which has geared operation in three

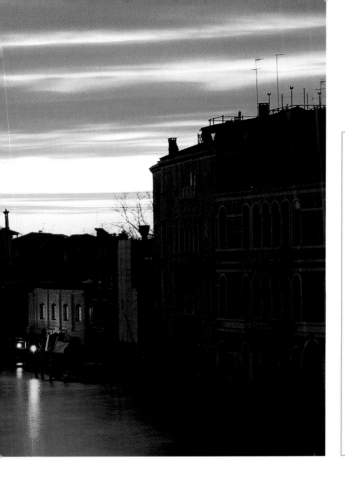

SPARE BATTERIES

There's nothing worse than running out of battery power in the middle of a muddy field at 6am. If your cameras are battery-dependent, always, always make sure you carry at least one spare set for each body. Otherwise it could be a long and disappointing walk home. Batteries tend to drain especially quickly in cold weather. Carrying spares means I can change them quickly and get back to work, putting the 'duds' in an inside jacket pocket to warm them up and coax a bit more life out of them.

If you use a digital camera and are reliant on rechargeable batteries, always have a back-up with you that's fully charged, and remember to put all batteries on charge each night.

I find purpose-made plastic boxes with moulded foam inserts ideal for storing spare batteries.

GRAND CANAL, VENICE, ITALY

If you don't want to be compromised by low light, a tripod is essential for landscape photography. Without one it would have been impossible for me to photograph this beautiful scene and record the rich colours of the natural and artificial lighting. Loading fast film or increasing the sensor speed of your digital camera may seem like a possible solution, but it's never the same as simply mounting your camera on a sturdy tripod.

Camera: Hasselblad Xpan / Lens: 45mm / Film: Fujichrome Velvia 50

TRIPODS

The two tripods I use are a Manfrotto 190 and a compact ball and socket head, or a Gitzo 1438 carbon-fiber tripod with Manfrotto 410 Junior Geared head. This latter combination is unbeatable when working with medium- and large-format cameras, such as the Fuji GX617.

planes for precise adjustment. However, the gears can also be disengaged for getting set up quickly. It's by far the best tripod head I've ever used.

CABLE RELEASE

When using a tripod-mounted camera I almost always attach a cable release so the shutter can be tripped without touching the camera. This eliminates any risk of causing camera shake and is especially important when using the bulb setting for long exposures. Traditional cable releases screw into the top of the shutter button and are activated by pressing a plunger on the other end. Most also have a lock so you don't have to keep the plunger depressed during a long exposure. Many modern SLRs, my Nikons included, require an electronic release, which plugs into the camera body.

I always carry two or three traditional cable releases, as I seem to wear them out with alarming speed.

HAND-HELD LIGHTMETER

Whether or not you need to bother with a hand-held meter depends on the type of camera you use. When I'm working with my Nikon SLRs I'm happy to rely on their integral Matrix metering because it's so accurate. I'm not as confident of the metering in my Hasselblad Xpan but, because I tend to use it alongside the Nikons, I usually take an exposure reading with one of them and transfer it to the Xpan. It's only when I switch to rollfilm cameras that a handheld meter becomes necessary. My Mamiya 7II does have integral metering, but it's quite basic and not up to coping with the tricky light I so often find myself trying to capture, while the Fuji GX617 has no metering whatsoever.

For many years now I've been using the same two meters – a Pentax digital spotmeter and a Minolta Autometer IV F, which can be used to take incident, reflected and flash readings. There are far more sophisticated models available, which combine all these functions in one package, but I'm not one for replacing equipment for the sake of it and while both remain reliable I see no need to change.

For advice on exposure and metering, turn to page 64.

MAP AND COMPASS

The importance of maps for landscape photography can't be overestimated. Without them, how on Earth do you know where you're going, or what to expect when you get there? That said, the way maps are used differs from photographer to photographer. Some study them

LIGHT METERS
Here are my faithful friends – the Minolta Autometer IVF and the Pentax Digital Spotmeter. I have been using both models for many years and between them they ensure I achieve correct exposure in the trickiest lighting situations.
▽▷

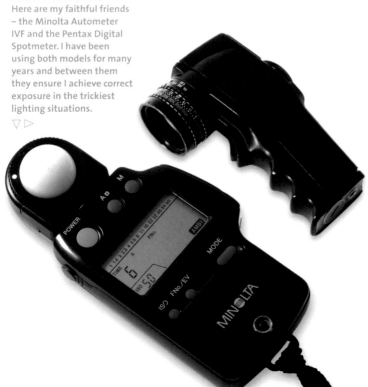

rigorously. They analyze the contour lines, measurements and markings to find out as much as possible about the topography of the landscape in an area. Or, they try and work out an estimate of the best time of day to be there, when a scene is no longer in shadow because the sun has climbed over a nearby hill. Others only use maps to take them to viewpoints they never knew existed, and to find the rivers, streams and lakes.

I rarely carry maps with me when I head off on foot. I study the maps carefully beforehand, usually to discover which way a scene faces so I know whether to go there in the morning or afternoon.

I use Ordnance Survey maps from the Landranger, Outdoor Leisure, and Explorer series. I also carry a basic Silva map-reading compass in my backpack, which I use to roughly determine the position of sunrise and sunset at unfamiliar locations.

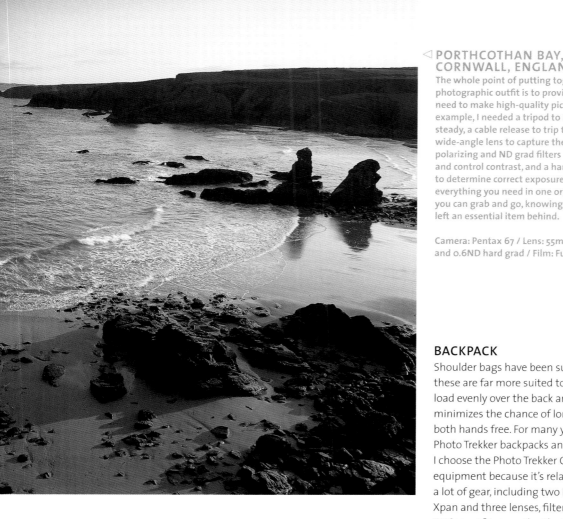

◁ PORTHCOTHAN BAY,
PORTHCOTHAN BAY, CORNWALL, ENGLAND

The whole point of putting together a photographic outfit is to provide everything you need to make high-quality pictures. Here, for example, I needed a tripod to keep the camera steady, a cable release to trip the shutter, a wide-angle lens to capture the scene at its best, polarizing and ND grad filters to boost colours and control contrast, and a hand-held spotmeter to determine correct exposure. Keeping everything you need in one organized pack means you can grab and go, knowing that you haven't left an essential item behind.

Camera: Pentax 67 / Lens: 55mm / Filters: Polarizer and 0.6ND hard grad / Film: Fujichrome Velvia 50

BACKPACK

Shoulder bags have been superseded by backpacks because these are far more suited to work in the field, distributing the load evenly over the back and shoulders. This improves balance, minimizes the chance of long-term back problems, and keeps both hands free. For many years now, I've been using Lowepro Photo Trekker backpacks and can't rate them highly enough. I choose the Photo Trekker Classic when I'm using 35mm equipment because it's relatively compact but can swallow up a lot of gear, including two Nikons and four lenses, a Hasselblad Xpan and three lenses, filters and film. For the Mamiya 7 and Fuji GX617 outfits I use the Photo Trekker AW (All Weather), which is slightly bigger. Where extra space is required, I attached a padded side pocket to this pack.

Neither pack is fully waterproof, but the AW model has a waterproof cover, which also makes a handy groundsheet.

AVOIDING FLARE

Many photographers swear by lens hoods to shield the front of the lens from stray light and avoid flare. I don't bother. I find that they just get in the way when I am using filters. Instead, I find other ways of keeping light off the lens. A hand works well – just peer through the camera's viewfinder while holding your hand over the lens until it's positoned to block out the sun. A standard-sized sheet of thin cardboard, such as the grey card used to take substitute exposure readings, can also be used for the same purpose.

When you are using rangefinder cameras that lack TTL viewing it's not so easy to use this method. So instead, I use my body to cast a shadow over the lens, being careful not to stray into its field-of-view, and trip the shutter with an outstretched arm and cable release.

KEEP IT CLEAN

Cameras, lenses and filters are tools. They have to last a long time, be reliable, and give a 100% performance every time.

I don't bother with protective UV or Skylight filters on my lenses because it's just another layer of glass to degrade image quality. This means the delicate front element of each lens is left vulnerable, but if you're careful, accidents should never happen.

To clean lenses and filters, remove dust, hairs, and other foreign bodies using an antistatic brush. Then breathe on the lens or filter and carefully wipe away any marks with microfibre cloths. I also carry waterproof-stuff sacks in each pack (the type designed to store sleeping bags) – they're ideal for protecting a tripod-mounted camera and lens. A microfibre cloth can be used to remove moisture from camera bodies and lens barrels, though a chamois leather works best.

PLANNING YOUR TRIP

Whether you're heading off for a few days or a few months, planning is the key to a successful photographic trip. Go prepared and no matter what type of environment you're intending to explore you'll be ready and equipped to make the most of it. But leave too much to chance and it could end in disaster. Take it from one who knows!

Even something as basic as underestimating the weather conditions so you don't have the right clothing can make a big difference to the success of a trip. Many years ago, I hiked out to a remote location only to find that the quick-release place for my tripod head wasn't actually on the tripod, or the base of my camera. I had never thought to check, so I was unable to get the shots I'd set out for, even though the light was perfect.

EQUIPMENT

The cameras and lenses I take depend on where I'm going and the pictures I want to take. I list every item and check them off. I travel with one of two kits – 35mm or medium format – and each kit has its own backpack containing cameras and lenses, cable releases, filter holder and adaptor rings, brushes and cleaning cloths, and accessories specific to that kit. Filters and hand-held light meters flit between the two kits as and when required. Each kit is also assigned its own tripod, and I make sure I have two or three baseplates packed for the respective tripod head.

CUBA, ZANZIBAR, TURKEY

Wherever I decide to travel, I always plan my trips carefully so that I get the most out of them photographically and minimize the risk of things going wrong. This has led to some amazing experiences over the years and I have been fortunate to photograph some of the world's greatest locations – though there are many, many more still to see.

Camera: Nikon F90x and F5 / Lens: 50mm and 80-200mm / Filters: Polarizer and warm-ups / Film: Fujichrome Velvia 50

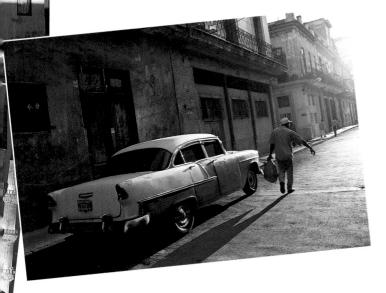

FILM/MEMORY

I still work with film, so I need to make sure I have enough for the entire trip. If I'm using rollfilm and I intend to shoot a lot of panoramics (which means only four frames to a roll with the Fuji GX617) I would pack a minimum of 50 rolls for a trip lasting four or five days, but at least 100 rolls if I am going to be away any longer.

If you've abandoned film for digital photography, then life is a little easier. However, lack of storage capacity, or memory, can be a problem because if you don't have enough space you need to start taking fewer pictures or to go through the ones you have already taken and erase the ones you don't want. Neither option is ideal. Always make sure you have enough memory cards with you so that none of them have to be wiped clean until you return home.

The photographers I know who shoot digitally also prefer to use cards with a smaller capacity, such as 1Gb and 2Gb rather than 4Gb or 8Gb. In this way, if one card develops a problem, the number of images that can be lost is kept to a minimum.

In addition to the memory cards, you will also need a portable storage device so that the images on each card can be backed up. I've known photographers also to pack a laptop and blank CDs or DVDs. This enables them to make an additional copy while they are away. But this is a matter of preference, because the quality of the latest memory cards and storage devices is so high and reliable.

If you do run out of memory-card space while you are away from home, you can always erase a card or two after copying its files onto a portable storage device or the hard drive of a computer, and then reusing it. Ideally, it's better if you don't have to wipe any cards until you return home. It's one less thing to worry about.

LOCATION RESEARCH

Researching your chosen destination before embarking on a trip is invaluable. I like the element of surprise that comes from visiting somewhere for the first time and discovering new locations, but I don't like to be completely in the dark.

My first step is usually to buy a guidebook. I prefer Lonely Planet and Rough Guides. They're down to earth, detailed, and reliable and provide plenty of information on places to stay. Next, I look around for photographic books and check websites. Picture library websites are ideal. Just type a location into the search engines. Tourist websites can be handy for the same reason. I'll contact other photographers for any location tips they might have, or log on to their website and check out their images. This isn't done with the intention of copying, but just to build up a picture of which places tend to offer the best potential.

At the time of writing, I'm about to visit the Isle of Lewis in Scotland's Outer Hebrides. It's my first trip, it's a relatively big island, and I will only be there for a few days. So, to avoid wasting time I have used the Internet and books to help me compile a list of the most promising locations. I have marked a map so I know where they are in relation to each other and whether they're likely to be good dawn or dusk locations. Once I arrive, these locations will be given priority, but I will also make an effort to explore other areas and find my own locations.

In March 2005 I visited Cuba for the first time. Research, guidebooks, and speaking to other photographers helped me decide which were the key areas. By the time I returned home ten days later, I felt confident I had some great images, and knew the locations well enough to return in the spring of 2006 and to lead two successful photographic tours of the island.

TAKING EQUIPMENT OVERSEAS

Airlines have always had fairly strict luggage size and weight restrictions, and it's well worth checking these before you travel. I have even seen photographers paying more in excess charges than their ticket cost, simply because they tried to carry too much equipment.

Hand-luggage limits are the biggest problem. The current size limit (though this may change) tends to be 45x35x16cm, while the weight limit could be anything from 6kg to no limit, within reason, but some airlines are more relaxed than others.

In my hand luggage I pack all my film, which may weigh as much as 5–6kg, and other travel items such as reading matter. I try not to pack any photographic equipment, because it's easy to end up with hand luggage that is double the permitted weight limit. Carrying such a heavy pack around airports is a hassle too, so I always aim to have only one piece of hand luggage. This complies with the airline's size requirements and their weight limitations, and makes travelling more comfortable.

My hold luggage is usually a heavy-duty canvas holdall. To make life easier, I pack as much camera equipment as I can into a pair of small Peli cases (model 1300). These are airtight, watertight and practically indestructible. They hold camera bodies, lenses, batteries, filters, and light meters. The two Peli cases fit into the holdall comfortably along with my tripod, which I bubblewrap for protection. There is plenty of space left for clothing and toiletries, which also act as padding, and the total weight has never been more than 25kg, even for a long trip.

FILM AND X-RAYS

I receive emails on a regular basis from concerned photographers who are travelling overseas and wonder what to do about having their film X-rayed.

What you should never do is pack film, whether unexposed or exposed, in your hold luggage, because it is subject to high doses of X-rays that could cause fogging. Instead, pack it in your hand luggage, or in a separate bag, and keep it with you at all times. The X-ray machines used to scan hand luggage are safe even if the same batch of film is X-rayed many times.

If I return from a trip with any unexposed film, I mark the box with a large X that reminds me that it has already travelled. I would use that film in the UK, but I wouldn't take it on another trip where it was subject to X-rays.

ALARM CLOCK

Successful landscape photography involves rising early, when most sane people are still fast asleep. I rely on the alarm-clock function of my mobile phone. This saves me the bother of having to pack a separate clock. The alarm will work even if the phone itself is turned off and modern phones last for ten days or more when fully charged. Do remember to adjust the internal clock on your phone to local time when you arrive, otherwise you'll be woken up hours early – or late!

◁ LOCH LEVAN, GLENCOE VILLAGE, HIGHLANDS, SCOTLAND

This dramatic panorama was captured moments before sunset as a storm descended from the nearby mountains and closed in around me. I was perched on the end of a pier trying to capture the unfolding drama in falling rain, knowing that any minute the bright hole in the sky would disappear. Fortunately, I was equipped with warm, waterproof clothing, so my only concern was for my camera rather than myself.

Camera: Fuji GX617 / Lens: 90mm (image cropped) / Filters: 0.3 centre ND / Film: Fujichrome Velvia 50

DOCUMENTATION

I tend to make a list of any vital documents I need for a trip. These include my passport, any visas, driver's license, vaccination certificates, travel tickets and insurance. I start collating them well in advance so they're all together with my photographic equipment.

Many countries require you to have a passport that's valid for at least six months after your trip ends. It's a good idea to check this periodically so you don't get a nasty shock a few days before departure, by which time it will be too late to apply for a replacement.

INSURANCE

I have a separate insurance policy for my photographic equipment, which includes overseas travel and covers everything on a new-for-old basis. This means that if an item is lost or stolen the replacement will be new, regardless of the age of the original – or the nearest alternative if the item concerned is no longer made. This is an important factor to consider because photographic equipment depreciates rather quickly, so if you lose a camera that's five years old and you don't have a new-for-old policy, the settlement offered by the insurer may be less than half the cost of a new replacement, which means you could end up seriously out of pocket. Hobbyist photographers can usually obtain sufficient cover for trips away on a household insurance policy because photographic equipment will fall under the Personal Possessions category. However, you should check the small print of your policy before embarking on a trip, just to be sure

that the level of cover you need is in place. Many insurers require details of individual items over a certain value, for example, and if you've recently upgraded a camera or invested in an exotic lens, your policy may need updating.

For general travel insurance, which covers clothing and other non-photographic items, as well as medical cover, I take out an annual worldwide policy. If you travel on a regular basis this is by far the most economical way to insure yourself and gives you one less thing to think about when planning a trip.

With both types of insurance, I always carry photocopies of my policy documents so that in the event of needing to make a claim I can contact my insurer immediately while still away from home.

I can also check to see what the insurer expects in the event of a claim. For example, most insurers will request documentation to prove that you have reported any loss to the local police wherever you happen to be in the world. Failure to do that could invalidate your claim – on the basis that if you don't bother to report a loss or theft then maybe there was never anything to report in the first place. Insurance companies will find any excuse not to pay out, so make sure you do exactly what they say to avoid problems.

CLOTHING

Having packed a large proportion of my camera equipment in my hold luggage, precious little space exists for clothes. Over the years I've become an expert at minimizing my travel wardrobe while making sure I have everything I need to provide a suitable level of comfort.

When I travel overseas it's usually to warmer climates so I need little in the way of clothing anyway. A couple of pairs of shorts, a battered pair of walking sandals that have served me well for the last 12 years, lightweight shirts or t-shirts, and a sunhat are pretty much it. In really hot or humid locations, such as deserts and the tropics I find 'Solardry' shorts and shirts ideal. They're very lightweight, they wick away sweat, and dry very quickly, which means they can be washed and dried overnight for reuse the following day. I even have some shirts with built-in sun protection and mosquito repellent.

For colder locations I wear cotton 'Cargo' pants. These have plenty of pockets, and are loose fitting and quick drying. I wear a base layer of thermals when necessary, along with several thin layers on my upper body (usually a cotton t-shirt, a thin fleece mid-layer, and a second thicker fleece). I wear a fleece hat to prevent heat loss through my head and fleece gloves keep my fingers warm. The final outer layer is either a lightweight wind- or waterpoof jacket and waterproof knee-lengths gaiters or, in more severe weather, a heavy-duty breathable, waterproof jacket and full length waterproof leggings. Footwear is always a pair of stout walking boots – I've been buying the same brand for years.

UNDERSTAN

Landscape photography should really be renamed lightscape photography, because while the subject matter we set out to photograph is land itself, it's the nature of the light striking the land that dictates its mood and physical appearance and inspires us to record an image of it with our camera. Light becomes our subject and the landscape a stage on which it performs. The key to success is capturing that performance at its most perfect.

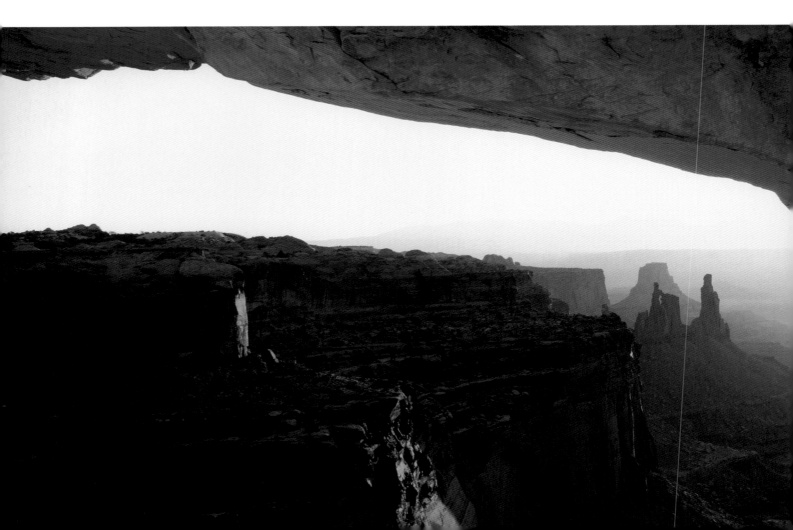

DING LIGHT

Daylight has many faces. It can be hard or soft, harsh or weak, warm or cold. The factors controlling these changes are the time of day, time of year, and prevailing weather conditions, and together they create an endless range of permutations that makes landscape photography such a challenge and a joy. Ironically, daylight is at its most beautiful when it's in short supply at the very beginning and end of the day. The time between can also be productive, but dawn and dusk are the main periods of activity for the landscape photographer. So, if you cherish sleeping late you're going to be in for a shock.

MESA ARCH, CANYONLANDS, UTAH, USA
When the sun rises behind the sandstone arch, it shines directly onto cliffs that drop beneath it. Some of the light reflects onto the underside of the arch, creating an orange glow and one of the most amazing natural lightshows I've ever seen.

Camera: Fuji GX617 / Lens: 90mm / Filters: 0.3 Centre-ND / Film: Fujichrome Velvia 50
▽

BEFORE SUNRISE

Before the sun rises, any light on the landscape is reflected from the sky. In effect the sky becomes the light source, and because it's so huge the light itself is soft and shadowless. It also has a slight coolness to it because the sky overhead is blue, while on the eastern horizon there will usually be a warm glow bleeding into the sky above the point where the sun will rise.

I always try to be on location at least 30 minutes before sunrise, preferably longer, because this glow before sunrise can look stunning. This glow also tends to be at its most intense at this time, and when the sun does appear, it has often faded.

This is the best time of day especially for shooting coastal scenery or lakes, because the water reflects the often-vivid hues in the sky. The soft, indirect light is very revealing, so fine detail in the foreground can be captured, like the patterns in rocks or the smooth shape of boulders and pebbles. Light levels are also low, so long exposures can be expected. This is another benefit when shooting coastal views, because you can record the motion of the sea. An important factor to consider is whether the contrast between the sky and land is naturally high or due to the lack of direct light, when a strong ND grad is required to balance the two if you want to record foreground detail. I find a 0.9 ND hard grad usually does the job.

SUNRISE

As sunrise approaches the early glow fades, often almost disappearing, and once the sun does peer over the horizon conditions change very quickly. In clear weather, warm rays of sunlight rake across the landscape, casting long shadows. The light is warm at sunrise because the sun's rays pass through the atmosphere at a shallow angle and the light is scattered, with many of the wavelengths at the blue end of the spectrum being filtered out. This also reduces the intensity of the light so contrast is lower. The shadows are weak because they're partially lit by the sky overhead, and they also exhibit a cool colour cast because the sky itself is blue. This contrast between the cool shadows and warm light can look stunning.

In temperate regions, sunrise normally occurs at around 4am during summer, 6am during spring and autumn and 8am in winter. It rises north of east in summer and south of east in winter.

How you photograph at sunrise depends on the strength of the light. In clear weather the sun tends to be intense from the moment it appears

DUNSTANBURGH CASTLE, EMBLETON BAY, ▷
NORTHUMBERLAND, ENGLAND

Light is everything to the landscape photographer, the raw material of every picture we take. Capturing it at its best requires a combination of experience, persistence, patience, and quite often, a little luck. I had tried on several occasions to get this particular shot. I knew where I needed to be and when, but the weather was out of my control so I just had to keep trying and hope for the best. Eventually, I was rewarded with this amazing glow before sunrise, creating a perfect backdrop to the haunting castle ruins and dramatic boulder field.

Camera: Mamiya 7II / Lens: 43mm /
Filters: 0.9ND hard grad / Film: Fujichrome Velvia 50

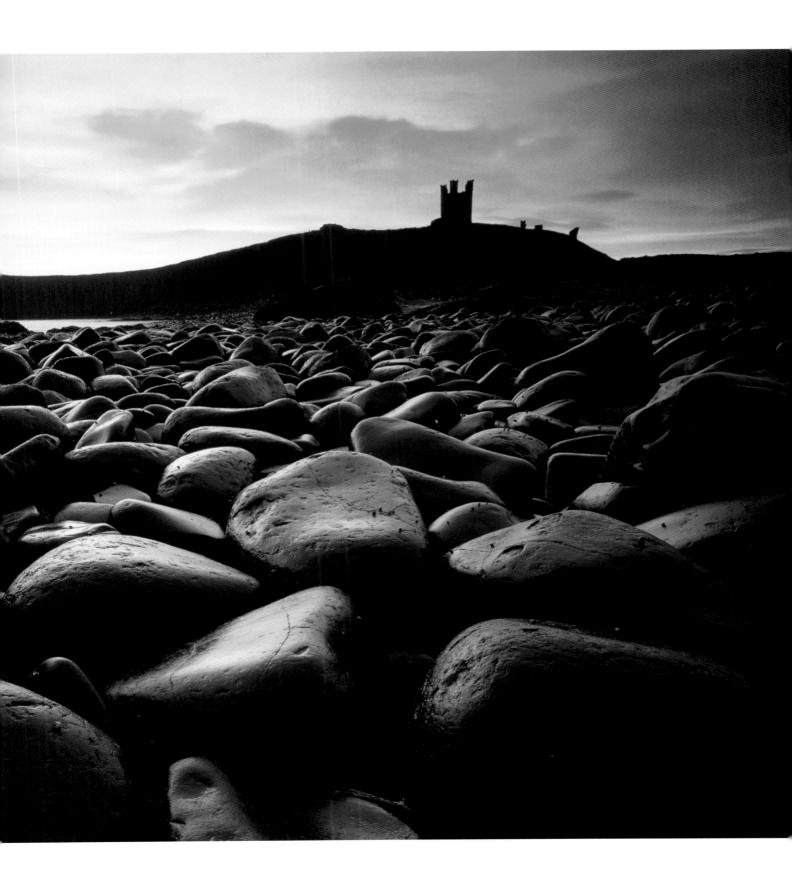

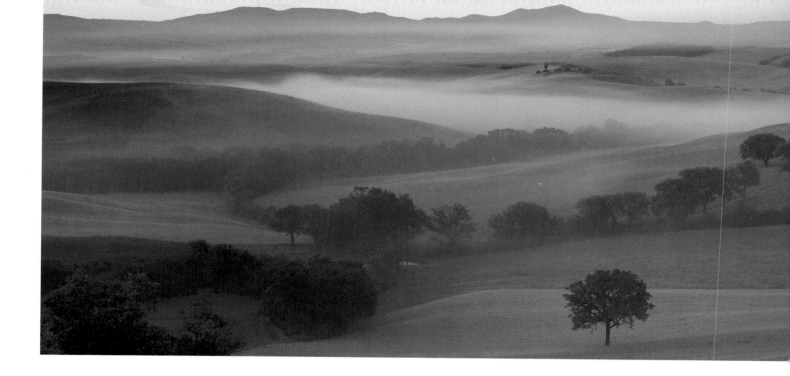

over the horizon, so shooting into the sun is likely to result in flare. A better option is to turn away and capture the effects of this first light as it bathes the landscape in a warm glow. If the sun rises into a cloudy or hazy sky, its orb will appear less intense but much warmer, so you can include it in your pictures with little or no risk of flare. Coastal locations and lake scenes are ideal for sunrise shots because the warmth of the sun will reflect on the water, and urban landscapes can also look stunning at this time of day.

EARLY MORNING

Once the sun is over the horizon the quality of light changes quite quickly. It becomes more intense as the angle between the sun and Earth increases because the atmosphere through which it passes is thinner and thus less scattering occurs. This also causes the colour temperature of the light to rise and the warmth quickly fades back to neutral as less of the blue wavelengths of light are filtered out.

During the summer, daylight is neutral in colour just two hours after sunrise – around 6am – and its colour temperature remains fairly constant, for about 12 hours. During spring and autumn, any warmth in the light will have gone by around 8am and the colour temperature remains steady until 4pm. In winter the colour temperature of daylight hardly ever reaches 5500k, even at midday, and because the angle between the sun and Earth is so shallow much of the blue light is scattered. The first two hours of daylight are the best for landscape photography at the start of the day as the light retains a warm bias, its intensity is still reasonably low and long shadows add depth and modelling, which is why an early start is necessary if you want to catch the light at its best. By 6am in summer and 8am through spring and autumn, the best of the light has gone, at least for a few hours anyway.

THE MIDDLE HOURS

Once the sun has been up for two hours, the quality of light for landscape photography in clear, sunny weather begins to tail off. The higher the

TURRET ARCH THROUGH NORTH WINDOW, ▷ ARCHES NATIONAL PARK, UTAH, USA

When the sun rises into a clear sky the landscape is bathed in a spectacular golden glow – in this case perfect light for enhancing the warmth of the 'red rock' scenery. I arrived well before sunrise and the scene looked rather drab, but the moment the sun appeared it was as if someone had flicked a switch and turned on a giant spotlight.

Camera: Mamiya 7II / Lens: 80mm / Filters: Polarizer / Film: Fujichrome Velvia 50

sun climbs into the sky, the more harsh and intense the light becomes, while shadows appear shorter and denser. By 9am in summer the sun has reached its zenith (it's highest point) and remains there until at least 4pm. This is the period when it's often suggested you put your camera away on sunny days because the light is no use for landscape photography.

On too many occasions over the years, I have continued to shoot through the day, only to be disappointed by the results. Landscape shot in the middle of the day looks flat and characterless, and blue sky is often weakened by haze. Polarizing filters are less effective, too. Contrast is also very high so if you correctly expose the highlights, shadows block up and no detail is visible. The colour temperature of the light is so high that pictures often come out with an unattractive cool cast, unless warm-up filters are used to correct it. There really is no comparison between a photograph taken at 6 in the morning and one of the same scene at 1pm, so you might as well save your time and energy and use it to travel to your next location – or go back to bed if you've been up since 4am!

The only time I break this rule is when I'm shooting urban landscapes. The graphic shapes, bold colours, and strong patterns often look better in strong light against cloudless blue sky, especially if you're trying to create simple, graphic images.

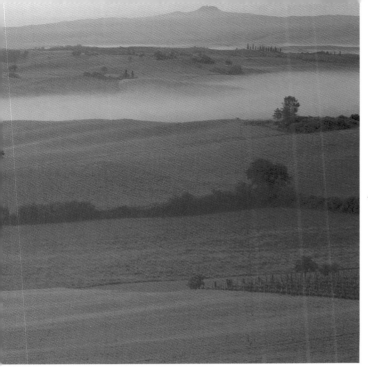

◁VAL D'ORCIA, TUSCANY, ITALY

Dawn is the most magical time for landscape photography, especially when you're faced with a scene as beautiful as this. I arrived at 5am on a spring morning in semi-darkness to find the valley lost in a sea of mist, but as the sun prepared to rise and the mist began to clear, I couldn't have wished for better conditions. Gentle undulations in the landscape were revealed by a soft pre-dawn light and the coolness of the slumbering landscape contrasted wonderfully with the warm glow in the sky. Everything was perfect – all I had to do was capture it.

Camera: Fuji GX617 / Lens: 180mm / Filters: 0.75ND hard grad / Film: Fujichrome Velvia 50

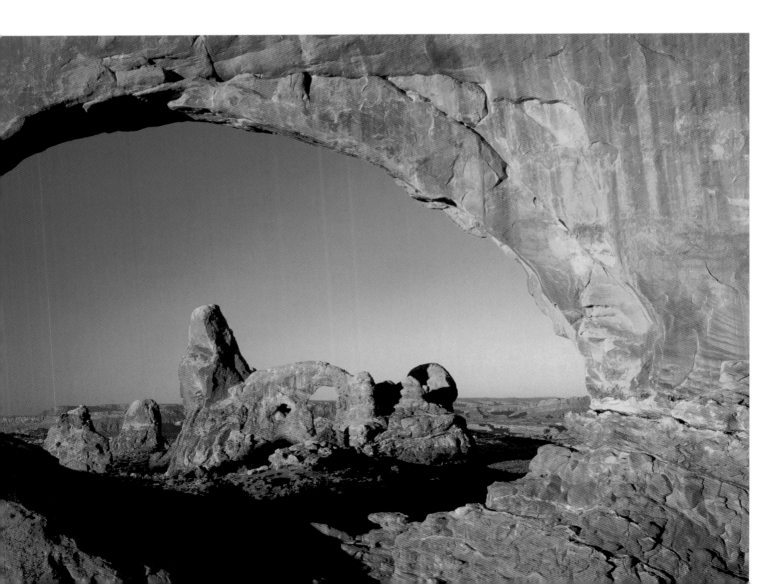

◁ NKOB, MOROCCO

Heavy clouds had kept the sun at bay for most of the day, but as I arrived in the small town of Nkob I could see that the sun would eventually drop below the cloud base so I headed to the roof of my hotel and waited. Before long my prediction came true and the old mud buildings of the town were brought to life by magnificent light from the low evening sun.

Camera: Nikon F5 / Lens: 80-200mm /
Film: Fujichrome Velvia 50

ALN ESTUARY, ALNMOUTH, ▷
NORTHUMBERLAND, ENGLAND

Who can resist a great sunset? Not me. When I realized that a fantastic autumn sunset was on the cards just down the street from my house, I grabbed my Lowepro backpack and headed to the edge of the estuary. The colours created when the sun finally set and underlit the clouds were amazing.

Camera: Pentax 67 / Lens: 105mm /
Filters: 0.6ND hard grad / Film: Fujichrome Velvia 50

◁ ARCHES NATIONAL PARK, UTAH, USA

The middle hours of the day are ideal for more graphic landscapes where use is made of strong shapes and bold colours. The bright sunlight was ideal for this scene as it really emphasized the grandeur of the sandstone mountain, and the contrasting splash of yellow in the foreground.

Camera: Mamiya 7II / Lens: 43mm / Filter: Polarizer /
Film: Fujichrome Velvia 50

Tropical scenes also look amazing when the sun is overhead because the harshness of the light bleaches out the sand so beaches appear pristine, and the sea reflects the blue of the sky to give it a stunning deep colour.

EVENING

Once mid-afternoon arrives, things start to improve again. The sun begins its slow descent towards the horizon and as it does the light begins to warm up. Its harshness and intensity are reduced and shadows becomes longer and weaker. Shape and character return to the landscape, and the longer you are willing to wait the better it gets.

Afternoon light is different from morning light. The atmosphere is denser, clogged by heat haze or, in urban areas, pollution, so the blue end of the spectrum is scattered and lost and daylight appears warmer. The last hour before sunset is often referred to as the Golden Hour and for many landscape photographers it's the most photogenic time of day. Long shadows also reveal texture and modelling to give your pictures a much stronger sense of depth.

SUNSET

One thing that cannot be disputed is the beauty of a sunset. When a decent sunset appears likely, I try to get to my chosen location at least 45 minutes before the big event, so I can choose the best viewpoint. With only an hour or so to go it's easy to predict where the sun will eventually set, or it should be if you've been mentally noting the sun's path across the sky through the day. What you shouldn't do is get so wrapped up in waiting for sunset that you miss great opportunities. For this reason, always remember to turn and see what dying rays of the sun are doing to the scene behind you – the golden glow is what has contributed to some of my best shots.

The way in which you photograph the sunset will depend on the type of location you're shooting in, the weather conditions, and what kind of images you have in mind. A classic approach is to shoot into the sun so that anything between the sun and the camera records as a silhouette. This is a good technique when shooting water because the glow of the sun and colour in the sky will be reflected on the water to create a perfect backdrop to silhouettes of boats, islands, piers, and so on.

If you can look at the sun's orb without squinting then you should be able to include it in your pictures without flare becoming a big problem. If the sun is too bright, either exclude it from the composition or wait until it has set. Either way, always take extreme care when shooting the sun through a telephoto or telezoom lens: its intensity could damage your eyesight.

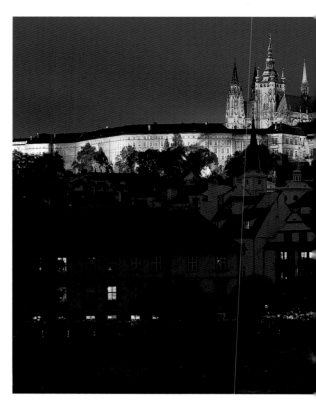

TWILIGHT

Once the sun finally disappears below the horizon, light levels quickly fade and the light on the landscape is again reflected from the sky as it was before the sun came up that morning. If you're lucky there will be a vivid afterglow in the sky, created by the sun as it underlights the clouds above the horizon, but even this will fade quickly, and before long a sense of tranquillity pervades. Colours are muted, the light is soft, shadows fade, and light levels fall away. The pastel colours left in the sky look stunning when reflected in lakes and rivers, or used as a background to silhouettes, while long exposures record movement like the swaying of trees in the breeze, the movement of clouds across the sky, the motion of the sea, or of water flowing in rivers and streams.

The first 30 minutes or so after sunset are usually the most productive, though I will often shoot until there's no colour left in the sky as the light has a surreal effect on the landscape and coastline, and it's interesting to see what happens when exposures of several minutes are used. This period is also the best time to shoot urban scenes. Natural daylight and man-made illumination are in balance so contrast is still manageable. The cool blue of the sky creates a fantastic backdrop to the warmer colours of artificial lighting and there's enough daylight around to prevent shadows from blocking up so you can't see any detail.

△
PRAGUE CASTLE, CZECH REPUBLIC
The crossover period between night and day is the perfect time to photograph urban views as daylight and artificial light sources are in balance and the deep blue of the sky creates a stunning backdrop. If the weather's grey and drab during the day, as it was here, you can rely on twilight to help you create great shots.

Camera: Fuji GX617 / Lens: 180mm / Film: Fujichrome Velvia 50

◁ ### NEAR TARBERT, KINTYRE, SCOTLAND
I love to shoot coastal views at twilight because the combination of muted colours and a long exposure are ideal for bringing out the atmosphere in a scene, as well as recording movement in the sea and sky. This photograph was taken in July at around 10.30pm – probably the latest I have ever photographed in the UK. The twilight just seemed to last forever.

Camera: Pentax 67 / Lens: 55mm / Filters: 0.6ND hard grad / Film: Fujichrome Velvia 50

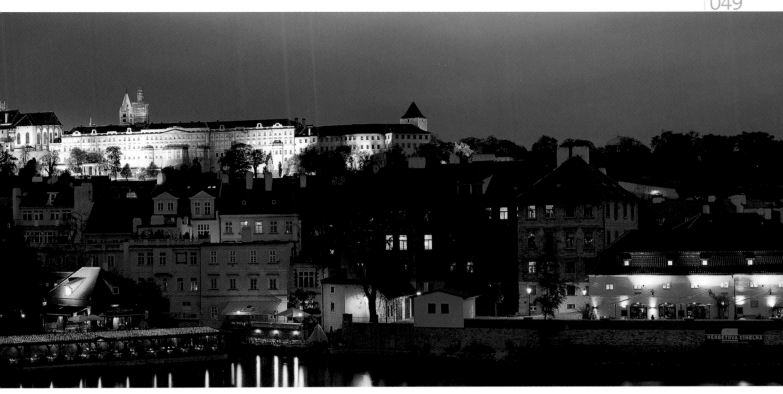

COLOUR TEMPERATURE

The position of the sun in the sky and prevailing weather conditions not only affect the intensity of the light, but its colour balance as well. The light is much warmer at sunrise and sunset, for example, because the sun's rays have to pass through a denser atmosphere when the sun is close to the horizon, and this scatters light at the blue end of the spectrum. At midday on a clear day the atmosphere is thinner, so less of the rays are scattered and the light has a more neutral colour. These variations are referred to using a colour temperature scale, which is measured in Kelvin (k). The warmer the light, the lower its colour temperature, and the cooler the light the higher its temperature – the opposite, in other words, to how temperature is normally expressed.

Our eyes can adapt to changes in the colour temperature of light automatically, so it always looks more or less white – this is known as chromatic adaptation or colour constancy. Unfortunately, photographic film can't, and records light as it really is, warm or cold.

Normal daylight-balanced film is designed to give natural-looking colours in light with a colour temperature around 5500k. In western Europe and the northern USA, this can usually be found between 6am-6pm during summer and 8am-4pm during spring and autumn in clear weather. In winter, colour temperatures rarely exceed 4500k so the light is always slightly warm, though weather conditions often diminish this. If the colour temperature is higher than this, the photographs you take will exhibit a cool colour cast, while if the temperature is lower than 5500k a warm cast is produced. This is why pictures taken without

filters at sunrise and sunset often look warmer than you remembered. The table below lists a variety of different lighting situations and the average colour temperature of each. Also included here are the recommended filters to balance the colour casts produced on daylight-balanced film.Whether or not you try to correct these colour casts is up to you.

I use an 81B or 81C when shooting in shade or overcast weather, to balance the slight coolness in the light that would otherwise show, but when the light is naturally warm I would never dream of trying to cool it down.

CONDITIONS	COLOUR TEMP(K)	FILTER REQUIRED
Open shade under blue sky	10000	Orange 85
Shade under partly cloudy sky	7500	81EF warm-up
Overcast weather	6000	81B warm-up
Average noon daylight	5500	None
Early morn/eve sunlight	3500	Blue 80C
Sunrise/sunset	2000	Blue 80A

HOUND TOR, DARTMOOR, ▷ DEVON, ENGLAND
When working in stormy weather, I try to predict if a break will occur and where the light will strike so that I can set up and wait. This is particularly important when using a large-format camera because it takes so long to set up that if you wait until the sun does break through, chances are it will have disappeared behind cloud again before you're ready to fire. In this case, I managed just two exposures before that happened, but they were all I needed.

Camera: Horseman Woodman 5x4in / Lens: 90mm / Filters: 0.6ND Hard grad / Film: Fujichrome Velvia 50

WEATHER

Although the light changes constantly as the day progresses, it is variations in the weather that create the endless permutations and make landscape photography so challenging and exciting. If every day were the same and the light was predictable much of that challenge would be lost because you could plan every picture down to the last detail. Fortunately, in most parts of the world that's not the case, so landscape photography becomes as much about capturing the effects of weather on the land as about the effects of light on the land.

Clouds have a dramatic effect on the quality of daylight. They soften and dilute it so that the intensity is reduced, contrast falls, and shadows become weaker. Clouds also add interest to a photograph and help you capture a strong sense of place, so never be afraid to make a feature of the sky by tilting your camera up to exclude most of the landscape.

Days when the sky is a veil of grey cloud are probably the least exciting for landscape photography on a grand scale because colours appear dull and muted and a lack of shadows means scenery tends to look rather flat and uninviting. However, overcast light is ideal for capturing details in the landscape, like the patterns and textures in rocks, the smooth shapes and soft colours in sea-worn boulders and pebbles, the rich colours of autumnal foliage, or banks of spring flowers. Strong colours actually look very intense in diffuse light because there's no glare to dilute saturation, and the lower contrast makes such conditions more suitable than bright

PREDICTING THE WEATHER

Watching television weather forecasts is a good way of keeping an eye on possible weather conditions. Radio and shipping forecasts are equally useful, especially if you intend to visit a coastal location. For long-term forecasts and for locations in other regions of the world, check the Internet. If you type the words weather forecast into a search engine, it will come up with links to websites.

Over the years, I've found that, unless rain is predicted for days on end, the best bet is just to go for it regardless of what the forecast says. Most of my landscape photographs are taken during trips of a week or more, so once I've driven 300 miles I've already committed myself, and wouldn't think of turning back if the weather is bad. The most dramatic light for landscape photography tends to occur during periods of so-called bad weather, even if the breaks only last for a few minutes each day. So, if you really want to take the best photographs you must be prepared to wait for those special moments for as long as it takes, no matter how brief they are.

sunlight. The best conditions for landscape photography are created on days when the sky is full of dark, brooding clouds, a strong wind is blowing, and there's the imminent threat of a storm. In such conditions there's a high risk of rain, but equally at some point the sun is likely to break through, producing a spectacular play of light and shade on the landscape. Such weather really keeps you on your toes. The light is constantly changing, and you have to call upon all your skills and experience to capture it. On many occasions I have waited for hours for such a break to occur, only to return empty-handed or to be on the verge of giving up when the storm momentarily subsides and rays of sunlight suddenly break through the sky. The risk and the wait are well worthwhile because when these breaks do occur they always produce dramatic, memorable photographs.

When faced by such changeable weather you need to act quickly because breaks may only last a few seconds before another boiling cloud snuffs out the sun. Getting the exposure right can be tricky because the unusual balance of

BLEA TARN, LAKE DISTRICT, ENGLAND

Variations in the weather are what make the landscape photographer's life exciting. You simply never know from one day to the next what you will encounter. I have visited Blea Tarn on numerous occasions and in each case the pictures are different – one day stormy and dramatic, the next calm and serene. On this still winter morning I was greeted by a frozen tarn and perfect reflections.

Camera: Mamiya 7II / Lens: 43mm / Filters: Polarizer / Film: Fujichrome Velvia 50

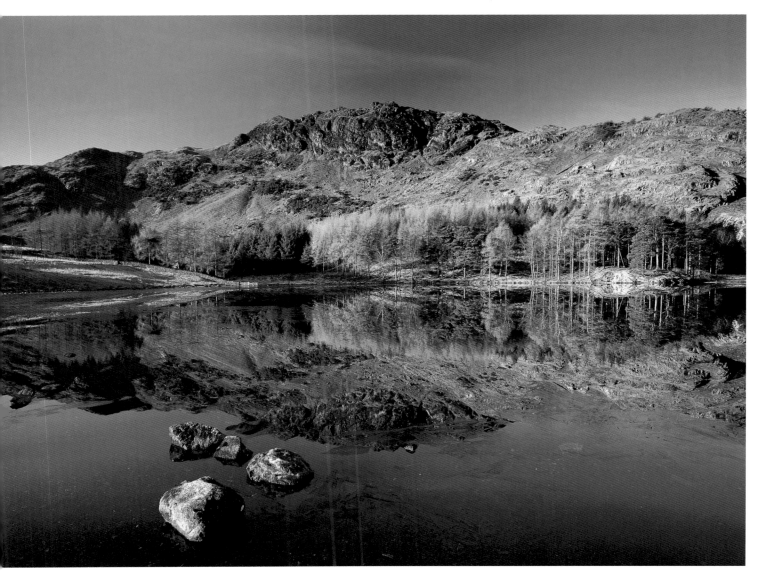

sunlit foreground and dark sky can upset camera meters and give a false reading. To avoid this, take a spot reading from the sunlit foreground with a hand-held meter and use an ND grad to darken the sky and enhance the stormy effect.

LIGHTING DIRECTION

Not only must you consider the overall quality of the light when taking pictures, but also the direction from which it's striking the landscape. This has a profound effect on how much or little texture is revealed, how high contrast is, and how strong the colours appear.

When the sun is behind the camera, this is ideal for revealing detail and colour, but depth and form are lacking because shadows fall away from the camera. Polarizing filters are also less effective because the area of sky where polarization is highest is found at right angles to the sun. The best time to use light from behind the camera is at sunrise and sunset when scenes are bathed in a golden glow and look stunning. With the sun so low in the sky, shadows are long though, and you may have problems keeping your own shadow out of the picture. A far better option is to keep the sun to one side of the camera so light strikes the scene at a right angle. This is particularly effective when the sun is close

to the horizon during the morning and evening as shadows rake across the scene, revealing texture and adding a strong sense of depth to your photographs. Polarizing filters also give the strongest effect on sidelit scenes. The only time side lighting can be a problem is if you include too many shadows in a photograph, which can easily block up in bright conditions. This shouldn't occur when the sun is close to the horizon. The long shadows are weakened by light from above, but care should be taken when determining correct exposure.

Another alternative is to shoot into the light or contre-jour. When the sun is low in the sky the approach can create stunning results. However, it's one of the trickiest lighting techniques in landscape photography.

BAMBURGH CASTLE, NORTHUMBERLAND, ENGLAND
Side lighting is the most effective form of illumination when it comes to revealing texture and form. In this case, I used it to reveal the delicate shape of the ripples in the sand. These carry your eye through the scene to the castle in the distance and give the picture a strong sense of perspective as well as scale.

Camera: Mamiya 7II / Lens: 43mm / Filters: 0.75ND Hard grad / Film: Fujichrome Velvia 50

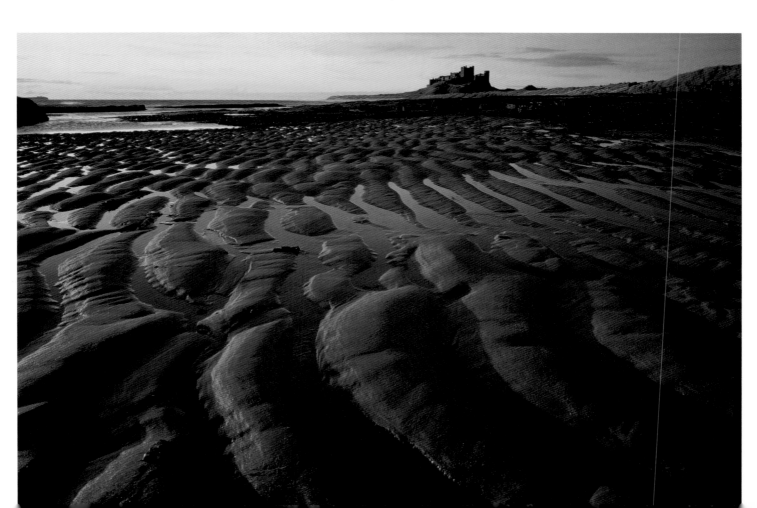

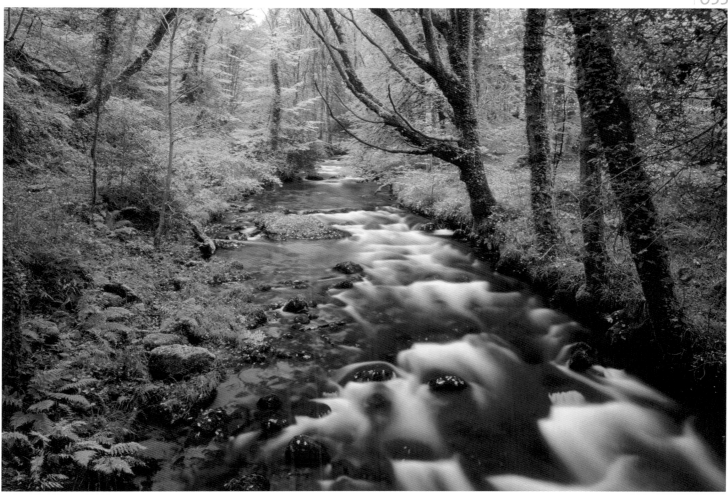

△
CHASE WOODS, BUCKLAND-IN-THE-MOOR, DARTMOOR, DEVON, ENGLAND

On drab, grey days I go in search of woodland or waterfalls. Both benefit from the soft light of overcast weather as it brings out the beautiful rich colours of the foliage while low light levels make long exposures essential and movement can be recorded.

Camera: Horseman Woodman 5x4in / Lens: 90mm / Filters: Polarizer / Film: Fujichrome Velvia 50.

Contrast is maximized and the chance of getting the exposure wrong is increased due to the excessive brightness of the sun and sky. If you rely on your camera's metering system to determine exposure, the reading obtained will be influenced by the brighter parts of the scene. Any solid features such as statues, trees or buildings, will record as striking silhouettes because they're in shadow. This effect can work well at sunset when the golden sky creates a beautiful backdrop. But if you set out to produce silhouettes, be sure to keep the composition simple, otherwise you'll end up with a confusing muddle of overlapping shapes.

To create a striking backlit effect when shooting woodland or misty scenes, simply meter for the shadows so the highlights burn out. If you're not sure where to meter from, take a general TTL reading, and then set the exposure compensation to +2 stops and it will work to reveal shadow detail and also overexpose and blow out the highlights.

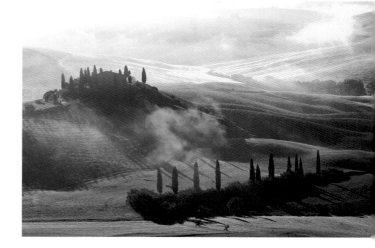

△
BELVEDERE, VAL D'ORCIA, TUSCANY, ITALY

This is the same scene as the one depicted on pages 44–45, but they're worlds apart in terms of mood and atmosphere. I captured this version later in the morning when the sun was still low in the sky and backlighting mist that was still lingering in the valley. Shooting into the sun can produce striking results – but watch out for flare.

Camera: Pentax 67 / Lens: 165mm / Film: Fujichrome Velvia 50

COMPOSITION

If light is the raw material of photography then composition is the glue that holds it together, the foundation on which it stands. For a landscape photograph to be great these two powerful elements must work together with equal force.

Your job is to use them both to your advantage. Daylight cannot be controlled because it's forever changing, but it can be anticipated and predicted, or you can throw yourself at the mercy of the elements and hope that you are justly rewarded. Composition is totally in your control because you decide what to include in a picture and what to exclude.

It's how you do it that counts, how you arrange the elements in a scene in your camera's viewfinder so they form a visually interesting whole. Quite often you will strive to achieve a sense of depth and balance so the final picture offers a realistic, three-dimensional image of the scene you photographed. But this doesn't have to be your goal. Imbalance and tension can work equally well. Discord can be as effective as harmony. Sometimes you will compose in an abstract way, removing all sense of depth and scale so the viewer's senses are challenged. Ultimately, it doesn't matter how you compose a photograph as long as you have planned it with purpose and intent.

Explore a subject from different angles and viewpoints using your lenses to stretch or compress perspective and pull in more than the naked eye can appreciate, or to isolate and magnify. Elements within the scene – shape, line, pattern, colour, scale – can be exploited and following certain 'rules' of composition will set you on the right course and help you to understand how a successful composition can be constructed.

Initially you will find composition frustrating. You know what you want to achieve because you've seen it a thousand times before in the work of other photographers, but somehow when you press your eye to the camera's viewfinder it doesn't quite work. Fortunately, composition can be a learned process – the more you practise, the better you become. That's when you will see a difference. Once composition becomes an instinctive act the battle is won. Here are my top compositional tips to help put you on the road to success.

LINDISFARNE CASTLE, HOLY ISLAND, ▷ NORTHUMBERLAND, ENGLAND

I wanted to emphasize the wonderful shapes in the rocks. I moved in as close as I could to the foreground and used the exaggerated perspective of a wide-angle lens. Using the smallest aperture (f/22) allowed me to record the whole scene in sharp focus, while a polarizing filter deepened the sky and maximized saturation in the rocks and lichens.

Camera: Mamiya 7II / Lens: 43mm / Filters: Polarizer / Film: Fujichrome Velvia 50

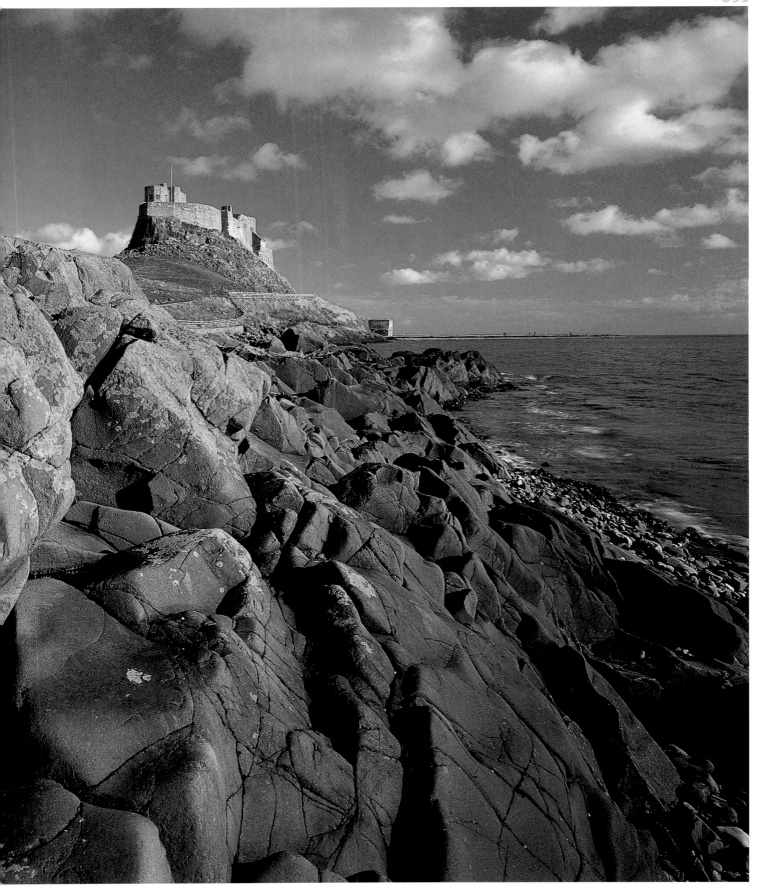

DEPTH

Photographs can only ever have two dimensions – height and width. However, the strongest compositions appear to have three dimensions due to clever use of features in the foreground of the scene to imply depth.

To achieve this, move close to a feature in the foreground of a scene so it appears large in the camera's viewfinder. At the same time, you'll notice that features in the distance such as hills or buildings look very small. Our brain knows that if something small appears big and at the same time something big appears small it must be because there's distance between them, so a strong sense of depth is created. This is known as 'diminishing perspective'. Wide-angle lenses are the best tool for this job because they 'stretch' perspective making the distance between the elements in a scene seem greater than it really is. They also provide extensive depth-

THE WAVE, COYOTE BUTTES, PARIA CANYON, ARIZONA, USA

I was fortunate enough to visit this amazing location in the autumn of 2005, and though I was only there for a few hours, I managed to expose a lot of film. There were so many photographic possibilities, not least among the twists and turns of the eroded sandstone wave where the strata in the rock created colourful lines that took the eye on a fascinating journey through the landscape. I exploited them by using my widest lens and moving in close to the foreground rock.

Camera: Mamiya 7II / Lens: 43mm / Filters: Polarizer / Film: Fujichrome Velvia 50
▽

of-field at small apertures so you can achieve front-to-back sharpness even when the nearest element in less than 1m from the camera.

Pretty much anything can be used as foreground interest – rocks, rivers, gates, walls, fences, trees, moored boats, flower beds, reflections, flowers, people. Features and elements in the scene that create natural or assumed lines work the best as they lead the viewer's eye into the scene.

BALANCE

Achieving a sense of balance in a landscape is important because it makes the photograph easy on the eye and visually stimulating to look at. The easiest way to do this is by using the rule of thirds to divide the frame into an imaginary grid using two horizontal and two vertical lines. This divides the frame in a balanced way. For example, if you're including a focal point, such as a barn in the middle of a field, the best place for it is on one of the four intersection points of the grid so it's kept off centre. I prefer top right or bottom right and find that I instinctively compose in this way.

The rule of thirds is also useful for positioning the horizon, either on the top line of the grid so the sky occupies one-third of the composition and the foreground two-thirds, or on the bottom line of the grid so the sky is emphasized. Either option is generally better than placing the horizon across the centre of the frame, unless you purposely want to create symmetry.

LINES

Natural or man-made lines are one of the most potent tools of composition. Humans are terribly inquisitive, so they can't resist following lines to see where they go. As well as providing a natural route into and through an image, lines can also be used to divide up an image into different areas, or to add a strong graphic element.

The most obvious lines are those created by man-made features such as roads, paths, tracks, bridges, telegraph wires, walls, hedges, fences, and avenues of trees. Shadows can also create strong lines, especially early or late in the day when the sun is low and long, and thin shadows stretch dramatically across the landscape. Natural features such as rivers and streams, although not necessarily straight, have the same effect because as they wind through a scene into the distance, they take your eye on a fascinating journey. Horizontal lines echo the horizon and the force of gravity so they're calm and easy on the eye. Man-made boundaries in the landscape such as walls, fences, and hedges are obvious examples of horizontal lines that help to divide them into definite areas, and shadows can also be used in this way.

Vertical lines are more active, producing dynamic compositions with a stronger sense of direction. Think of the regimented trunks of trees and the soaring walls of skyscrapers. To maximize the effect, shoot in the upright format so the eye has further to travel from the bottom of the frame to the top. Use the bold lines of trees and walls to frame the scene beyond, or fill the frame using a telephoto lens to produce simple, graphic images.

Diagonal lines add depth because they suggest distance and perspective. They also contrast strongly with the horizontal and vertical

△
ENTREVEAUX, PROVENCE, FRANCE
I hurried to this village on my first day in Provence, hoping that I would arrive in time to capture it bathed in evening light. Sadly, I was a little too late and the church tower was pretty much the only thing still in sunlight. However, I quickly realized that this in itself could make the shot because the tower stood out and was the dominant feature in the scene. I decided to place the church tower on the bottom third of the imaginary rule-of-thirds grid. This not only resulted in a logical and balanced composition but also emphasized the scale of the church dwarfed by the towering cliffs rising up behind it.

Camera: Pentax 67 / Lens: 165mm / Filters: Polarizer / Film: Fujichrome Velvia 50

lines that form the borders of an image, and in doing so can create tense, dynamic compositions that catch the eye and hold the attention of the viewer. Because the eyes tend to drift naturally from bottom left to top right, diagonal lines travelling in this direction have the greatest effect, carrying the eyes through an image from the foreground to the background.

Converging lines are the most powerful tool of all. If you stand in the middle of a long, straight road and look down it, you'll notice that as the distance increases, the sides of the road appear to move closer and closer together until they eventually meet at a place in the distance. This is known as the vanishing point, and it creates a strong sense of depth because, although you know the road is the same width along its entire length, the effect of the vanishing point means the road appears to become narrower, and so it must be moving away from the camera.

This converging effect is best emphasized using a wide-angle lens so the lines appear particularly wide apart when close to the camera and then seem to rush away to an imaginary point in the distance. For this type of shot, you should always set a small lens aperture such as f/16 or f/22 to maximize depth of field and record the whole scene in sharp focus.

TINERHIR, MOROCCO
The sense of scale is undeniable in this photograph of the remains of an ancient Kasbah (fortified village) in the Dades Valley of southern Morocco. By shooting in upright format and placing the ruined houses at the very bottom of the frame I was able to emphasize the height of the towering sandstone cliffs and capture the true grandeur of the scene. Without the houses, all sense of scale would have been lost.

Camera: Nikon F5 / Lens: 80-200mm / Film: Fujichrome Velvia 50

SCALE
Another way of implying depth is to include something in a composition that allows us to quantify the scale of a scene. Anything of a recognizable size will work, such as a cottage at the foot of a mountain. Because we have a good idea of the size of these things we can make a direct comparison with other elements in the scene, and determine that the mountain must be enormous because the cottage looks tiny against it. Without this comparative-size recognition we wouldn't be able to determine the scale of the subject and that would mean much of its impact would be lost.

Telephoto lenses are more effective than wide-angle lenses in exploiting scale because they allow you to pull together the features in a scene. This crowding effect also tends to emphasize scale because big elements seem to bear down on smaller ones.

PERSPECTIVE
Another way to create an illusion of depth in your landscape photographs is to exploit aerial perspective, which happens when colour and tone diminish with distance, due to atmospheric haze, mist, or fog. If you gaze across a mountainous scene at sunrise, for example, the mountains closest to the camera will appear darker in colour or tone than those further away. The same applies with trees in mist, or the undulations of a rolling landscape. Telephoto and telezoom lenses are ideal for emphasizing this because they not only compress perspective so the elements in a scene appear closer together but they also allow you to home in on the more distant parts of the scene where the haze or mist is stronger. Aerial perspective can also be implied by use of colour.

CANYON VERDON, PROVENCE, FRANCE
Aerial perspective is demonstrated in this evocative photograph. The further the mountains are away from the camera, the lighter their tone. This effect was enhanced by the haze of the early morning and use of a telezoom lens to compress perspective, so the mountains appear crowded together.

Camera: Nikon F90x / Lens: 80-200mm zoom / Film: Fujichrome Velvia 50

▽

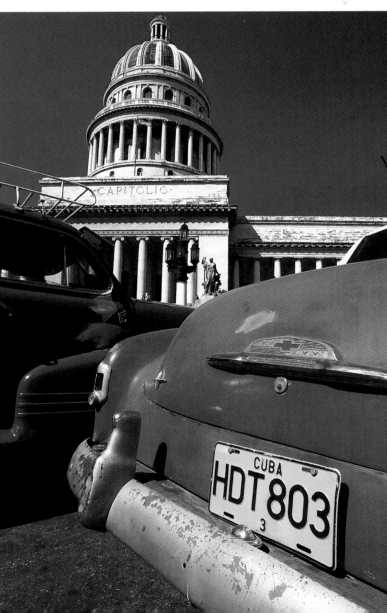

HAVANA, CUBA

Bold, contrasting colours never fail to give a picture impact. Here I made the most of the situation by moving in close to the car and shooting from a low angle so the bright splash of red, the most dominant of all colours, was captured against the deep blue sky.

Camera: Nikon F5 / Lens: 20mm / Filters: Polarizer / Film: Fujichrome Velvia 50

DADES GORGE, NEAR TINERHIR, MOROCCO

In complete contrast to the photograph of the red car, this scene makes use of soft, harmonious colour and diffuse backlighting to create a very tranquil, restful image. Colours that are close together in the spectrum, such as red, orange, and yellow, harmonize. If they're rendered weak enough by the light, your harmony will be achieved no matter what the colour combination.

Camera: Nikon F5 / Lens: 80-200mm / Film: Fujichrome Velvia 50

Cool colours such as blue and green appear to recede, so they make ideal background colours to objects with warmer hues such as red, orange, and yellow, which are then said to advance. You can use this effect by composing photographs with warmer colours in the foreground.

COLOUR

When used creatively colour can lend great aesthetic power to your compositions simply because of the way people respond to it. If you fill the frame with bold, contrasting colours such as blue and yellow, or red and green, you'll immediately produce a picture that's exciting and dynamic to look at. On the other hand, by concentrating on colours that harmonize, such as the beautiful earthy hues in a landscape or an autumnal woodland scene, the result will be far more soothing and restful.

Small patches of colour can work just as well. If you photograph a landscape and there's a hiker in the distance wearing a red anorak, he will dominate the shot and become the main focal point, no matter how small. The same applies with a red postbox on the side of a building, or a red poppy in a field of yellow mustard flowers.

To make the most of bold colours, shoot in sunny or bright overcast weather and use a polarizing filter to reduce glare so colour saturation is increased. Extra impact can also be added by using a wide-angle lens and moving in close so that perspective is distorted and bold splashes of colour can be captured against the deep blue sky.

SYMMETRY

Symmetry is a rare thing in the landscape, simply because the forces of nature have a habit of creating irregularity. However, symmetry can be a strength, resulting in images that have a simplicity and solidity. They are grounded and equal, calm and steady. Symmetrical pictures lend themselves to simpler compositions and often result in restful photographs.

Of course, you don't have to shoot square pictures to achieve symmetry. This can be done in any format just by the way you arrange the elements of a scene in the viewfinder. I tend to find myself doing this more when shooting panoramics than any other format. A classic example is photographing a scene reflected on calm water. Symmetry is created by the mirror image and the most effective way to compose this is by using the line where the land and water meet to divide the picture across the middle. Another example would be a lone tree in the middle of a field. If you drew a vertical line down the middle of the picture, one side would mirror the other. I also like to use symmetry when shooting out to sea, giving the sky and sea equal weight in the composition so the final image is almost abstract in its simplicity.

DETAIL

Sweeping vistas are all well and good, but you don't always need to shoot the whole thing to capture the character of a location or to produce interesting pictures. In fact, the principle of less is more is often a better

TOP LEFT TO RIGHT:
ERG CHEBBI, SAHARA DESERT, MOROCCO
LINDISFARNE (HOLY ISLAND),
NORTHUMBERLAND, ENGLAND
GLEN NEVIS, HIGHLANDS, SCOTLAND
Wherever I am in the world I enjoy looking for interesting details in the landscape, like patterns in nature, textures, shapes, the play of light, and shade. They're there in abundance if you make the effort to look, and isolating them from the bigger picture is great fun.

Camera: Mamiya 7II, Pentax 67, Nikon F5 / Lenses: 150mm, 135mm macro, 80-200mm zoom / Film: Fujichrome Velvia 50

approach because details can be the source of stunning shots. The key is to use your eyes and imagination. Fit a telezoom lens to your camera, then look around for patterns and textures and fill the frame to create simple but effective compositions. Woodland is a great source of patterns, from the repetition of the tree trunks to carpets of fallen autumnal leaves. Rocks also offer amazing patterns and textures, and look for shapes in a scene, like the 'S' bend of a meandering river glowing gold at sunset, a field of poppies swaying in the breeze, ripples in sand, or the crazy paving of a cracked river bed. It's all out there – you just need to learn to look beyond the obvious.

CELEBRATE THE SKY

Landscape photographers often spend so much of their time concentrating on features of the surrounding scenery that the sky above is left to play a minor role. It doesn't have to be this way. The sky can take centre stage and become the dominant feature of the picture.

In deserts and empty, flat landscapes the sky helps define the character of the place, so by exploiting it you can capture a feeling of isolation, scale, and infinite space. But wherever you are, if interesting cloud patterns fill the sky above, it's worth tilting the camera upwards to make a feature of them. Remember that a neutral density grad filter will almost certainly be required to reduce contrast between the sky and land if you want to record detail in the small amount of land that is included. In sunny weather, try a polarizing filter and see what happens. The difference can be help you create a stunning picture literally from nothing just by deepening the blue of the sky and emphasizing the clouds beneath it.

◁ GRASMERE, LAKE DISTRICT, ENGLAND
Whenever I encounter a scene like this, where the landscape is perfectly mirrored in calm water, my instinct is always to compose symmetrically. This results in a static, balanced composition that adds to the sense of tranquillity and calm already present in the scene itself.

Camera: Fuji GX617 / Lens: 90mm / Filters: 0.45ND hard grad and polarizer / Film: Fujichrome Velvia 50

ISOLATE

Selective focusing is a great way to make specific elements in a scene stand out while everything else is thrown well out of focus so they don't compete for attention. To do this you need a combination of a telephoto or telezoom lens, which allows you to home in on interesting features in a scene, plus a wide aperture such as f/2.8 or f/4 so depth of field is minimized and only the point you focus the lens on comes out sharp.

This technique can produce simple, graphic compositions when photographing urban locations, because towns and cities are full of fascinating details. However, it works equally well in the landscape, allowing you to focus attention on natural patterns and textures.

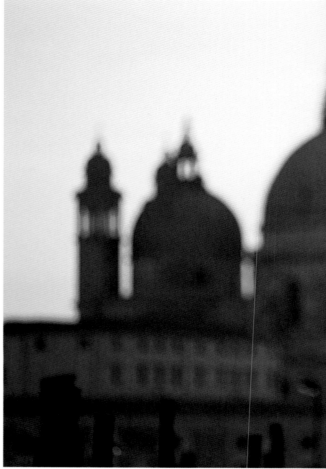

△
VENICE, ITALY
The idea for this shot came when I noticed how the glass in the ornate lantern was backlit by the setting sun. Fitting a telezoom lens to my camera I was able to pull it in much closer, while setting the lens to its widest aperture enabled me to isolate it from the background and create a strong three-dimensional feel.

Camera: Nikon F5 / Lens: 80-200mm / Filters: 81EF warm-up / Film: Fujichrome Velvia 50

SIMPLIFY

The KISS (Keep It Simple, Stupid) method can be applied to landscape photography as much as any subject. There really is no need to overcomplicate a composition just for the sake of it. I see this often among inexperienced photographers. Unsure of what should be included and what should be kept out, they end up producing a cluttered composition that sends out mixed messages and looks a mess. I was guilty of the same mistake myself in the early days when I was searching for my own creative voice. But over time, experience and confidence have taught me the fewer elements you have to deal with, the easier it becomes to organize them in an effective way.

When I am confronted with a beautiful scene, I instinctively begin a process of elimination, identifying not only key elements but also things that can be ignored. It's a process of

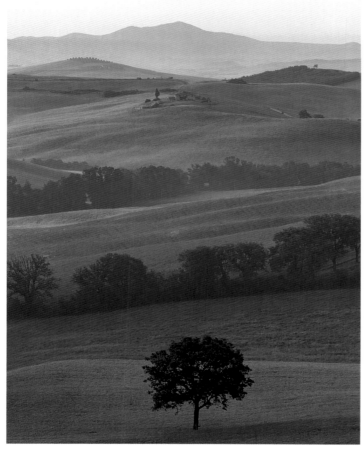

△
VAL D'ORCIA, TUSCANY, ITALY
I have photographed this scene many times. Each is successful in its own way, simply because it offers so much potential for creative expression. What I like about this example is its simplicity. The tree anchors the composition, giving it balance, weight, and scale while the ever-fading layers of the undulating landscape carry your eye across the valley and into the distance. I could have used a wider lens to include more, but on this occasion I didn't feel it was necessary and instead decided to keep my message very simple.

Camera: Pentax 67 / Lens: 200mm / Filters: 0.6ND hard grad / Film: Fujichrome Velvia 50

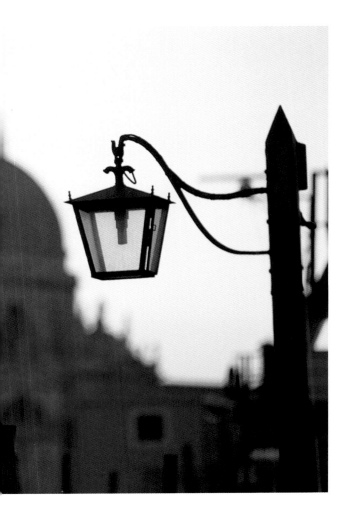

KASBAH TELOUET, NEAR OUARZAZATE, MOROCCO

This photograph was taken completely by chance – but then the most rewarding ones often are. It was late afternoon and the light on the crumbling fortress was perfect, revealing the rich colour of the mud walls. Reaching a dead end as I wandered around the perimeter, I turned to head back and noticed how the main tower was framed perfectly by an old archway. Crouching down low, I was able to capture not only this, but some old exposed timbers overhead silhouetted against the sky. The result is a dynamic, graphic composition that makes good use of colour, shape, light, and shade.

Camera: Nikon F5 / Lens: 20mm / Filters: Polarizer / Film: Fujichrome Velvia 50
▽

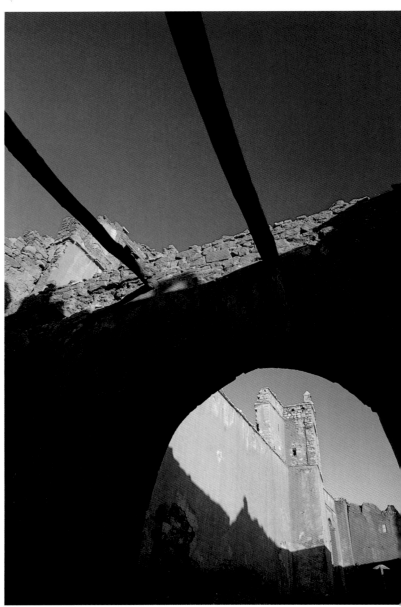

stripping down the landscape until what I'm left with is all I need to produce a successful composition. Often, the final subject matter is far simpler than I first imagined it would be.

FRAME

Another useful way to create an interesting composition is to frame a subject or scene with features close to the camera. An immediate benefit of doing this is helping to direct attention towards the most important part of the picture. You can also use frames to obscure unwanted details or to fill unwanted space that would dilute the impact.

Wide-angle lenses are ideal for emphasizing frames – you can move close to any suitable features and control how much of the image they occupy. If you stand beneath a tree, the branches might frame the top of the photograph, while standing in an archway could frame the top and sides of the image. Setting a small lens aperture such as f/11 or f/16 will provide the depth of field to record the frame and the scene beyond in sharp focus.

If the sun is not behind the camera the frame records as a silhouette, further emphasizing the effect. Because the shade of the frame can fool your camera's metering system, step beyond the shade to take a meter reading or use a spotmeter to read from a part of the scene beyond the frame.

EXPOSURE AND METERING

If light is the raw material of landscape photography and composition the foundation on which it's built, exposure is the cement that holds everything together. Get the quantity just right and you'll have a result that's immensely strong. But get it wrong and your hard work will come tumbling down around your ears.

Modern technology has made taking perfectly exposed pictures simpler than ever, so disasters should be easy to avoid. Not only are the latest metering systems able to analyze a scene and identify potential problems, adjusting the exposure accordingly, but the immediacy of digital imaging also means you can check an image seconds after it has been recorded. If there's a problem with exposure, you can either rectify it on the spot, or in post-production, just as a badly exposed negative can be rescued during printing.

So why dedicate a whole chapter to the subject of exposure and metering when it can be left to the wonders of technology? The reason is because there's more to exposure and metering than simply getting enough light to the film or digital sensor in your camera. How you use the controls that enable exposure has other implications. The lens aperture doesn't just vary the amount of light passing through the lens, but also helps determine how much of the scene will record in sharp focus, the depth of field. Similarly, the shutter speed doesn't just control how long light is allowed to reach the film or sensor, but it also records the natural motion of elements in a scene, like the rushing of a river.

Understanding what's going on when you trip the camera's shutter is also useful because it puts you more firmly in control of the photographic process, instead of relying on a machine, and this inevitably leads to better, more considered work. Cameras are very good at making technical decisions but not creative ones, and when it comes to landscape photography, what's technically a correct exposure isn't necessarily the best exposure for a given situation. Unless you understand how exposure works, you can't use it creatively and put your personal stamp on an image.

I can't remember the last time a photograph was completely lost due to exposure error, because even in the most difficult situations there are ways and means of making sure at least one frame is perfect. The key is to learn from your mistakes. If you find your pictures are badly exposed in certain types of lighting or when photographing the landscape in a certain way, you may need to change the way you meter so the problem doesn't happen again. It doesn't take long to learn the best way to get the sort of results you want from your landscape photography.

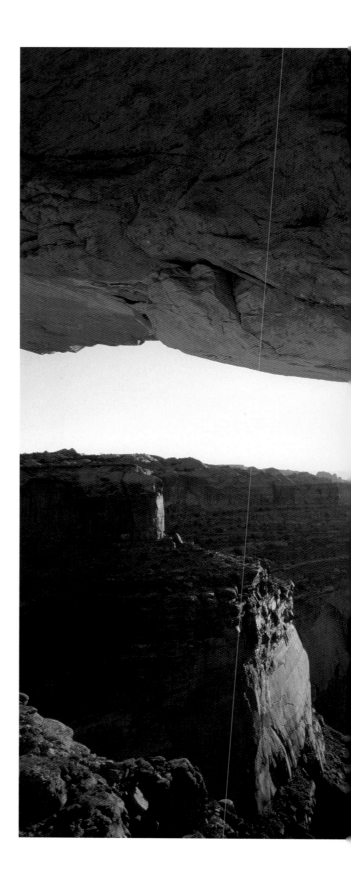

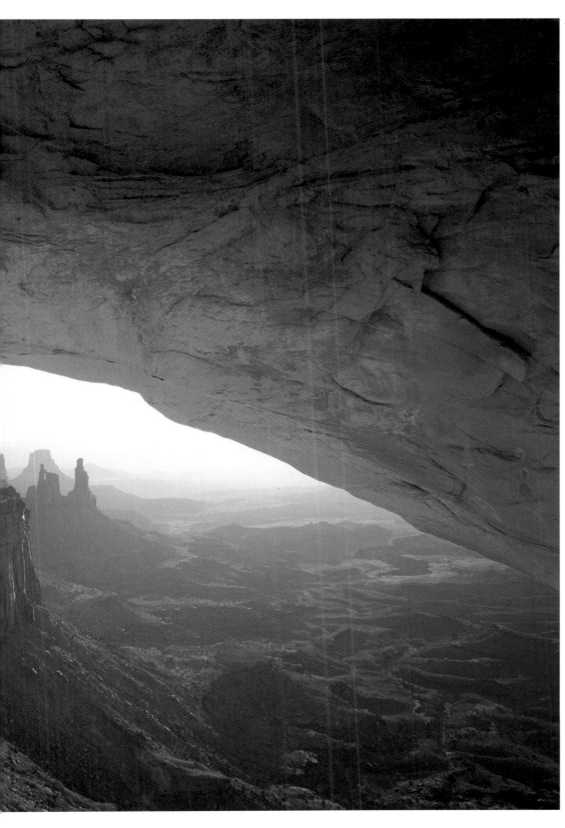

◁ MESA ARCH,
CANYONLANDS,
UTAH, USA

The trickiest scenes to expose tend to
produce the most amazing pictures, so
a thorough understanding of exposure
and metering is vital if opportunities
aren't to be missed. In this case my
job was to find a compromise that
would record the wonderful orange
glow on the underside of the rock arch
(created by light reflecting up from
the sandstone cliffs below) without
burning out the highlights or blocking
up the shadows. Fortunately, enough
light was being bounced around to
keep contrast within a manageable
range. Using a hand-held spotmeter, I
took a reading from the underside of
the arch, increased it by one stop to
compensate for the high reflectance
of the sandstone, and then used the
exposure reading as a starting point.
Unwilling to miss 'the' shot, I did
bracket exposures quite widely too
– it was worth wasting a little film to
ensure I got some frames spot on.

Camera: Mamiya 7II / Lens: 43mm
/ Film: Fujichrome Velvia 50

KISS

Some photographers get a great deal of satisfaction from indulging in complicated metering techniques. They use a hand-held spotmeter to take umpteen exposure readings from different parts of the scene to analyze its brightness range. It's as if it would be impossible to find the correct exposure any other way. I prefer to employ the KISS approach to metering.

If I'm shooting with my Nikon 35mm SLRs I don't ever bother using a hand-held meter, preferring instead to rely on Nikon's superb Matrix metering, a multipattern metering system that I've found to be extremely accurate and reliable. I'm not saying it's totally foolproof, but over the years I've got to know its strengths and weaknesses and I can identify situations where it's likely to struggle and I adjust the exposure accordingly.

I always use the Nikons in Aperture Priority AE mode. This allows me to select the aperture I want to control depth of field while the camera sets the required shutter speed to achieve correct exposure. When exposure compensation is applied to increase or reduce the exposure, the shutter speed is adjusted so the aperture, and depth of field, remain unchanged.

BAMBURGH BEACH, NORTHUMBERLAND, ENGLAND

Sunrise and sunset shots are easy to get right using modern integral metering systems, but less reliable with a hand-held meter. I used one of my Nikon SLRs to determine correct exposure here, tilting it down to exclude the sky, metering from the rocks and sand in the foreground. The exposure was then set manually.

Camera: Mamiya 7II / Lens: 43mm / Filters: 0.6ND hard grad / Film: Fujichrome Velvia 50

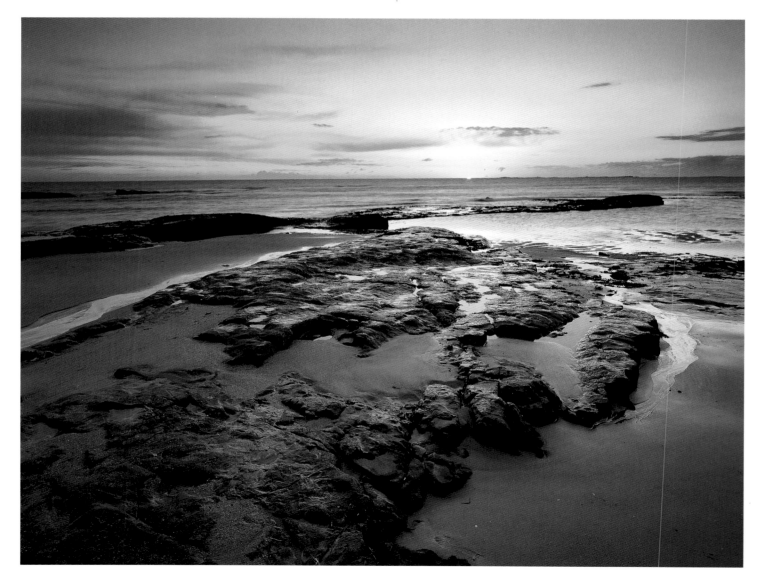

Snow creates one of the most extreme exposure situations because it's highly reflective and can easily upset your camera's integral metering system. One way to avoid problems is by taking a general reading then bracketing exposures up to two stops over the metered exposure in 1/3 or 1/2 stops. Another is to use a hand-held meter to take an direct reading of the light falling onto the scene.

Camera: Pentax 67 / Lens: 55mm / Filters: 0.6ND hard grad / Film: Fujichrome Velvia 50

There's a popular misconception that using your camera in manual exposure mode gives you more control because you have to set both aperture and shutter speed. However, it's a myth. The only time fully manual mode is required is when you're using a hand-held meter to establish correct exposure then transferring the reading to your camera. It's also the best choice if you need to ensure the exposure setting doesn't change once set.

WHAT OF THE OTHER EXPOSURE MODES FOUND ON MODERN FILM AND DIGITAL SLRS?

Well, I'd say avoid Program mode or the fully automatic 'Idiots' mode, often a green square on the mode dial, because it sets both aperture and shutter speed automatically and while this may achieve correct exposure, the aperture may be too wide to provide sufficient depth of field. Some SLRs have a Program Shift function that allows you to change the aperture and shutter speed combination to a smaller aperture (and slower shutter speed), and this gives more depth of field. By the time you've fiddled with this you might as well have set Aperture Priority mode (often marked Av on the exposure-mode dial) so you have control over the aperture and depth of field.

Shutter priority (Tv) mode works in reverse to aperture priority (Av) mode in that you set the shutter speed and the camera sets the aperture. It's just as quick to use as Aperture Priority, but if you need to compensate the exposure you must remember that the aperture will be adjusted and this will change depth of field. Consequently, it offers no real benefit for landscape photography and Aperture Priority is much more suitable.

BACK TO BASICS

The sole purpose of exposure is to get exactly the right amount of light onto a piece of film or digital sensor so an acceptable image is recorded. To do this you have two controls - the shutter speed, which governs how long light is allowed to reach the film or sensor, and the lens aperture, which governs how much light passes through the lens. On modern cameras both of these controls are variable. It's possible to produce a correctly exposed picture in any given situation.

If you set your lens to a wide aperture such as f/2.8 or f/4, a lot of light will pass through it so a fast shutter speed can be used. In other words, you can produce exactly the same exposure using different combinations of aperture and shutter speed – as aperture size is reduced, the shutter speed must be increased and vice versa. For example, if your camera or lightmeter suggests an exposure of 1/30sec at f/8, any of the aperture and shutter speed combinations shown below could be used to give exactly the same exposure.

Lens aperture	f/2.8	f/4	f/5.6	f/8	f/11	f/16	f/22
Shutter speed	1/250	1/125	1/60	1/30	1/15	1/8	1/4

In landscape photography, the aperture (f/number) is generally given priority over shutter speed because it's the aperture than helps determine depth-of-field, or how much of the scene is recorded in sharp focus. As front-to-back sharpness is usually required, a small aperture (large f/number) is set, such as f/16 or f/22, and as you can see from the chart above, this means the shutter speed will be slow, which is why I advocate the use of a tripod when shooting landscapes. This way you can work at small aperture to maximize depth-of-field without the risk of camera shake caused by the accompanying slow shutter speed. A small aperture and corresponding slow shutter speed can also be used to capture motion, usually of moving water.

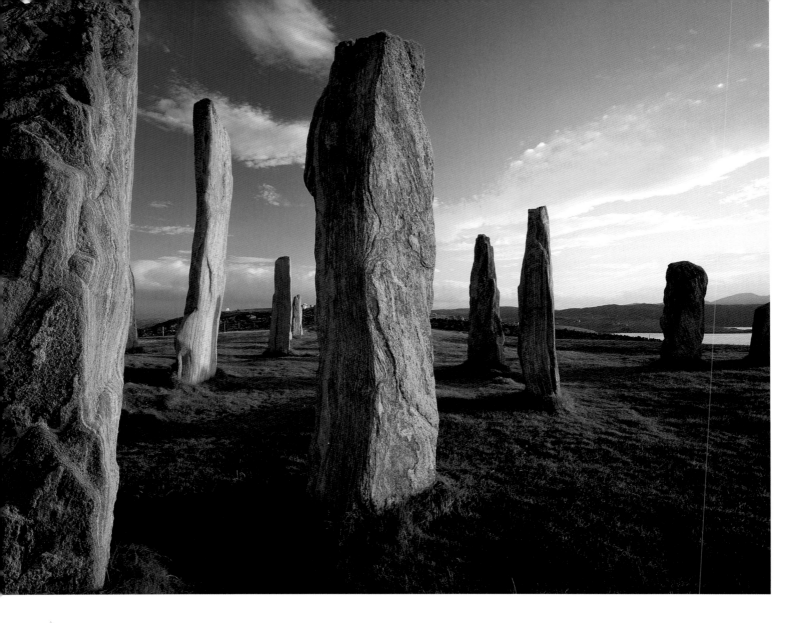

STANDING STONES OF CALLANISH, ISLE OF LEWIS, OUTER HEBRIDES, SCOTLAND

Care must be taken when metering for side-lit scenes – there's a danger of underexposure. Here I used a hand-held lightmeter to take an incident reading of the light failing on the stones, holding the meter so that the invercone was angled midway between the position of the sun over to my right and the camera itself. The exposure used was ideal for bringing out the rich texture and colour of the stones bathed in evening sunlight.

Camera: Mamiya 7II / Lens: 43mm / Filters: Polarizer / Film: Fujichrome Velvia 50

As well as relying on the Matrix metering of my Nikon SLRs when I'm shooting 35mm landscapes, sometimes I even use the F90x purely to use as a lightmeter when working with my Mamiya 7II and Fuji GX617 kits. When shooting into the light at dawn and dusk, for example, I feel more comfortable metering with the Nikon, simply because it's much more sophisticated than a hand-held meter. It measures light levels in different parts of the frame and then analyzes them to come up with an

ideal exposure. I'm more than capable of doing this myself with a hand-held spotmeter, but using the Nikon is quicker and easier.

In summary, then, I would say if you own a modern camera with sophisticated TTL (through-the-lens) metering, don't feel compelled to rush out and buy a fancy hand-held meter. Instead, make the most of the sophistication you already have, because once you know it, you'll never need anything else.

HOW METERING SYSTEMS WORK

If you want to make the most of your camera's integral metering system you need to understand how it works. This, in turn, will help you appreciate and understand why it isn't foolproof.

There are two factors that come into play here. Firstly, all camera meters measure reflected light, which is the light bouncing back off of a subject or scene. Secondly, they're calibrated to correctly expose scenes that reflect roughly 18 per cent of the light falling onto them. These are known as average scenes and in visual terms, 18 per cent reflectance can be

represented by a mid-grey colour, known as 18 per cent grey.

Most of the landscapes you photograph will fall into this category in that they comprise a general mixture of colours and tones rather than having a predominance of light or dark tones, something you should be able to determine just by looking.However, once you encounter scenery that doesn't comply with some or all of these factors, your camera's integral metering system can no longer be relied on to give an accurate exposure reading and you need to ensure exposure error doesn't occur.

Underexposure is the biggest threat in landscape photography, simply because your subject matter often includes areas of extreme brightness or high reflectance. For example, if you include lots of sky in a picture or shoot into the sun, the reflectance of the scene will be pushed much higher than 18 per cent by the brighter areas, but your camera still treats it as 'average' and underexposure results, with the landscape coming out too dark. The same applies when photographing snowy scenes. Snow is considerably brighter than an average midtone such as green grass, so if you rely on your camera's metering system to determine the exposure

LOCH BA', RANNOCH MOOR, SCOTLAND

The muted colours and high-key tones are what makes this photograph, so to ensure I captured them exactly right I bracketed exposures. I used the integral metering system of my camera to take a reflected reading, knowing that the light tones would probably cause underexposure. I used the reading obtained from my first frame, then took several more shots, increasing the exposure by 1/3stop until I was two stops over the initial exposure. I knew the last couple of frames would probably be blown out, but it was worth sacrificing a little film to get this result.

Camera: Fuji GX617 / Lens: 90mm / Filters: 0.3 centre ND and 0.45ND hard grad / Film: Fujichrome Velvia 50

▽

BRACKETING

One way to guarantee that you produce a perfectly exposed image is by using a technique known as bracketing, which involves taking pictures at the metered exposure, then others at exposures over and under it as a safety net. You can do this using your camera's Autobracketing (AEB) function if it has one. However, I prefer the Exposure Compensation facility as it's more flexible. Modern SLRs usually allow you to select up to +/- 5 stops in 1/3 or _ and full stop increments. You can also choose to bracket exposures just one way – either under or over the metered exposure. As underexposure is far more likely when shooting landscapes, I usually set a + amount.

How much? That depends on the situation you're facing and also the medium you're working with. Color negative film is very tolerant to exposure error and can still give an acceptable print when over or underexposed by two or three stops, so bracketing in full stop increments is fine. Color transparency film requires greater accuracy, so I bracket in 1/3 stops. Applying the bracket in 1/3 stops is easy with an automated SLR because you can use the Exposure Compensation facility and usually adjust both aperture and shutter speed in 1/3 stops.

With a fully manual camera it's more complicated because you have to use the increments of adjustment that are available. For example, with my Fuji GX617 I can only adjust the exposure time in full stops whereas the aperture can be adjusted in 1/3 stops. So, to increase the exposure by 1/3 stop I must open-up the aperture by 1/3stop and leave the shutter speed alone. The same applies when applying +2/3stop – it's done on the lens. If I need to apply a full stop of compensation then I can do it via the shutter speed, setting 1/2sec instead of 1/4sec, say.

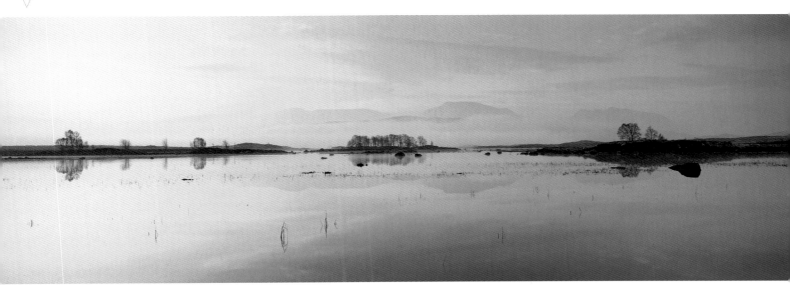

NEAR LOUGHRIGG TARN, ▷
LAKE DISTRICT, CUMBRIA, ENGLAND
Silhouettes are the result of underexposure caused by a
bright background overinfluencing the exposure so any
solid features come out black. I simply switched to aperture
priority mode and fired away, no bracketing required.

Camera: Mamiya 7II / Lens: 43mm / Filters: Polarizer /
Film: Fujichrome Velvia 50

required it will underexpose by up to two stops, recording the snow as grey rather than white.

Overexposure is less common in landscape photography, but this does not mean it cannot occur. If you're photographing a scene where sunlight is picking out a distant building or hill but everything else is in semi-shade, your camera's metering system will set an exposure for the predominant tones in the scene, the darker tones, and overexpose the sunlit area, completely ruining the beautiful effect of the light.

AVOIDING EXPOSURE ERROR

The key to ensuring your landscapes are correctly exposed at all times is to learn to recognize situations where exposure error is likely to occur. Then, you can give your camera's metering system a helping hand.

When I'm working with my Nikons, I set them to Matrix Metering and Aperture Priority and take a reading using the TTL metering system. If I decide that the scene is likely to cause exposure error I adjust the exposure accordingly, using the camera's exposure compensation facility.

If I'm shooting in a desert environment in bright sun, I know that the high reflectance of the sand in the dunes will cause underexposure. I tend to start shooting with the exposure compensation set to +1 stop to avoid error and film wastage. The same applies when shooting tropical beach scenes in full sun, or shooting into the sun at dawn and dusk.

I tend to meter with filters on the lens so any light loss is compensated for automatically. This even includes neutral density (ND) grad filters. In the days of simple, centre-weighted metering, metering with a graduated filter on the lens would probably have led to overexposure. Because modern metering systems take and compare numerous light readings from around the frame, they can produce accurate exposures even with a grad filter on the lens. In theory the grad should actually make it even easier for the camera to achieve correct exposure. Tt reduces the amount of light reaching the metering system from the sky and so lowers contrast.

LOWER ANTELOPE CANYON,
NEAR PAGE, ARIZONA, USA
When light levels are low and exposure long, reciprocity
failure can cause underexposure, so it's vital that you bracket
exposures at least one stop over what you think is 'correct'.

Camera: Fuji GX617 (cropped) / Lens: 90mm / Filters: 0.3
centre ND / Film: Fujichrome Velvia 50
▽

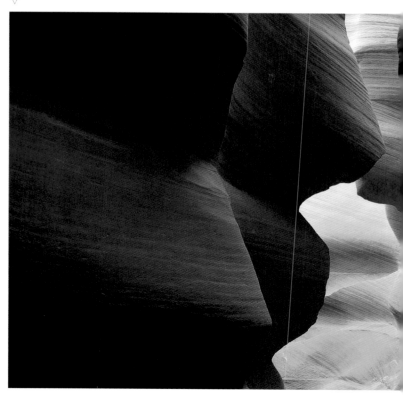

USING A HAND-HELD METER

When I'm working with cameras that either lack any kind of integral metering or have basic (and so unreliable) metering, I usually carry a Pentax digital spotmeter as well as a Minolta Autometer IVF.

The Minolta IVF is designed mainly to measure incident light – the light falling onto the subject – so it isn't influenced by high reflectance. This makes it ideal when shooting snow scenes, or other highly reflective subjects such as beaches or sand dunes. I also enjoy photographing the stark whitewashed architecture of the Greek Islands and Mediterranean. An incident lightmeter is ideal for this, whereas a reflected meter would undoubtedly give underexposure, even the reliable Matrix metering of my Nikons couldn't be trusted.

To take an incident reading, all you have to do is hold the meter in the same light that's falling on your subject. With landscapes I do this simply by holding the meter above my head so the white 'invercone' or metering dome pointing behind me.

When the sun is at right-angles to the camera I also take a reading with the invercone pointing towards the sun so I can compare the two. I know that the reading taken with the invercone towards the sun will be the minimum exposure required while the reading taken with the invercone pointing behind me will be the maximum exposure required. If I'm not sure which extreme – or something in between – will give the best result, I bracket exposures to cover all bases.

An incident meter falls short when you're shooting into the light or the light is patchy and uneven because to obtain an accurate reading the meter must be held in the light you want to expose for – not so easy when it's falling on a distant hill and you're in shade. In these situations, a spotmeter is much more suitable because you can use it to meter from a very small area (the metering angle of my Pentax spotmeter is just 1 per cent) and prevent others areas that are lighter or darker causing exposure error. In stormy weather, for example, a spotmeter can be used to meter from the sunlight foreground, even if you're in shade, or a sunlit area in the distance. I also use it to isolate a midtone in the scene, such as green grass, and base the exposure for the whole shot on the reading obtained.

The main thing to remember about spotmeters is that they measure reflected light and they're also calibrated for 18 per cent reflectance, just like your camera's meter. So in order to obtain an accurate exposure reading you must meter from a midtone in the scene with roughly 18 per cent reflectance.

It's usually quite straightforward to identify a midtone in the landscape. Things like well lit foliage and green grass and blue sky have roughly 18 per cent reflectance, as do weathered building materials, such as wood, brick, and stone. Where there is none, choose something close, then adjust the exposure. For example, when shooting in deserts I often take a spot reading from the sand and then increase the exposure by one stop.

RECIPROCITY LAW FAILURE

Reciprocity is the relationship between shutter speeds and apertures which allows you to control the amount of light reaching the film – 1/60 second at f/2.8, 1/30 second at f/4, 1/15 second at f/5.6, 1/8 second at f/8 and 1/4 second at f/11 are all the same in exposure terms. Unfortunately, once you start using exposures longer than one second this reciprocal relationship begins to break down, film becomes less sensitive to light and you need to increase the exposure over what your lightmeter says is correct.

As a rule of thumb, if your lightmeter suggests an exposure of 1 second, increase it by 1/2 stop, if it suggests 10 seconds increase it by 1 stop, and if it suggests 40 seconds increase it by 2 stops. I find that this simple approach works well, though I always bracket exposures. For example, if the metered exposure is 4 seconds I would shoot a sequence of frames at 4, 6 and 8 seconds as a minimum.

Color casts are also a side effect of reciprocity failure. While these casts can be corrected with compensating filters, I find that they usually improve the image rather than spoil it, so I rarely bother.

DEPTH OF FIELD

Picture the scene. You're out in the countryside, about to photograph the most breathtaking landscape you've ever seen. The light's fantastic, your composition is perfect, and a meter reading has been taken to determine correct exposure. All you have to do now is focus and fire. Just one snag: where, exactly, do you focus the lens when shooting landscapes to ensure that everything in the scene is recorded in sharp focus?

For many, the answer is to stop the lens down to f/22, focus on infinity and hope that such a small aperture will provide sufficient depth of field to achieve front-to-back sharpness. However, using such a hit-and-miss approach suggests that they don't know how to assess depth of field properly, so they won't know if everything is sharply focused until they see the end result, by which time it's usually too late. If you want to eliminate this risk, and guarantee front-to-back sharpness, it's essential to take control of depth of field.

KNOW YOUR DEPTH

In practice, the combination of f/22 aperture and an infinity focus often work perfectly well, especially when using wide-angle lenses, which provide reliable depth of field at small apertures.

If you stop a 28mm lens down to f/22 and focus on infinity, everything in the scene will record in sharp focus from roughly 1m to infinity. With a 24mm lens at f/22 and infinity, depth of field will extend from around 0.7m to infinity, and a 20mm lens stopped down to f/22 and focused on infinity will record everything in sharp focus from just 50cm to infinity. The problems begin when you want to include something that is closer than the aperture/focal length combination allows, because you'll end up with a foreground that is out of focus.

This is more likely to happen with standard or telephoto lenses because they give far less depth of field compared with wide-angle lenses, even at minimum aperture. A 135mm lens (or zoom set to 135mm) focused on infinity and stopped down to f/22 will record everything in sharp focus from around 23m to infinity, for example. With a 200mm at f/22 and infinity this is changes to 50m to infinity, and with a 300mm telephoto becomes 110m to infinity. The chance of including something in a composition that's closer than these distances is clearly high.

Stopping down to f/22 for every shot also has technical drawbacks. Firstly, it means you'll need to use longer exposures, making a tripod essential even in bright sunlight if you're working at a low ISO and using a polarizer. Secondly, lenses tend to give their poorest optical performance at minimum aperture, with the sharpest results obtained around f/8-11. Fortunately, there are two easy ways of overcoming this problem.

DEPTH OF FIELD BACK TO BASICS

Whenever you take a picture, an area extending in front of and behind the point of focus will be sharp. This area is known as the depth of field, and three factors determine how deep it is.

1. THE APERTURE SET ON THE LENS

The smaller the lens aperture, and the bigger the f/number, the greater the depth of field. An aperture of f/8 means more of the scene is in sharp focus than if you use a larger aperture such as f/2.8 or f/4.

2. THE FOCAL LENGTH OF THAT LENS

The shorter the focal length, and the wider the lens, the greater the depth of field at any given aperture. A 28mm wide-angle lens will give far more depth of field at f/8 than a 50mm lens set to f/8, but a 50mm lens set to f/8 will give greater depth of field than a 300mm lens set to f/8.

3. THE FOCUSING DISTANCE

The farther away the main point of focus is from the camera, the greater the depth of field must be for any given lens and aperture setting. If you use a 50mm lens set to f/8, depth of field will be greater if you focus that lens on lom than it will focused on lm.

To check depth of field you can use your camera's stop-down preview facility. Most SLRs have this, but not compact cameras. When activated, it stops the lens down to the aperture it is set to and by looking through the viewfinder you can then get a fair indication of what will and won't be in focus. With such small apertures as f/16 and f/22 the viewfinder image goes quite dark and you need to keep your eye to the viewfinder for quite a while until it adjusts and the image is clearly visible.

◁COUPALL FALLS, GLEN ETIVE, HIGHLAND, SCOTLAND
Being able to control and maximize depth of field is crucial when shooting landscapes, as you need to be sure that everything is recorded in sharp focus, from the immediate foreground to infinity. In this case, the waterfall in the foreground was no more than 1m from the camera, but by using hyperfocal focusing and stopping the lens down to f/22 I was able to achieve sufficient depth of field.

Camera: Mamiya 7II / Lens: 43mm / Filters: Polarizer / Film: Fujichrome Velvia 50

HYPERFOCAL FOCUSING

The most popular method of maximizing depth of field is to use a technique known as hyperfocal focusing.

1. If you look at a typical lens barrel you'll see that either side of the main focusing index there is a series of f/numbers. This is the lens's depth-of-field scale.

2. To maximize depth of field, focus the lens on infinity then check the depth-of-field scale to see what the nearest point of sharp focus will be at the aperture set – the distance opposite the relevant f/number on the scale. This is the hyperfocal distance. In the picture below, of a 43mm lens for my Mamiya 7II camera, you can see that at f/16 with focus set at infinity, the hyperfocal distance is just under 2m, so with the lens focused on infinity, depth-of-field will extend from around 2m to infinity.

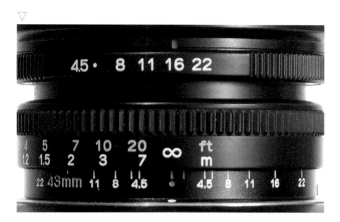

3. By refocusing the lens on the hyperfocal distance, depth of field will extend from half the hyperfocal distance to infinity, so you can achieve greater depth of field and ensure features close to the camera will record in sharp focus. In this case, increasing depth of field from 2m–infinity to 1m–infinity makes a huge difference when it comes to emphasizing foreground interest.

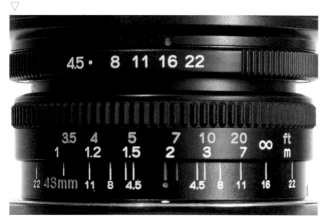

Having refocused the lens on the hyperfocal distance, if you're using an SLR camera and you peer through the viewfinder, pretty much everything you see will appear to be blurred. Ignore this. The final shot will be sharp from front to back because the lens only stops down to the taking aperture at the moment of exposure, and that's when the extensive depth of field is achieved. I use this technique all the time when shooting with medium-format equipment because the cameras I use (Mamiya 7II and Fuji GX617) are rangefinder models rather than SLRs with through-the-lens viewing so the only way to control, assess, and maximize depth of field is by using the depth-of-field scales on the lenses.

CALCULATING HYPERFOCAL DISTANCE

Unfortunately, the majority of photographers use autofocus zoom lenses these days and they tend to lack a depth-of-field scale, making the hyperfocal focusing technique outlined above impractical. If this sounds like you, a more reliable method is to calculate the hyperfocal distance using this simple equation:

Hyperfocal distance = F (squared)/(fxc) where:
F= lens focal length in mm
f= lens aperture used, eg f/16
c= Circle of confusion (a constant value is used for Circle of confusion - 0.036 for 35mm format lenses and 0.127 for medium-format)

For example, if you're using a 28mm lens set to f/16, the hyperfocal distance is 28 squared/(16 x 0.036)
= 784/0.576
= 1.361m, rounded up to 1.4m

By focusing the lens on roughly 1.4m, depth of field will extend from half that distance (0.7m) to infinity. This is too fiddly to do every time you take a picture, of course, so to save you the bother, here's a table I prepared with the hyperfocal distances for lenses from 17–200mm and apertures from f/8 to f/32. These values apply for zoom lenses set to the relevant focal lengths, as well as prime (fixed focal length) lenses.

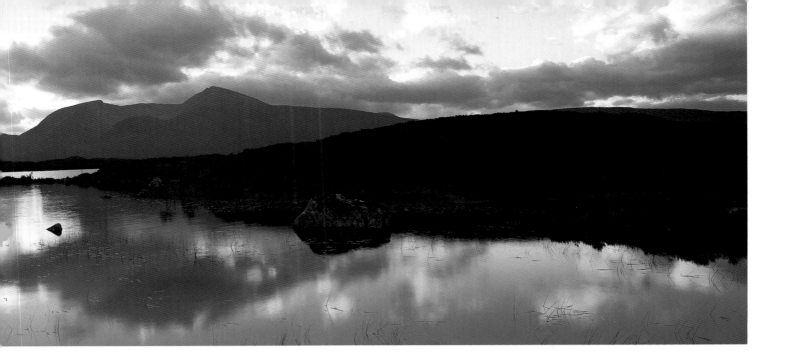

Aperture (F/stop)	Lens focal length (mm)								
	17mm	20mm	24mm	28mm	35mm	50mm	70mm	100mm	200mm
f/8	1.0m	1.4m	2.0m	2.8m	4.2m	8.5m	17m	35m	140m
f/11	0.75m	1m	1.5m	2m	3m	6.3m	12.3m	25m	100m
f/16	0.5m	0.7m	1m	1.4m	2.1m	4.3m	8.5m	17.5m	70m
f/22	0.35m	0.5m	0.7m	1m	1.5m	3.1m	6.2m	12.5m	50m
f/32	0.25m	0.35m	0.5m	0.7m	1m	2.2m	4.2m	8.5m	35m

△

LOCH BA', RANNOCH MOOR, SCOTLAND

The bigger the film format, the less depth of field, so when I use my Fuji GX617 panoramic camera I need to stop the lens down to much smaller apertures than normal to guarantee front-to-back sharpness. The 90mm lens used for this shot has a minimum aperture of f/45, giving depth of field from 1.5m–infinity if I also focus the lens on the hyperfocal distance and allow for slight innacuracy of the scales.

Camera: Fuji GX617 / Lens: 90mm / Filters: 0.3 centre ND and 0.45 ND hard grad / Film: Fujichrome Velvia 50

To use the chart find the focal length you're using along the top, the aperture you want to use down the side, then read across to find the hyperfocal distance.

For example, if you're using a 24mm lens set to f/22, the hyperfocal distance is 0.7m. By focusing the lens on 0.7m, depth-of-field will extend from half the hyperfocal distance (0.35m) to infinity.

To check this is sufficient, focus on the nearest point you want to include in the picture then look at the distance scale on the lens barrel to see how far away that point is. If it's more than the nearest point of sharp focus you've just determined, you can fire away, safe in the knowledge that you will achieve front-to-back sharpness. If it's less than the nearest point of sharp focus, there's a danger that the immediate foreground won't be sharp, so refer back to the table and stop your lens down to a smaller aperture.

This probably sounds very complicated right now, but if you read through the information several times, and refer to the table while handling your lenses, it will soon become clear and you will never again take a landscape picture that suffers from fuzzy foreground. Even better, why not copy the table, then slip it into a clear plastic wallet so you can refer to it in the field?

If you use a digital SLR with a DX-sensor, the focal length you need to refer to on the chart is the focal length after you have applied the calculation. For example, if you use a 17mm lens with a DX SLR its effective focal length is roughly 1.5x that – around 24mm – so you need to use the hyperfocal distances listed for a 24mm lens, not 17mm.

Also, the hyperfocal distances only apply for 35mm format lenses so if you're using a medium-format camera you need to recalculate them using a constant value of 0.127 for circle-of-confusion, not 0.036.

SCALE ACCURACY

Although depth of field and distance scales are an invaluable aid to maximizing depth of field, what you need to be aware of is that they are rarely 100% accurate, so if you trust them to the letter, problems are likely to occur. I realized this when I first started to use the hyperfocal focusing technique and found to my horror that the most distant parts of the scene often appeared out of focus when the transparencies were scrutinized with a magnifier.

This occurred because I focused the lens so the infinity marker on the distance scale fell opposite the f/number on the depth of field scale that matched the aperture I was shooting at. So if I was shooting at f/16, I would focus the lens so the infinity symbol was opposite f/16 on the depth of field scale. But because the depth of field scale wasn't completely accurate, the parts of the scene at infinity came out unsharp.

To avoid this you must focus the lens so that the infinity symbol on the barrel is set to a point that's at least half a stop wider than the aperture you intend to shoot at. For example, if I want to shoot at f/22, I focus the lens so that the infinity symbol is either between f/16 and f/22 on the depth of field scale or, in some cases, opposite f/16 to be completely sure that the distant parts of the scene will be recorded in sharp focus. The key is to conduct tests with your lenses and see how accurate the scales are.

THE WILD LANDSCAPE

I've always been fond of wild places. As a child I would daydream about rafting down wild rivers or crossing uninhabited wilderness. As a keen Boy Scout I spent days backpacking in Lakeland fells, trekking across desolate moorland in North Yorkshire or simply heading out on long walks in foul weather. I began to look at my surroundings more closely and marvelled at the beauty and grandeur of the landscape, and the way light, weather, and seasons had such a dramatic effect on its mood.

It was this love of the great outdoors that prompted me to pick up a camera and start photographing the landscape when I was 15 years old. And it's no surprise that my first good landscapes were taken on the windswept uplands of Dartmoor not many years later; dark, dramatic images that captured light and weather at its most extreme.

In more recent years the wild north of Scotland has become a destination I return to again and again. It is perhaps the last place in the United Kingdom where you really do feel that you're in the middle of nowhere. The bleak, barren islands of Harris and Lewis hold similar appeal, while further south, the Cheviot Hills of Northumberland and the mountains and valleys of north Wales are never short of drama.

For me it isn't so much the scale or isolation that makes it wild, but the nature of the landscape. Rannoch Moor is a good example of this. It is a mysterious maze of bogs and lochains that can feel like the most desolate place on Earth and yet some of the most magnificent views of it are photographed from the side of the busy A82 trunk road, where trucks thunder pass at such speed that the rush of wind they leave in their wake is strong enough to topple the heaviest tripod.

WEATHER OR NOT

Prevailing weather conditions also play an important role. On a sunny days with blue skies, even the most rugged terrain will appear serene and welcoming, and capturing its true character is impossible because everywhere looks like a picture-postcard scene rather than dramatic and untamed. But when the sky is a boiling mass of dark storm clouds that look intent on releasing their fury at any moment, a strong wind is blowing, and the sun gives signs of breaking, it's a different story and any location seems wild and threatening.

△
RANNOCH MOOR,
HIGHLANDS, SCOTLAND
Although dramatic shafts of sunlight undoubtedly bring a rugged scene to life, it is still possible take successful photographs without them. In this case the much-desired break seemed unlikely, but soft light did a great job of revealing the colours and textures in the foreground while the boulder and dead tree trunk added character to the composition and created a sense of depth and scale.

Camera: Fuji GX617 / Lens: 90mm /
Filters: 0.3 centre ND and 0.6ND hard grad /
Film: Fujichrome Velvia 50

I'm in my element in such conditions. In that 'calm before the storm' period a sense of foreboding descends and the whole of nature seems to stop what it's doing, take a slow look around, and decide whether to stay put or head for cover. The tension is tangible. Hang around in these conditions and a soaking could be on the cards. But equally, the sun may break through and illuminate the landscape before you, creating perhaps the most dramatic lighting conditions you're ever likely to see. I've taken the easy option on more than one occasion and regretted it dearly when, minutes later, the storm suddenly breaks. Equally, I've been driving along, quietly minding my own business, when the signs are suddenly there that something good may happen and I've immediately changed tack, found somewhere to park, and set up my camera.

That's the one frustrating thing about stormy weather. You simply can't predict the outcome. Instead, you have to weigh up the odds and make a decision. Stay or go?

One thing's for certain, though. The photographers who produce the most dramatic landscapes are those who would rather pull on an extra layer of clothing and take the risk, not the ones who run for cover at the first sign of rain or cancel a trip if the weather forecast looks dodgy. The fact is, fair weather doesn't produce wild landscapes and fair-weather photographers miss the best light. Simple as that!

◁LOCHAIN NA H'ACHLAISE, RANNOCH MOOR, HIGHLANDS, SCOTLAND

This view over Lochain Na h'Achlaise towards the Black Mount Hills captures the rugged beauty of Rannoch Moor like no other, and has become something of an iconic scene over the years. I have photographed it on numerous occasions, but this dawn shot, captured in April, is the one I like best. There's still snow on the distant mountains – a dusting on the tops isn't uncommon as late as July – the calm lochain is revealing perfect reflections, and the light has a sublime beauty to it that no filter could ever hope to replicate. I have never seen it like this before and I'm unlikely to see it like this again.

Camera: Fuji GX617 / Lens: 80mm / Filters: 0.3 centre ND and 0.45ND hard grad / Film: Fujichrome Velvia 50

◁COMBESTONE TOR, DARTMOOR, DEVON

Dartmoor is one of my favourite 'wild' regions in the UK. Vast tracts of desolate moorland are peppered with dramatic granite tors and prehistoric relics, and on the higher reaches the wind blows so hard trees grow leaning to one side. This photograph was taken at sunrise on a blustery autumn day. It was one of those days that made me wonder if the light would ever come but the probability was high enough to make me stay for a while. Adopting an optimistic view, I set up my camera and tripod and composed this scene, using the big slabs of granite as foreground interest. Then it was simply a case of waiting and hoping, and after 20 minutes my luck was in. Raking sunlight burst through the clouds and brought the scene to life.

Camera: Horseman Woodman 5x4in / Lens: 90mm / Filters: 0.6ND hard grad / Film: Fujichrome Velvia 50

BE PREPARED

Capturing wild landscapes and wild weather is relatively straightforward. Mother nature does all the hard work for you. When the sun breaks through a stormy sky, the usual balance of bright sky and darker foreground is reversed and for once the foreground is often darker than the sky. In theory this negates the need for ND grad filters because by exposing for the sunlit foreground, the darker sky is unlikely to wash out. However, as you'll see if you read the picture captions in this chapter, I still tend to use an ND grad because I like to heighten the dramatic contrast between sky and land.

My preferred metering method in stormy weather is to use a hand-held spotmeter. That way, I can set-up the camera, compose the shot, align my ND grad as required and wait for the light to be just right. All I need to do then is quickly take a meter reading from a sunlit mid-tone, such as grass or rock, quickly read off the shutter speed that corresponds with the lens aperture I've already set on the lens, transfer that to the camera, and then get to work. The thing about working in stormy weather is that the light could last for a few minutes, but then again it may fade after a few seconds, so you need to make that first shot count. This can be a daunting prospect because the pressure is really on, but with experience it's surprising how you switch to autopilot and make decisions instinctively.

Thanks to the wonders of digital technology, of course, you can shoot with the grad in place and check the first exposure immediately after making it. The exposure can then be increased or reduced if necessary, and the density of the ND grad if it isn't giving you the desired effect,

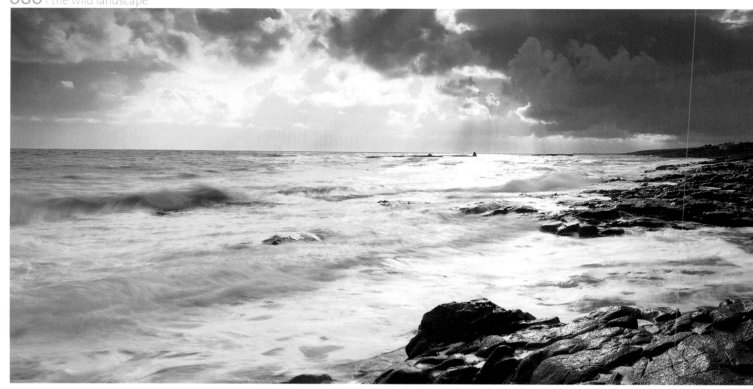

△

NEAR CRASTER, NORTHUMBERLAND

I walked out to this location one morning with high hopes of taking some great panoramas looking towards Dunstanburgh Castle (see page ??). Unfortunately, the light and weather wasn't playing ball and after an hour or so I turned and started heading back along the coastal path. I then noticed the view towards the village of Craster and realised that this would make a far better photograph than the one I'd set out to take. The village seemed dwarfed beneath towering banks of cloud, while the heavy sea had a wonderful metallic sheen.

Camera: Fuji GX617 / Lens: 90mm / Filters: 0.6ND hard grad / Film: Fujichrome Velvia 50

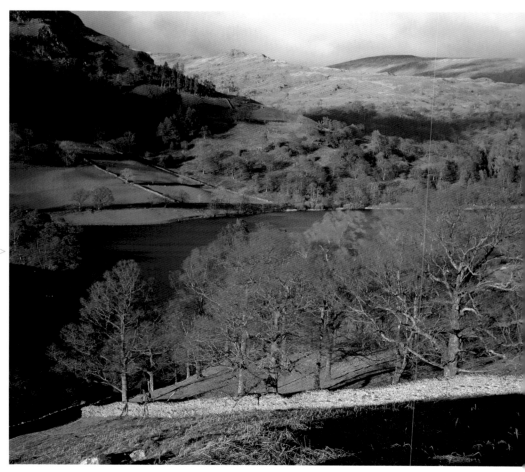

RYDAL WATER FROM ▷ LOUGHRIGG TERRACE, LAKE DISTRICT, CUMBRIA

I'm not quite sure how I managed to take this photograph. The wind was so strong on the day that keeping my tripod upright was a task in itself, but when the camera on top of it is a bulky 5x4in model, life becomes even more complicated. I lost count of the number of times the dark cloth slapped me around the face as I tried to compose and focus from beneath it, but eventually I got there and managed to shield the camera enough with my body to keep the wind off it during exposure and ensure the pictures were sharp.

Camera: Horseman Woodman 5x4 / Lens: 50mm / Filters: 0.6ND hard grad / Film: Fujichrome Velvia 50

and a second exposure made. This means that you should never have the need to make more than two exposures to get a perfect result when working with a digital camera, so even if the light is changing rapidly there can be no excuses for missing it – which is more than can be said for film users!

If the sun breaks through while rain is falling you may also be able to include a colourful rainbow in your shot. If a rainbow is going to appear you will see it if you stand with your back to the sun. Use a telephoto lens to home in on the bow, or a wide-angle lens to include it in a sweeping composition. The colours in the bow will look stronger if they're against a darker background, such as a stormy sky or shady hills, while using a polarizer may intensify those colours.

In situations where the light keeps threatening to break but never quite manages it, another option is to shoot into the sun. Doing this can produce dramatic sunburst effects, with light from the sun radiating from behind the clouds. That light may not be powerful enough to illuminate the landscape, but it will make the sky look amazing. If you home in on the brightest area of sky with a telephoto lens you can record features on the horizon such as trees or hills in silhouette simply by leaving the exposure to your camera's integral metering system. Alternatively, use a wide-angle lens to include foreground interest in the shot, and then tone down the sky with an ND grad filter so it doesn't burn out. You will need a stronger ND grad to do this; ideally you should use a 0.9 that reduces the brightness of the sky by three stops. You should also meter from the foreground rather than the sky, because it's that part of the scene you want to correctly expose. The grad filter will then bring the sky brightness down to a similar level so it requires the same exposure as the foreground, and the resulting images are likely to look more dramatic than the actual scene did.

PREDICTING THE WEATHER

The weather has a habit of changing rapidly in hilly country. Being able to predict what's likely to happen by assessing the present weather system is a handy skill. In Britain, for example, the most prevalent weather pattern consists of a depression moving west to east. As the depression develops the cloud pattern changes. If you know which type of cloud occurs at different stages you can deduce which part of the weather system is overhead, and work out what's coming.

Heavy cloud cover usually indicates the arrival of a cold front, but if you wait for eight to 12 hours there's a likelihood of dramatic storm clouds developing. Several hours after that may come lovely white clouds against a backdrop of blue sky. If there are white cumulus clouds against a pale sky, a warm front may be approaching. Over the next few hours the sky will probably turn into a dull blanket of grey cloud. Conditions will worsen, and you might as well go home!

Another way to assess developments is the crossed-winds rule. Stand with your back to the wind, turn 30° clockwise, and look up at the sky. If the clouds are moving from left to right a warm front is approaching and the weather is likely to worsen. If the clouds are moving from right to left a cold front is receding, so better weather will soon follow. If the clouds are moving towards or away from you, chances are there will be little change over the next few hours.

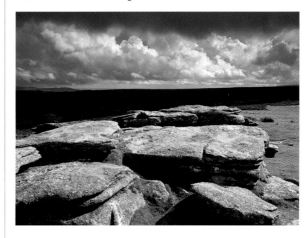

CLASSIC LANDSCAPE

The Val d'Orcia, near San Quirico d'Orcia in Tuscany, Italy, is a legend among landscape photographers. The famous view toward the Belvedere farmhouse bathed in early morning sunlight must surely rank as one of the most breathtaking panoramas in the world.

If there is such a thing as the perfect scene, this is it. A verdant landscape, it is complete with cypress trees standing sentinel on distant ridges and medieval hilltop villages fashioned from mellow stone. In spring the valley is often scattered with vibrant red poppyfields that nestle among myriad shades of green, and if you rise early enough you will often find a gentle sea of mist ebbing and flowing around the hills and hollows that seem to stretch out for miles to the horizon. You couldn't dream up such natural beauty if you tried, for here is visual poety, nature at its best.

There's something about rolling landscapes that appeals to us all. Their serenity and gentle beauty has a calming effect on the soul; they offer a spiritual window on the world and provide a welcome release from the hustle and bustle of urban life – as though you could simply walk into the picture and enter another world.

When I'm photographing scenes of this type I feel myself physically relaxing and slowing down. The desire and determination to create a successful image is still there, but the pace at which I work seems less intense, even if the light is changing as quickly as it might during a dramatic mountain storm or a desert sunrise.

One of the problems with being photographers is that we spend so much time trying to take perfect pictures of beautiful scenes we never give ourselves the opportunity to step back from the camera and just

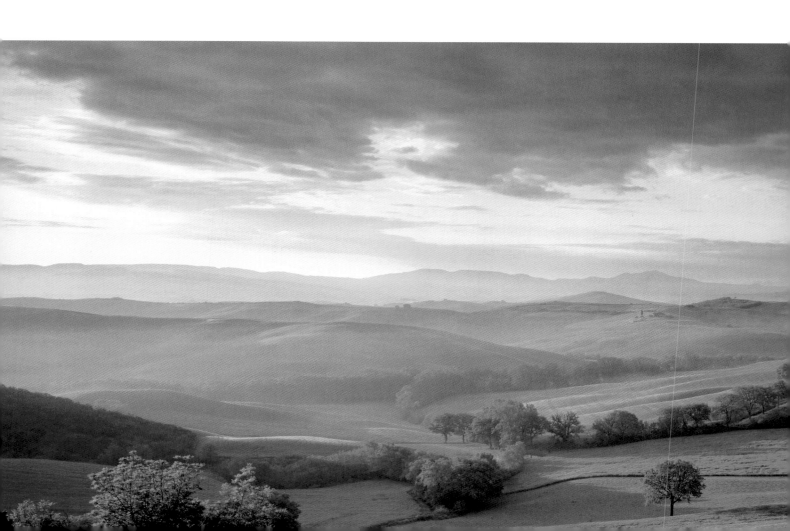

admire the view for what it is. But when I'm shooting scenes of this type I find moments of reflection are important. They help me see things that had perhaps gone unnoticed, and provide me with an opportunity to look deeper into the scene and gain a clearer understanding of exactly what it is I'm trying to say when I point my camera in a particular direction and prepare to trip the shutter.

STORYTELLING

One of the most useful things I ever read about photography when I first picked up a camera is that a well composed landscape should tell a story. It should have an introduction that grabs the attention of the viewer and guides them into the scene, a middle distance that takes the eye on a journey of exploration and an ending that brings that journey to a satisfying conclusion.

The main image here, of Val d'Orcia, achieves this because the eye is naturally drawn from the bottom left-hand corner to the single tree in the foreground and onto the sunlit farmhouse. This anchors the composition down, adds scale and provides an important focal point.

From there the receding hills take the eye up through the scene where it can pick out isolated farmhouses, rows of cypress trees and finally the hazy outline of hills on the horizon. When people look at landscape photographs they aren't aware this is happening, but that's exactly how it should be. For me, the perfect photograph is one in which the viewer can get lost, and be momentarily transported to another place where their imagination is free to run wild and their senses are brought to life – without them actually realizing it. It is like a mild form of hypnosis.

BELVEDERE, VAL D'ORCIA, TUSCANY, ITALY
In May, the landscape of Tuscany is green, and mist often fills the valleys at dawn. I arrived before sunrise to find little mist and a heavy blanket of cloud overhead, but before long the cloud began to break up, and the sun rose into a clear sky. Belvedere was bathed in golden light while warming rays revealed the gentle shapes in the landscape.

Camera: Fuji GX617 / Lens: 90mm / Filters: 0.3 centre-ND and 0.6ND hard grad / Film: Fujichrome Velvia 50
▽

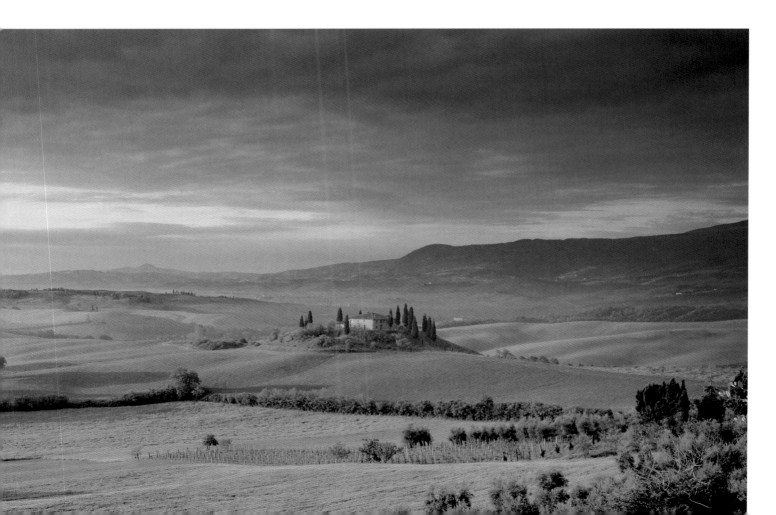

Rolling landscapes particularly tend to have this effect. The receding features in the scene naturally link together and in doing so take the viewer's eye instinctively from one to the next, and before they know it they're hooked. Gently undulating scenes also have the right kind of mood. A bit like a big armchair, they make the viewer feel cosy and safe.

COMPLETE THE PICTURE

Interestingly, when I set out to choose images to illustrate this chapter, I found myself drawn to telephoto shots as much as those taken with a wide-angle lens.

My natural choice for landscape photography has always been the wide-angle lens. But classic, rolling landscapes are often better recorded through a telephoto lens because these gently compresses perspective,

pulling the key elements in the scene together. This results in a tighter, more intimate composition where the eye doesn't have to travel far before it encounters something of interest. Because of this, there's less chance of the viewer attention becoming distracted.

NEAR BRANTES, PROVENCE, FRANCE

Lines are a powerful compositional aid because they act like a magnet to the eye and resisting the temptation to follow them to see where they lead is almost impossible. Fortunately for me there was a barn conveniently placed on the other side of the field that provided a perfect focal point and I was able to use the lines to lead the eye straight to it. The soft colour of the lavender and the shady bulk of the distant hills all help create a narrative that allows the mind to wander freely.

Camera: Pentax 67 / Lens: 55mm / Filters: Polarizer / Film: Fujichrome Velvia 50
▽

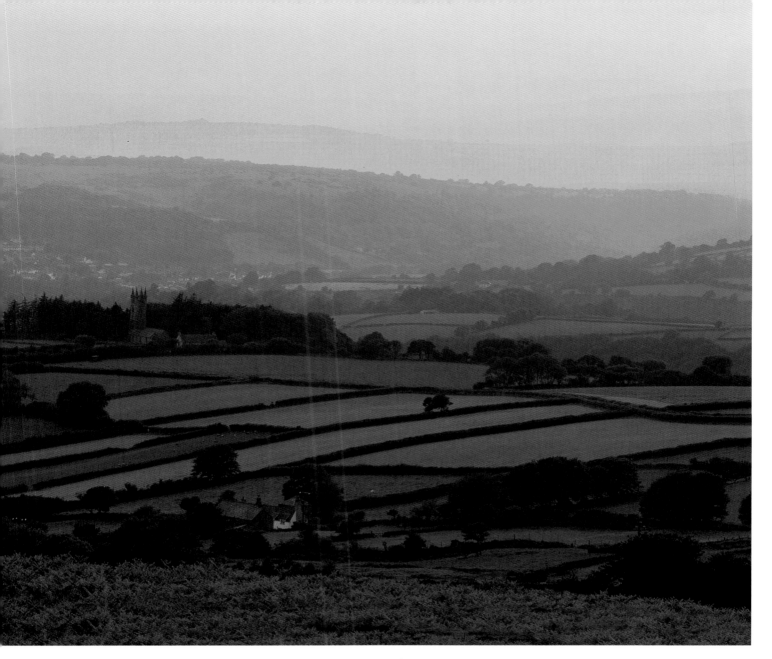

△
WALKHAMPTON COMMON, DARTMOOR, DEVON, ENGLAND

The sun dipped out of view, contrast fell and the soft light combined with the warmth in the sky to bring out the atmosphere, reminding me of a Constable painting. Using a moderate telephoto lens compressed the perspective, and a neutral density grad filter ensured warmth in the sky.

Camera: Pentax 67 / Lens: 300mm / Filters: 0.6ND hard grad / Film: Fujichrome Velvia 50

◁ UPPER SWALEDALE, NEAR MUKER, YORKSHIRE DALES, ENGLAND

The upland landscape of Swaledale is renowned for its old stone barns and meandering dry stone walls, and this view captures both in great concentration. It's a classic Yorkshire scene and the congested telephoto composition tempts you to delve deeper and explore every corner of the scene. I took similar shots with a wide-angle lens but they didn't have the same intimacy or impact.

Camera: Pentax 67 / Lens: 300mm / Filters: Polarizer / Film: Fujichrome Velvia 50

△
NEAR KESWICK, LAKE DISTRICT, ENGLAND
I spotted this scene by chance while driving along the A66, a busy road between
the Lakeland towns of Penrith and Keswick. My journey came to an abrupt halt
when I caught a glimpse of the distant farmhouse. Finding a clear view involved
scrambling over a wall and tramping around a muddy field until all the elements
fell into place, but it was worth the effort and I felt a great sense of satisfaction
when I finally located 'the' spot. A symmetrical composition proved to be the
most effective, with the farmhouse as the main focal point in the centre of
the frame nestled in the 'V' or two towering fells. This resulted in balance and
harmony, with the slopes of the hills and the line of trees directing the eye to the
farm. Soft morning light and rich autumnal colours completed the picture.

Camera: Fuji G617 / Lens: Fixed 105mm / Filters: Polarizer / Film: Fujichrome Velvia 50

The panoramic format works in a similar way, laterally providing
a wide-angle view while at the same time cropping out unwanted
foreground and sky so the viewer can focus on the most interesting
part of the scene. The 90mm lens I often use on my Fuji GX617 camera
has a lateral angle of view similar to a 20mm ultra wide-angle lens,
for example. This makes it ideal for sweeping panoramic views such as
Belvedere on pages 84-85. If I had photographed the same scene with
a 20mm lens on a 35mm SLR, the final image would have looked totally
different, with the most interesting slice of the scene lost between acres
of sky and a cluttered foreground.

You will also notice that the images in this chapter were all shot in
relatively gentle light. I prefer the light before dawn most of all when
shooting classic rolling landscapes because it just oozes atmosphere.
There's a greater chance of capturing mist at dawn than at dusk and
the earth is also cold so there's often a nice contrast between the
emerging warmth in the sky before sunrise and the coolness of the
landscape, which is illuminated by soft reflected light coming from the
sky overhead (see page 45). When the sun does finally rise, the shadows
remain cool while warm rays of light rake across the scene, revealing
texture and form.

At dusk the light is much richer due to the scattering and filtering
of the sun's rays by haze. I find the last hour of daylight to be the most
effective, when the light turns everything it touches to gold. Contrast
can be a problem, so I will often wait until the sun has dipped beneath
the horizon and the landscape is once more lit by the overhead sky.

A human element can transform the mood of a picture because it
makes it easier for us to relate to and encourages the imagination to
wander. Belvedere, the farmhouse depicted on pages 84–85 is a great
example. How can you look at it and not imagine what it must be like
to live there, peering out over such amazing scenery every morning
– scenery you can call your own. Similarly, in the Lakeland panorama

◁
**HADRIAN'S WALL
ABOVE SYCAMORE GAP,
NORTHUMBERLAND, ENGLAND**
Natural features in the landscape often do all
the hard work for you when it comes to creating
an interesting composition. In this case, the
meandering line created by Hadrian's Wall snaking
into the distance makes the picture, not only
taking the eye on a journey around the natural
contours of the landscape but also adding human
interest that encourages the viewer to think as
well as look.

Camera: Pentax 67 / Lens: 45mm / Filters: Polarizer
/ Film: Fujichrome Velvia 50

shown here, the main focal point is a traditional whitewashed
farmhouse nestling between two hills. For anyone caught
up in busy urban life this – a rambling old house in beautiful
surroundings free from the noise of traffic, the crush of crowds
and the stresses of modern living – is surely the ultimate
dream of the perfect escape. Landscape photography isn't just
about recording beautiful scenery. It's also about capturing
dreams.

Finally, remember that a photograph can't have emotion if
you don't allow your own thoughts and feelings to influence
your actions. Photography in its basic form is a mechanical
process and if left that way results in images that are clinical
and dull. Allow yourself to step back mentally and look at a
scene with your eyes instead of through a viewfinder, and as a
human being rather than a photographer. Your reaction to it is
likely to be more meaningful and better work will result.

I often ask myself what I am trying to achieve in a given
situation. What's the attraction? Why am I considering
committing this scene to film? How do I intend to capture this
scene as accurately as possible? And most important of all, I
will ask myself how this could be better.

CANYONS AND VALLEYS

I'm rather embarrassed to admit it, but until the autumn of 2005 I had never visited the USA. Despite being home to some of the world's most spectacular scenery, birthplace of many of the world's greatest landscape photographers, and a destination that had been high on my wish list for many years, it had somehow eluded me. Then friend and fellow-photographer Andy Jenkins, who was born and raised in Utah, invited me over to explore his 'backyard' and I embarked on a ten-day trip that was to change my life as a landscape photographer forever.

The first thing that struck me when we headed into the wilderness is the sheer scale of it. Compared to familiar places I've come to know and love such as Tuscany, the Scottish Highlands, and even my own backyard, the Northumberland coast, the valleys and canyons of the southwest USA are simply vast, covering thousands of square miles, much of it accessible at best by four-wheel drive and at worst on foot.

So where do you begin when you arrive at a National Park that's the size of a small country? I didn't have to worry, because my companions – Andy, his brother Tony, and father Doug – had spent years exploring Utah and Arizona. It made me realize the importance of doing a great deal of background work before even attempting to visit such regions. So I proceeded in my research as if I were travelling alone, rather than relying on their knowledge and experience.

In the weeks before the trip, I spent as much time as I could researching the photographic potential of the area. I leafed through every book I could lay my hands on, marvelled at the work of American landscape photographers such as Tom Till, David Muench, Jack Dykinga, and Michael Fatali and slowly compiled a list of the locations I yearned

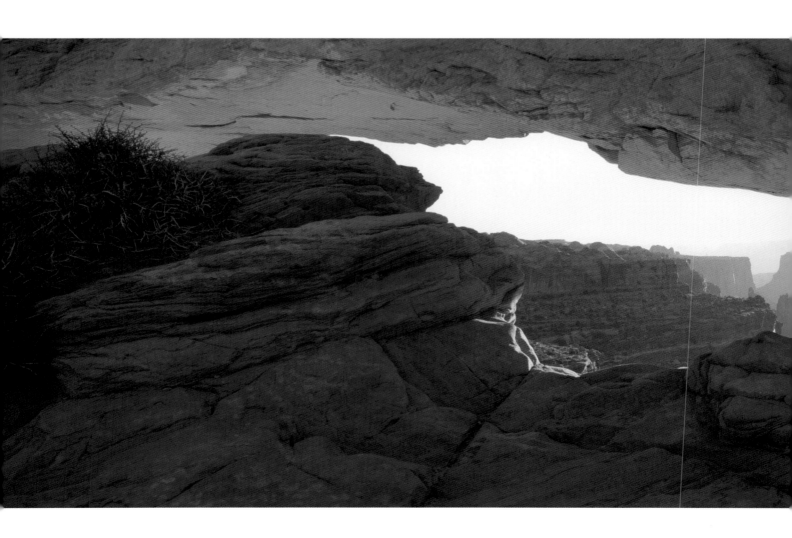

to visit and photograph, such as Mesa Arch, Arches National Park, Monument Valley, Antelope Canyon, Bryce Canyon, and more. I also tried to establish if specific views would be best photographed at dawn or dusk, to avoid wasting time. With Doug's local knowledge he was able to turn my wish list into a detailed ten-day itinerary.

Many of the locations I wanted to visit are well documented, some would say to the point of saturation, and a part of me did question the logic of taking yet more photographs of the same old places. What could I achieve that hadn't already been done – and probably better than I would ever manage myself? However, curiosity got the better of me. I wanted to see those those iconic landscapes of the American Southwest for myself. I also wanted to put myself on the line and discover how my work would measure up to the American landscape photographers I admired.

Bearing in mind they had spent years returning to the same locations in all seasons and all weathers and I had just ten days, I accepted that I wouldn't even scratch the surface. But far from feeling weighed down by this knowledge, I relished the prospect of discovering new places and felt excited by the opportunities that lay ahead.

LIGHT COMES FIRST

As with any type of landscape photography, the quality of light is key. During the trip, light was given priority at all times and everything else came second, including eating and sleeping.

The weather in Utah and Arizona is fairly predictable, even during autumn, so we could plan a visit to a location feeling reasonably confident that clear conditions would greet us. On the whole this proved to be the case. It also became obvious very quickly that the light would be at its best only for short periods each day – the first hour after sunrise and the last hour before sunset – and there would be little point shooting most of the locations outside this period. The results simply wouldn't cut the mustard.

As distances are often great in the Canyons and Valleys of the USA, this makes early starts and late finishes unavoidable. If you need to drive 50km then hike several more to reach your chosen location for a 7am sunrise, then starting off at 3am is in order.

I discovered this almost immediately on arrival. Our first location was to be Mesa Arch in Canyonlands National Park. Getting there well before

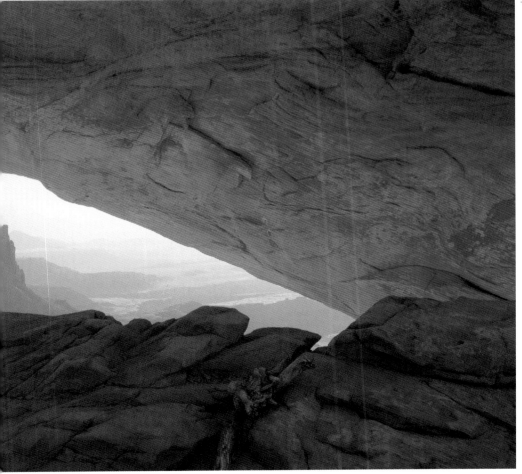

◁ MESA ARCH, CANYONLANDS NATIONAL PARK, UTAH, USA

This is one of many photographs I took of Mesa Arch during a single visit. Thanks to planning, a reliable alarm clock, and a very early start, my companions and I had the location pretty much to ourselves. There were only two other photographers there when we arrived. As expected, the sky was clear and within minutes of the sun rising, the underside of the arch was on fire with a vivid orange glow. Photographing it was surprisingly straightforward. The arch itself was masked by the sun and no filters were required – only careful metering. It was one of the most spectacular natural light shows I have ever witnessed and marked the start of an adventure I will never forget.

Camera: Fuji GX617 / Lens: 90mm / Filters: 0.3 centre ND / Film: Fujichrome Velvia 50

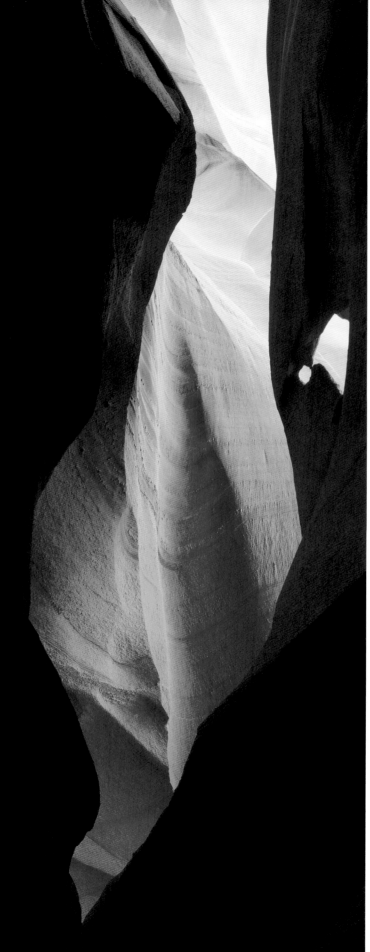

sunrise is crucial because it's a popular location, but there's only space for half a dozen photographers to set their tripods and enjoy a decent view. After a trans-Atlantic flight, a four-hour drive, and two hours sleep, we were up and out at 5am. We headed into the wilderness in darkness, knowing we had just one attempt to get our shots before heading on to the next location.

Mesa Arch itself is nothing spectacular. It's tiny to compared to many of the natural sandstone arches in the Southwest USA. What makes it special is the location. Set on a high plateau called the Island in the Sky, it frames a breathtaking view over the canyon of the Colorado River more than 1,000ft below. Better still, when the sun rises it lights the sandstone cliffs and reflected light illuminates the underside of the Arch so it glows orange.

◁ **LOWER ANTELOPE CANYON, NEAR PAGE, ARIZONA, USA**
I took this simple image during a morning visit to Lower Antelope, using a short telephoto lens to home in on the sensuously sculpted walls and capture the beautiful shades of orange and yellow that are created by sunlight penetrating the canyon and reflecting off the sandstone. Light levels were low and exposures ran into many seconds, making a sturdy tripod essential.

Camera: Mamiya 7II / Lens: 80mm / Film: Fujichrome Velvia 50

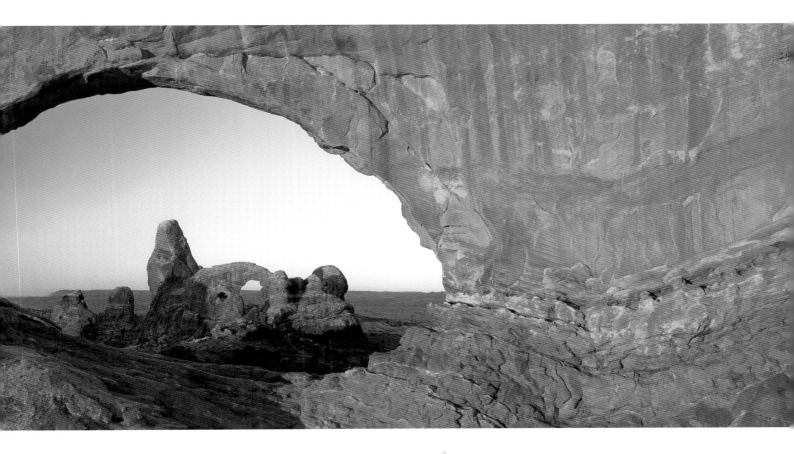

HORSESHOE BEND, NEAR PAGE, ARIZONA, USA
The scale of this scene is staggering, with sheer cliffs plummeting more than 1,000ft down to the Colorado River. We decided sunset would be the best time of day. On arrival the sun was still above the horizon and far too intense to shoot, but as soon as it set such beauty was revealed.

Camera: Mamiya 7II / Lens: 43mm / Filters: 0.9ND hard grad /
Film: Fujichrome Velvia 50

▽

TURRET ARCH THROUGH NORTH WINDOW, ARCHES NATIONAL PARK, MOAB, UTAH, USA
There's nothing more satisfying than planning a shoot, anticipating the conditions, and coming away with exactly the photographs you set out to take. For this shot I simply waited for the rising sun.

Camera: Fuji GX617 / Lens: 90mm / Filters: 0.3 centre ND and polarizer /
Film: Fujichrome Velvia 50

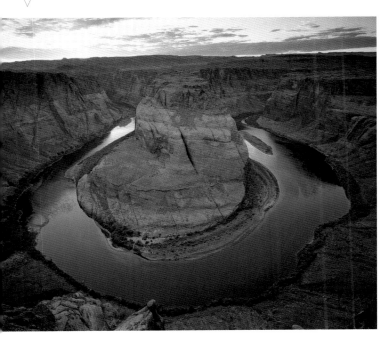

Nothing prepares you for this amazing spectacle. It's almost as if someone flicks on a light then slowly turns the dimmer switch from dull to bright as the intensity of colour on the arch builds. The final result was well worth the early start and the lack of sleep. I was convinced that my baptism in the American Southwest was finally over.

From that point on the trip followed a similar pattern. We were rising in darkness, driving and hiking to a location, and then returned for breakfast once the light had lost its colour and character, before packing and heading to the next location ready for a late afternoon and evening shoot. A routine and rhythm quickly developed and within a few days normal life and the rest of the world were temporarily forgotten as photography became the focus of everything.

CAPTURE THE MAGIC
My technique throughout the trip remained simple. Preparation was key, to ensure we were in the right place at the right time. But if the weather played ball – as it usually did – the actual act of capturing a scene on film was relatively

straightforward. Mother Nature had done all the hard work, shaping the landscape into breathtaking forms over millions of years, then illuminating it every day with such grace. Often, a scene composed itself. You could see quite clearly what needed to be done and that in turn dictated viewpoint and lens choice. For example, a classic image of Arches National Park in Utah is that of Turret Arch framed by North Window at first light, when the rising sun illuminates the sandstone so it glows orange. There is no variation on the viewpoint to get this shot simply because moving more than two or three metres to the left or right changes the view and spoils the composition. The viewpoint itself is the top of a huge rock where there is space, comfortably and safely, for only two or three tripods. So, if you get there too late, not only will you

THE MITTENS, MONUMENT VALLEY, UTAH/ARIZONA, USA

Our first visit to Monument Valley proved unproductive due to bad weather so we decided to forfeit Bryce Canyon and return later in the trip. This proved to be a wise move because conditions were much better and we enjoyed both a fantastic dawn with the legendary Mittens in silhouette and an evening shoot capturing the towering sandstone formations bathed in golden light.

Camera: Fuji GX617 / Lens: 180mm / Film: Fujichrome Velvia 50

▽

BE PREPARED

Canyons and valleys can be dangerous places where the terrain is often unforgiving, vehicle access is limited, and the weather can fluctuate. So before heading out, make sure you're prepared. Sturdy footwear is essential to avoid strained ankles and a layering approach should be adopted for clothing, and wearing a hat will protect your head from the sun and also keep it warm in the cold. Carry high-factor sunscreen to help avoid burning, along with blister bandages and other first-aid basics.

Sustenance is equally important. Carry plenty of water, especially when hiking in hot weather, and snacks such as fruit, nuts, and energy bars. Keeping yourself in good shape and generally healthy when working in remote locations will not only enable you to be more focused on your photography, but will also ensure you get home safely. Avoid travelling into remote locations on your own, especially if you don't know the area well. If that can't be avoided, let someone know where you're going and when you expect to be back so that if you miss the deadline the alarm can be raised.

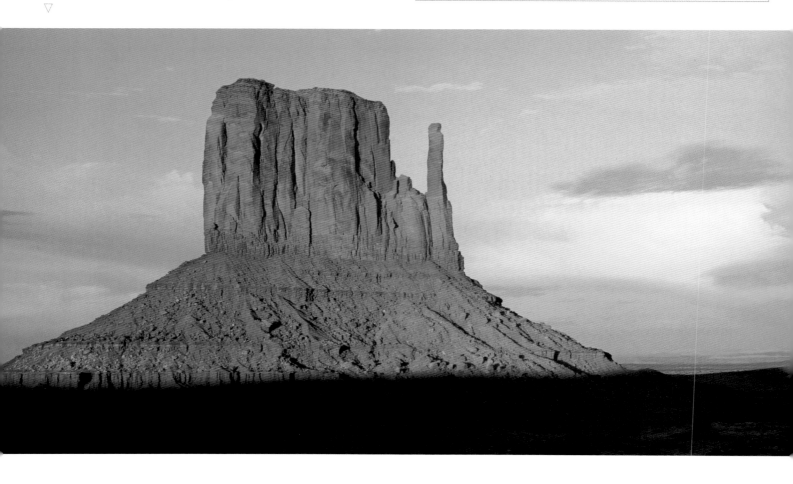

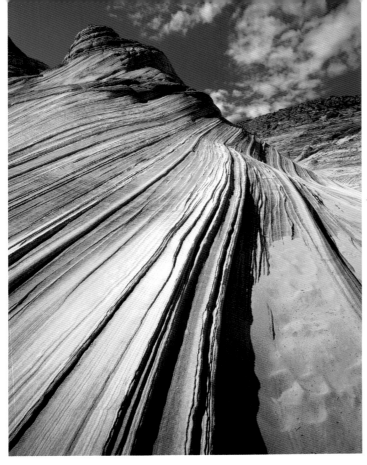

◁ THE WAVE, PARIA-VERMILLION
CLIFFS WILDERNESS,
ARIZONA, USA

This amazing corner of the Colorado Plateau is
highly protected and only 20 permits a day are
issued to visitors. Fortunately, my companions
and I were lucky enough to obtain the permits
we needed, which are awarded by ballot at the
local ranger station, and the following morning
set out on a 6km return hike over slick rock to
explore the colourful sandstone contortions. I
purposely avoided taking the classic view of the
Wave and instead looked for simple, graphic
compositions that revealed the lines and swirls in
the sedimentary rock. Of all the locations I visited
during my visit to Utah and Arizona, this is one
that I felt I failed to do justice to and would dearly
love to return.

Camera: Mamiya 7II / Lens: 43mm / Filters:
Polarizer / Film: Fujichrome Velvia 50

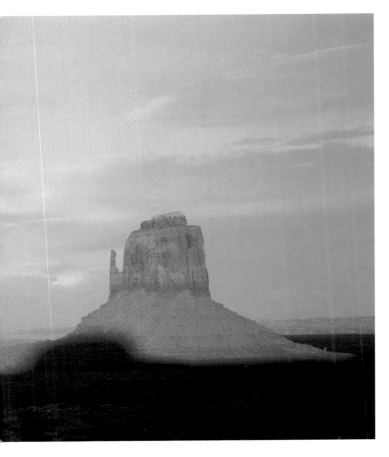

miss the best light (which comes within the first 10–15 minutes after
sunrise) but also run the risk of the crucial tripod spots already being
occupied by other photographers.

Metering requires care when shooting red rock on such a grand
scale, as it has a higher tonality than the mid-tone value your camera's
integral metering system is designed to correctly expose and, when
flooded with sunlight, it can easily cause exposure error.

The cameras I used on the trip either lack metering altogether (Fuji
GX617 panoramic) or have very basic, and therefore unreliable, metering
(Mamiya 7II), so I relied instead upon my handheld meters. Where the
light was even I took the easy option and measured the light falling
onto the scene with an incident meter. Where it wasn't, I preferred spot
metering instead, and if I couldn't identify an obvious mid-tone then I
would 'spot' from something else in the scene that was brighter than a
mid-tone and adjust the exposure accordingly. For example, I reckoned
that sunlit sandstone was around a stop brighter than a mid-tone so the
exposure suggested by my spotmeter would be increased by a stop. As a
safety precaution I also bracketed exposures for every shot by at least 1/3
over and under the 'correct' exposure, and if in doubt I bracketed up to a
full stop over. Having travelled thousands of miles to get there, I saw no
sense in missing crucial shots for the sake of a few frames of film.

By the end of the trip my love affair with America's 'Red Rock Country'
was sealed. I realised that I had only witnessed a tiny fraction of what
it had to offer, and that if I returned every year for the rest of my life I
would still barely scratch the surface. But I also knew that I had taken
some powerful photographs and that my photographic horizons had
been changed forever.

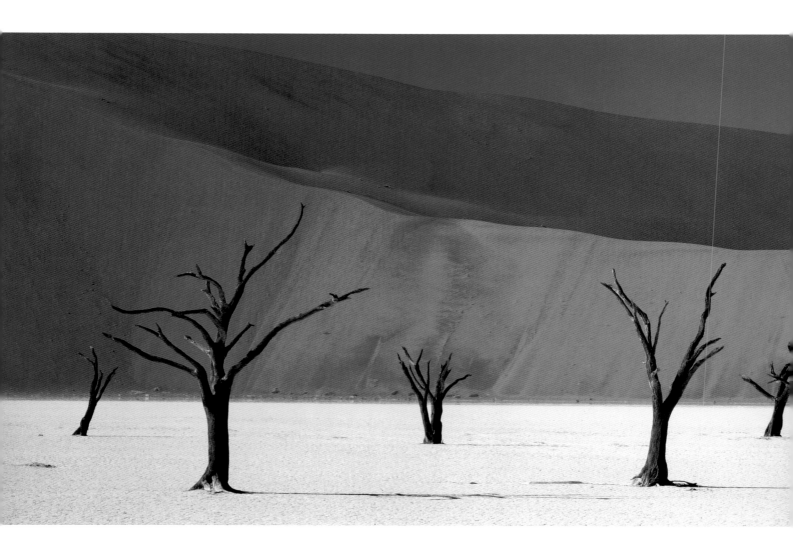

DESERTS

I'll never forget my first desert adventure. It was to Erg Chebbi in the Sahara Desert of southern Morocco, a rolling sea of red sand that stretches as far as the eye can see. Arriving at the nearby village of Hassi Labiad in darkness after a long drive south, I had no idea of what surprises awaited me. However, the suspense – and a fitful night's sleep – was more than justified when I rose before dawn the next morning, stepped into the chilly air and was immediately confronted by the dramatic silhouettes of sand dunes against the starry twilight sky, so close I felt that I could reach out and touch them.

Minutes later I was among the dunes, surrounded by mountains of sand rising and falling in gigantic, graceful mounds and slowly coming to life as the first rays of golden sunlight crept over the horizon. I had walked less than 500m, yet I could have been hundreds of miles from civilization, lost in this stark, silent world of sand and sky.

As the sun began to rise the dunes took form. Gentle ripples and tracks began to appear as the light cast long, cool shadows. Individual grains of sand sparkled like jewels. In the distance, the bold outline of rolling dunes was being carefully sculptured into fascinating studies of light and shade while on a far ridge the tiny silhouettes of a camel train could just be seen, edging its way slowly and carefully along the soft sand to some distant place.

In every direction there were endless photographic opportunities. Wide-angle views that emphasized the

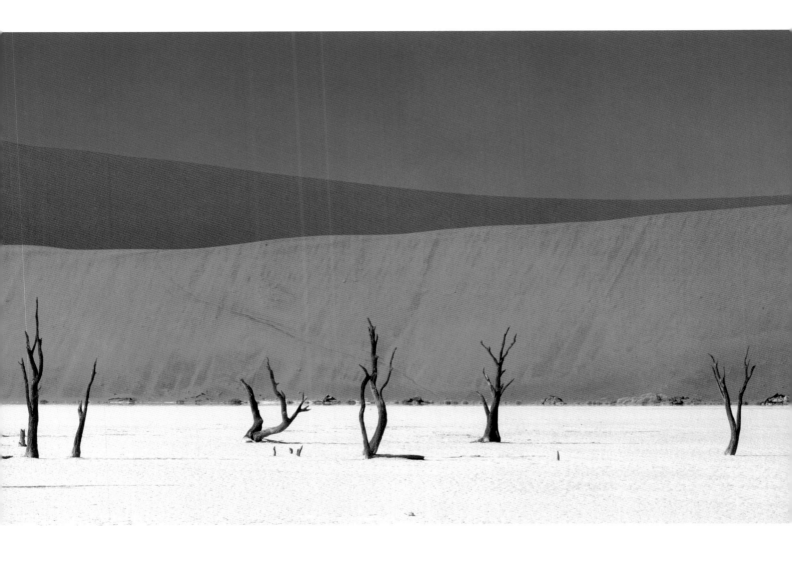

△
DEAD VLEI, NAMIB DESERT, NAMIBIA

These skeletal trees against a backdrop of deep orange dunes have become an iconic image of the desert and all that is magnificent about it. I've been lucky enough to visit them at Dead Vlei on several occasions, and each time it's a memorable experience that results in new and exciting images. This panoramic view was shot early one morning. I had spent some time locating a viewpoint where none of the trees overlapped or broke the ridge line on the dune and where I could make the most of the bold bands of colour to create a simple but powerful composition. Soon after the temperature hit 40°C and with no shade to offer protection from the sun I was forced to leave the location.

Camera: Fuji GX617 / Lens: 180mm / Filters: Polarizer / Film: Fujichrome Velvia 50

wonderful foreground ripples. Telephoto shots that filled the frame with shapes and shadows. Red sand shimmered beneath deep, cloudless blue sky and with every passing minute the character of the scenery changed as the light become stronger and the sun higher. I was in an alien world, in a harsh, unforgiving environment where survival is a continual battle. Yet at the same time I couldn't help but marvel at the sublime beauty of my surroundings. I felt alive, inspired, and completely at home.

That first visit marked the start of my love affair with deserts. Since then I have returned to Erg Chebbi (at the time of writing I am just a week away from my latest trip to Morocco). I have also ventured further afield to the Namib Desert, the oldest of them all and home to mountains of orange sand that stand more than 1000ft high, the biggest dunes in the world.

SHOOTING SAND
The scale and starkness of the scenery draws me back to deserts time

after time. Deserts are stripped to their bare bones, quite literally, by the ferocity of the sun and the lack of moisture. They're parched, barren places; landscapes in a minimalist form where colour, shape, pattern, and texture take centre stage and light makes or breaks their performance. I discovered this on my very first desert trip, having started shooting before sunrise and continuing until late morning when the sun was high and the light harsh. Comparing those photographs back home, I realized that light is everything in the desert. It defines the colour of the sand, the shape of the dunes, and the textures and patterns that give a photograph depth and character. But within two hours or so of the sun rising it has usually climbed so high into the sky that those delicate ripples and patterns fade to nothing, the rich colour of the sand is bleached by the harshness of the light and the dunes appear like flat cardboard cut-outs against a bland, hazy sky.

PROTECTING YOUR GEAR

Sand is the worst enemy of photographic equipment. Sadly, deserts contain rather a lot of the stuff, so if you want to avoid problems you need make sure your camera and lenses are protected. I always place each lens and camera body inside individual clear polythene bags – freezer bags or ziplock bags are ideal – and only take them out of the bags when they're in use.

When I am shooting, I also make sure my camera pack is zipped-up to prevent sand getting inside. It's easy to kick up sand while moving around, or for a sudden gust of wind to do the same. At the end of each photographic session, I then check any cameras and lenses that have been out of their poly bags and brush them down with a stiff brush to remove sand and dust. The same is done with filters.

At night, if I'm camping among the dunes, I place my whole camera pack inside a large poly bag – bin liners are ideal – and tie the top, just in case the wind picks up. I've slept through a sandstorm before and lived to tell the tale, but I'm not sure how my camera would have faired had it been left out in the open all night without extra protection.

So far these precautions have worked and despite spending several weeks in deserts over the last decade, my cameras and lenses have remained in perfect working order.

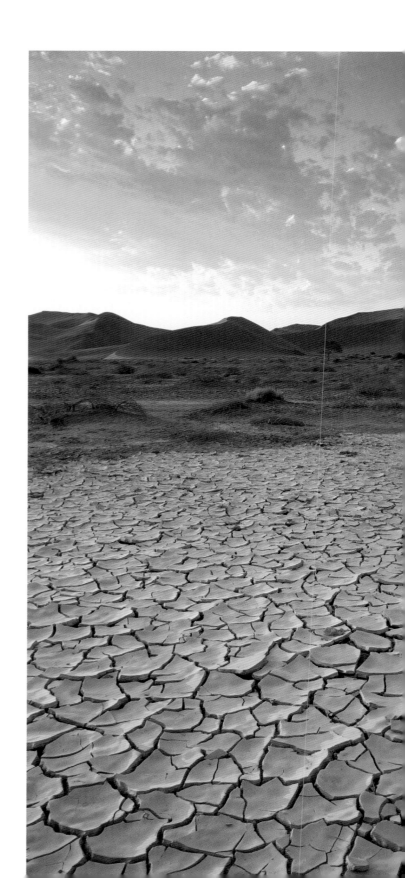

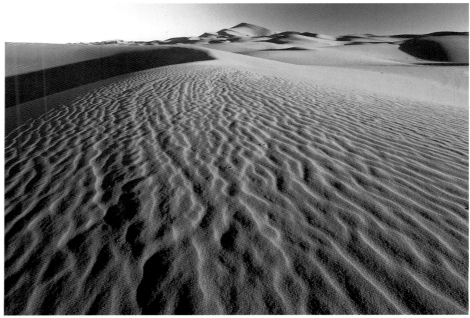

ERG CHEBBI, SAHARA DESERT NEAR
MERZOUGA, MOROCCO
The gentle ripples in desert sand are best revealed by low sunlight
across the scene so that shadows highlight every undulation in the
surface. Here I used a wide-angle lens from a low angle to make a
feature of the ripples, which form shimmering lines that carry the eye
through the scene to the towering dunes in the distance.

Camera: Nikon F5 / Lens: 20mm / Filters:
Polarizer / Film: Fujichrome Velvia 50

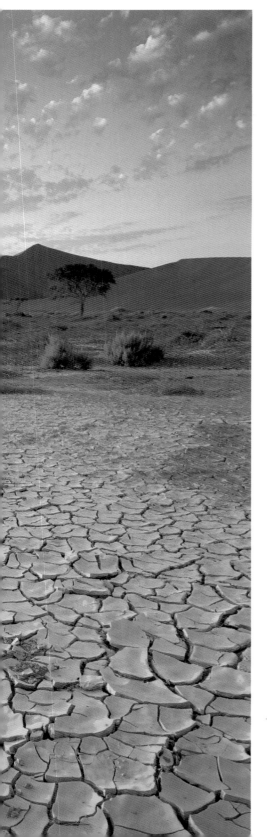

BE PREPARED

Deserts are hostile places. Never venture into a desert without the aid of local guides. All
my treks into the Moroccan Sahara have always been made with local camel guides who
know the area like the back of their hand, and even though we have never been more
than a few kilometres from the nearest village, I still wouldn't want to try and find my
own way out of the dunes because once you're among them, they might as well go on
forever. Similarly, on my trips into the Namib Desert I have taken an experienced desert
guide and travelled in a fully equipped 4x4.

It may be nice and cool when you head out before sunrise, but by 10am temperatures can
be over 40°C. In this kind of heat, dehydration and heat stroke can come on very quickly.
Always carry at least 2 litres of water in your pack and have plenty more on the vehicle.
A bush hat is vital for keeping the sun off your head, and I favour lightweight 'solardry'
trousers and long-sleeved shirts that provide sun protection but also wick away moisture
to keep me comfortable and cool.

◁ SOSSUSVLEI, NAMIB DESERT, NAMIBIA
Desert photography isn't just about sand dunes. I made a feature
of the amazing patterns in the cracked mud. The shot was taken
just as the sun was rising and it was worth getting up for.

Camera: Pentax 67 / Lens: 55mm / Filters: 0.9ND hard grad /
Film: Fujichrome Velvia 50

STAR TRAILS

Thanks to a lack of light pollution and humidity, night skies in the desert provide the perfect material for star trail shots, where long exposures are used to record light trails caused by the rotation of the earth on its polar axis.

For the best results, shoot in a northerly direction so you can include the Pole Star – around which all other stars appear to rotate (or Southern Cross in the southern hemisphere). Use your widest lens set to its widest aperture (smallest f/number) and include a ridge of dunes in the bottom of the frame to add scale. All you need to do then is lock the camera's shutter open on B (bulb) for a couple of hours using a remote release.

The effect works just as well with digital cameras, but you need to set the sensor to its lowest ISO to minimize noise. Also be aware that such a long exposure combined with low temperatures can cause batteries to drain.

ERG CHEBBI, SAHARA DESERT NEAR MERZOUGA, MOROCCO

For this star trail I used an exposure of two hours, setting-up the camera and tripod on a dune, locking the shutter open then returning after supper to end the exposure.

Camera: Nikon F5 / Lens: 20mm / Film: Fujichrome Velvia 50

NAMIB RAND, NAMIBIA ▷

I find the simplest compositions to be the most effective when photographing deserts and always try to reduce a scene to its bare minimum by carefully selecting the viewpoint that I shoot from. Here I was initially attracted by the strong ripples in the sand and moved in for a closer look. By dropping down low I then realized that I could capture the tops of a distant mountain range looming above the sand bank but exclude everything else.

Camera: Hasselblad Xpan / Lens: 30mm / Filters: 0.45 centre-ND and polarizer / Film: Fujichrome Velvia 50

REVEALING DEPTH

When shooting deserts, I start out with a wide-angle lens so I can include lots of foreground and make a big feature of ripples at my feet. I prefer a 20mm lens for my Nikon SLRs, a 43mm on my Mamiya 7II, and a 30mm on my Hasselblad Xpan. All three have a huge angle-of-view and achieve vast depth of field when stopped right down to minimum aperture. That said, telephoto lenses are also invaluable because they allow me to home in on small details in a scene, such as the play of light and shade on the dunes or graphic shapes within a scene. For that purpose, I always carry an 80-200mm telezoom for my Nikon 35mm SLRs, often with a 1x4 teleconverter for added magnification. In the Namib Desert I also found the 180mm and 300mm lenses for my Fuji GX617 panoramic camera invaluable and used the wide 90mm far less than I envisaged.

One item I find highly useful is the polarizing filter. As well as deepening the blue sky it also improves clarity and increases colour saturation in the sand so the contrast between blue and orange/red is heightened for maximum impact. A polarizer will also emphasize ripples in the sand, especially when they're delicate.

CHANGING LIGHT

Once the sun has been up for a couple of hours, the light has usually lost its colour and the dunes look flat and lifeless. The light falling on the

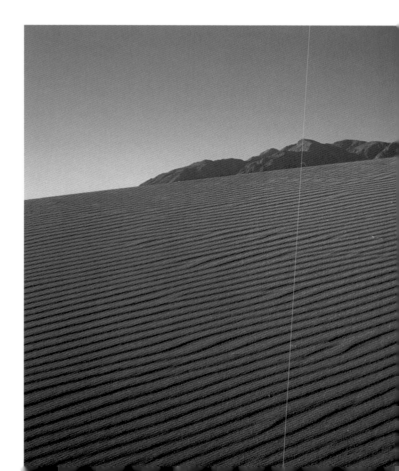

landscape in the afternoon and evening is often richer than it was at the beginning of the day, mainly because the atmosphere is less clear and the earth is warmer, and I find that the last hour before sunset can be the most productive. Once again, the sun is low is the sky and raking shadows are cast across the sand. If I find a great location in the morning, I will often return there in the afternoon because new opportunities present themselves. It's also good to go back to the same location because the more you get to know it the more you will see.

ERG CHEBBI, SAHARA DESERT NEAR MERZOUGA, MOROCCO

When I take groups of photographers into the Sahara Desert we travel on camels and camp in the dunes – an amazing experience in itself. The camels and their trusty leaders also become the subject of our cameras, and I never fail to return without at least a few more images to add to my collection.

Camera: Nikon F5 / Lens: 20mm and 80-200mm / Filters: Polarizer / Film: Fujichrome Velvia 50

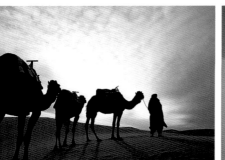

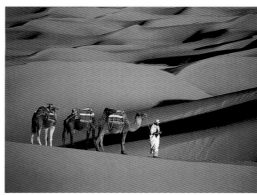

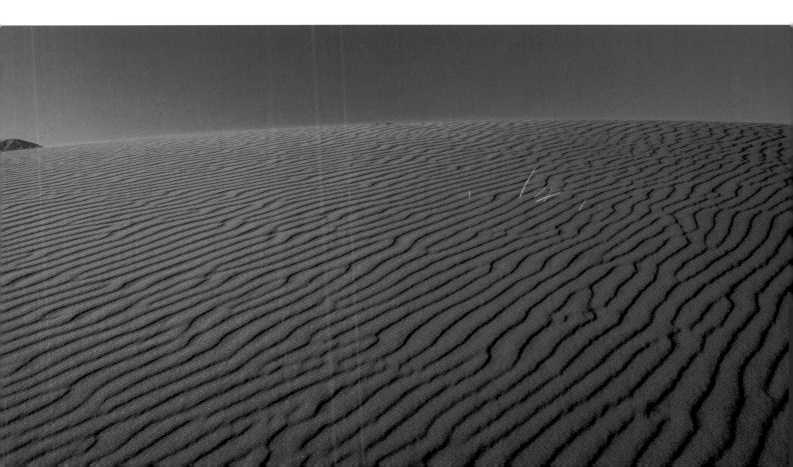

LANDSCAPE IN CLOSE-UP

Like most landscape photographers, I tend to see the world on a large scale. When I explore the countryside or coastline with a camera, my main priority is generally to capture the bigger picture – the grand vista or sweeping panorama. As I wander along, I instinctively compose pictures in my mind, scanning the scene from bottom to top or left to right in an attempt to see how key elements relate, and how I might link them together to create a successful photograph.

Over the years, however, I have discovered that while the bigger-picture approach undoubtedly leads to dramatic photographs, as many of the examples in this book demonstrate, details in the landscape can also be the source of beautiful and inspiring images because they capture aspects of a location – the patterns, textures, and colours fashioned by nature – that tend to be missed.

Details also provide much more scope for personal interpretation because no one else is likely to see them in quite the same way as you– if they see them at all. When you photograph the landscape in miniature, you set out with no preconceptions. Famous views have been photographed many times before, so it's hard to shoot them yourself without being influenced by familiarity. But with details this is rarely the case because you wouldn't travel to a location specifically to photograph a pile of seaweed or lichens on rocks. They tend to be an added bonus of being there and looking beyond the obvious.

WEATHER WORRIES

If I'm totally honest, the main factor that encourages me to look for details in the landscape is poor weather. When the light is good you'll usually find me shooting dramatic scenes with a wide-angle lens. However, a frustrating fact of life for the landscape photographer in the UK is that the light isn't always good. Dull, overcast days can be expected at any time of year. So, rather than get depressed at the prospect of an unproductive day, I go looking for details. In fact, occasionally, when I find myself at a location that's rich in such details, I will actively will the weather to turn foul so I have more suitable light to work with. Hard to please or what?

The coastline is especially rewarding for details and the haunt I prefer above all others. I could spend days exploring beaches, photographing pebbles, shells, the patterns and shapes in rocks, driftwood and seaweed. Intertidal zones are especially interesting because they're in a constant state of flux and every time the tide recedes you never know what surprises it will reveal. And you can count on it – there will be surprises.

◁ NEAR HORGABOST, ISLE OF HARRIS, OUTER HEBRIDES, SCOTLAND

I caught a glimpse of this beach while driving along the coast of Harris and decided the rock formations deserved closer inspection. The weather had turned cloudy so the light was perfect for details shots and scrambling down to the beach, I felt a surge of excitement because there seemed to be so many possibilities among the pebbles and sea-worn slabs of granite. This was the first composition I made. Unfortunately, it also proved to be the last because within minutes of arriving the heavens opened and heavy rain began to fall. I quickly metered and exposed a single frame before the deluge forced me to pack my camera away and seek shelter. Two hours later it was still raining and I realized that the chance of taking any more photographs that day was slim. Fortunately, I was happy with the one shot I was able to take.

Camera: Mamiya C220 / Lens: 80mm / Film: Kodak Portra 160VC

I also enjoy photographing natural patterns and textures and find that woodland is a great source of subject matter – the deeply textured bark of old tree, its sinuous exposed roots covered in fine green moss, bracket fungus clinging to rotting wood, fallen autumnal leaves. Dull weather provides the best conditions for woodland photography because the light is soft and contrast low, but light levels are also very low and so exposures can run into many seconds.

And what of man's hand on the landscape? Though we tend to exclude signs of man from our photographs, he has been shaping the landscape for centuries and is an inescapable part of it. For that reason, I am more than happy to seek out and capture man-made details, such as the patterns created by dry stone walls and the patterns and textures within the walls themselves, or regimented rows of conifers in forestry plantations. Such details as these can be just as interesting as those shaped by nature and time. Back on coastline I find myself attracted to old fishing boats, lobster pots, fishing nets, and anything else that may present interesting colours, patterns, or textures. On a recent trip to Scotland's Outer Hebrides, I spent a very enjoyable afternoon photographing details in an abandoned croft house on the Isle of Lewis that was slowly being consumed by nature.

COMPOSING DETAILS

There are no hard and fast rules to composing detail shots. As always I just go with my instinct: if it looks good in the viewfinder it works.

That's not to say that I don't spend time fine-tuning the composition before making an exposure. Having located interesting subject matter,

it may take half an hour or more of continually adjusting the camera position until I'm happy with the arrangement of elements in the frame. Even the smallest adjustment of camera position or angle can make a big difference.

Details require balance and logic to make them work. There's no point in just aiming your camera at a pile of pebbles and expecting a masterpiece. Nature may be capable of great things, but you need to seek out the scene within a scene with patience and care. In fact, the need for careful composition is even more important with details. You're presenting something that few people would even notice in the landscape, so unless it's visually arresting the viewer will miss the point and quickly lose interest.

I admit that I do move things around when composing these details in the landscape. I realize some purist photographers have very strong views about the ethics of meddling with nature in the quest of photographic perfection, but a little tweaking is, to my mind, perfectly acceptable if it benefits the final photograph. Obviously, there is a limit to how much 'gardening' you can do before you end up with a rather contrived still-life study rather than a natural detail.

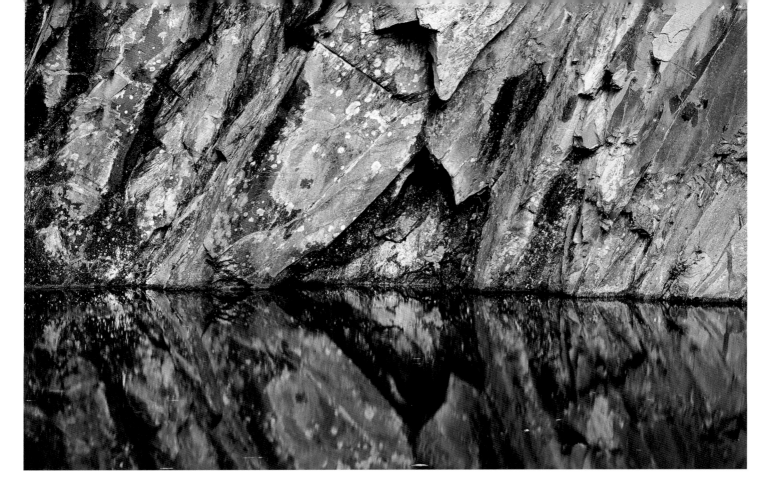

DETAILS FROM AROUND THE WORLD

Wherever I travel, I always make a point of looking for interesting details. The selection shown here are just a few of the many I've taken over the years. Starting clockwise from the top are: Lindisfarne, Northumberland; Glen Nevis, Scotland; Rydal Cave, Lake District; Namib Desert, Namibia; Peterborough, Cambridgeshire; and the Sahara Desert, Morocco. One of the great things about photographing details is you can find fascinating subject matter literally anywhere. Admittedly, several of the shots here were taken in rather exotic locations, but the frozen leaves were photographed in my garden.

Camera: Nikon F5, Mamiya 7II / Lenses: 50mm and 105mm macro (Nikon), 80mm (Mamiya) / Film: Fujichrome Velvia 50

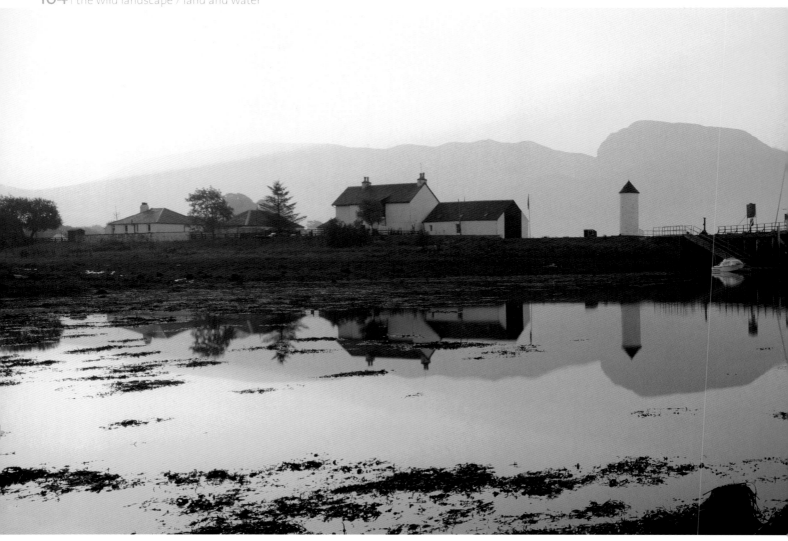

LAND AND WATER

We may gripe about the weather in the UK, but one benefit of high rainfall levels is that water adds great interest to our landscape compositions. The Lake District is perhaps the most beautiful region in England, but can only boast so many lakes, tarns, rivers and waterfalls because it is also the wettest region. If you head there for a few days there's a high probability it will pour down. It's the same in Scotland. The Isle of Skye is renowned for rugged beauty but it is covered in high mountains, so there are often weeks when it doesn't stop raining. For landscape photographers there's no gain without rain.

Rivers and streams make foreground interest, adding a sense of scale, motion and direction to a composition, helping to lead the eye through a scene. This technique works particularly well if you use a wide-angle lens to create sweeping, dynamic compositions. Due to the way they stretch perspective, wide-angle lenses are also handy for utilizing small areas of water. If you move in close and low with a 24mm or 28mm lens, for example, even a puddle or tiny pond can be made to fill the foreground. Stopping the lens down to f/16 or f/22 will maximize depth of field and ensure everything comes out sharply focused.

With a telephoto or telezoom lens you can compress perspective and emphasize the bends in a meandering river or stream to create a dramatic composition. This effect works especially well at sunrise or sunset, when the river picks up the warm colour in the sky and snakes into the distance like a ribbon of gold.

Where there's water you will also find reflections, and for me there's nothing better than a flat, calm lake at dawn or dusk, mirroring the surrounding scenery and the pastel colours in the sky. For the best results you need a perfectly still day so the water's surface is mirror calm. Even when there's a breeze blowing you may find a calm spot in a sheltered area. Remember too, that weather conditions tend to be calmer before

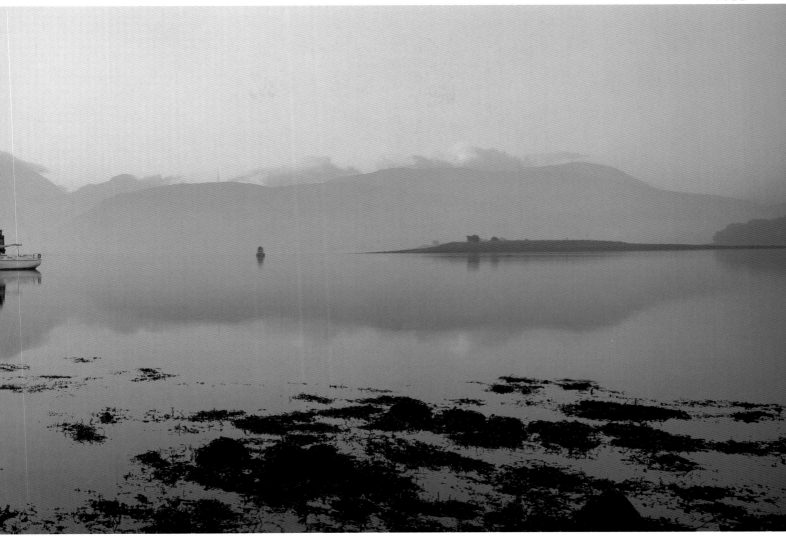

sunrise. Where you have a nice reflection of the landscape and sky in the water it often pays to compose the scene symmetrically, so the far shore cuts across the centre of the frame. This gives you a balanced composition that's easy on the eye and captures the calm, serene mood of the scene.

One problem you'll encounter when photographing scenes of this type is that the reflection often comes out quite a lot darker in the final picture than you remembered it. The solution is to use a neutral density (ND) grad filter to tone down the top half of the picture so you can give more exposure for the reflection and balance the tones. In other words, you cover everything in the top of the picture down to the far shore of the lake with the graduated part of the filter, then increase the exposure by an amount equal to the density of that grad filter so the landscape is left unchanged but the reflection of the landscape is lightened. A 0.3 or 0.45 ND grad is usually strong enough and hard-edged ND grads tend to work better than soft-edged grads. Ideally, the difference in brightness between the scene and its reflection should be no more than one stop. If it is, then the reflection will appear too dark.

Care must be taken though, because if you use a grad that's too dense you'll end up with a reflection that's lighter than the scene being

△
LOCH EIL, CORPACH, FORT WILLIAM, SCOTLAND
I arrived in semi-darkness to find the loch flat and calm with a perfect reflection of the landscape beyond. The tide level was low enough to permit access to the seaweed-strewn shoreline. Delicate mist over the loch and a palette of beautiful pastel colours completed the picture. All I had to do was stand back and record it, using a 0.45ND hard grad to balance the brightness between the scene and its reflection. This is a classic example how water can make a picture, and also why the time before dawn is so magical for photographing scenes with water.

Camera: Fuji GX617 / Lens: 90mm / Filters: 0.3 Centre-ND and 0.45ND hard grad / Film: Fujichrome Velvia 50

reflected, and that goes against the laws of physics. The appearance of water is determined mainly by the colour of the sky, so by shooting at different times of day or in different weather conditions a variety of results can be created as the shades and hues change.

In sunny weather under blue sky, rivers, lakes and the sea tend to look very blue, whereas on a cloudy day they appear grey and drab. Early or late in the day, water takes on an attractive warm cast. At sunrise in spring and autumn mist often rises off the water, which can look incredibly atmospheric, and at sunset it can shimmer like gold.

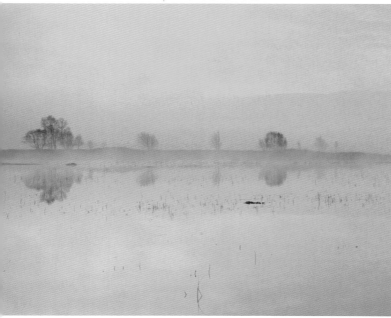

△
LOCH BA', RANNOCH MOOR, HIGHLANDS, SCOTLAND

Despite the weather being changeable over previous days, this April morning was completely calm. When I reached the edge of the loch the far shore was lost in mist, but before long it started to lift, revealing perfect reflections and beautiful colours. I must have used every lens in my backpack to photograph the scene, on both 6x7cm and 6x17cm panoramic, and after the tenth roll of film finally managed to drag myself away, exhausted but happy!

Camera: Pentax 67 / Lens: 45mm / Filters: 0.45ND hard grad / Film: Fujichrome Velvia 50

Don't stop shooting once the sun has set. Keep watching, and notice how the colour of the water slowly turns back to blue as the light fades, but the sky on the horizon is still warm. This warm/cold contrast can look stunning when shooting lakes. Because light levels are low, exposures become long and even the slightest motion in the water will record as a gentle blur, along with anything else that happens to be moving in the scene, such as reeds in the water.

The position of the sun also plays an important role. When it's almost overhead around midday a glassy, highly reflective finish is produced, with lots of tiny highlights dancing on the water's surface. But during the morning or afternoon, when the sun is at a low angle, this light across the water's surface reveals any texture, and you get much better results.

GO WITH THE FLOW

The most effective way to photograph moving water in rivers, streams and waterfalls is by mounting your camera on a sturdy tripod and using a slow shutter speed, so it records as a graceful blur flowing effortlessly around rocks, or plummets earthward in aqueous cascades.

The optimum exposure you need in any given situation will mainly depend on how much water is flowing, but your general aim should be to record some texture in the water.

If a waterfall is running at a gentle trickle, then an exposure of five to ten seconds may be required, so the volume of

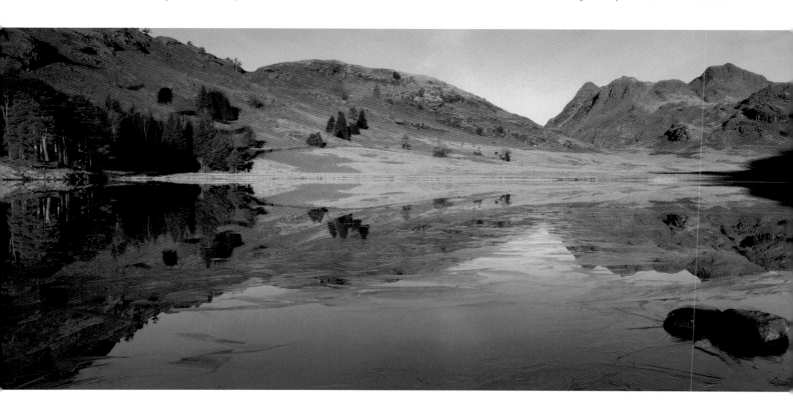

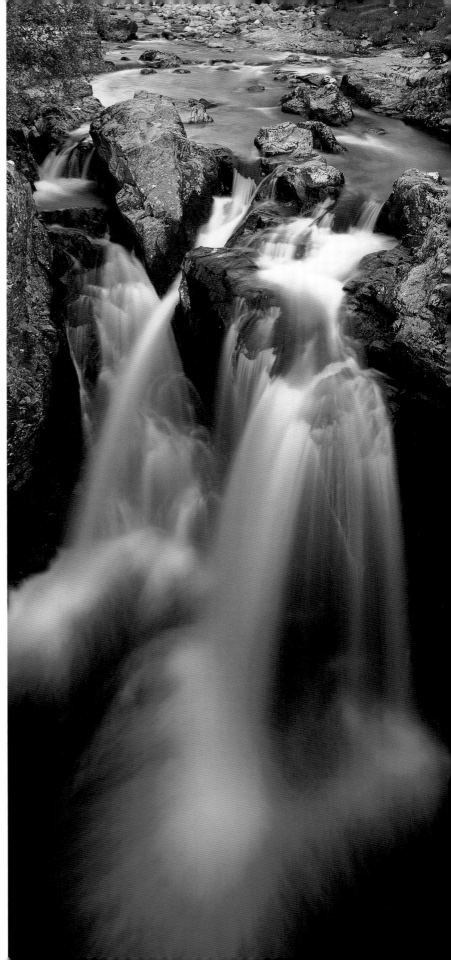

LOWER FALLS, GLEN NEVIS, NEAR FORT WILLIAM, SCOTLAND ▷

This upright panorama was taken on a dull day when the light was nice and soft and contrast was low. I set up my tripod as close to the edge as I dared, so I could not only show the river approaching the falls but also plummeting down to a deep pool 30 feet (9m) below. The blue colour cast was a natural consequence of shooting in overcast weather and into shade, where the colour temperature of the light was much higher than the usual 5500k that colour film is designed for use in.

Camera: Fuji GX617 / Lens: 90mm / Filters: 0.3 Centre-ND / Film: Fujichrome Velvia 50

BLEA TARN, LAKE DISTRICT, ENGLAND

The first time I visited Blea Tarn the weather was grim to say the least. Sunrise came and went unnoticed, thanks to a heavy bank of cloud, and the surface of the tarn was dark and choppy with not the slightest hint of a reflection to be seen. Unperturbed, I returned the next morning and it was as if I had ventured into another world. A clear night sky meant temperatures had plummeted to several degrees below freezing. The edges of the tarn were frozen and within minutes of the sun rising the menacing peaks of the distant Langdale Pikes were bathed in golden light, and reflected perfectly in the calm, icy water. When faced with conditions like this, it's difficult not to take great pictures.

Camera: Fuji GX617 / Lens: 90mm / Filters: 0.3 Centre-ND, 0.45 ND hard grad and Polarizer / Film: Fujichrome Velvia 50
▽

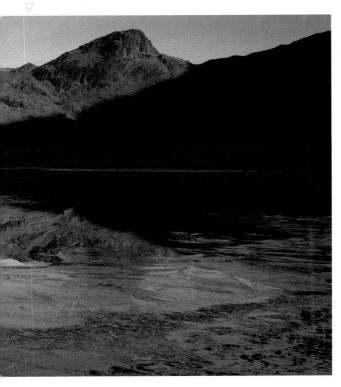

water flowing through the scene while your camera's shutter is open is increased and a decent motion effect is recorded. However, when lots of water is flowing, such as after heavy rain, the exposure needs to be much briefer. Otherwise areas of the picture where the water volume is high will overexpose and you'll have blown-out highlights. If you shoot digitally, experiment with different exposure times until you find one that records a good effect without blowing the highlights. With film you don't get instant feedback, so if in doubt, try a range of exposures.

For example, if a meter reading indicates that correct exposure is four seconds at f/22, expose one frame at that, then further frames at three seconds at f/16 1/2, two seconds at f/16, 1 1/2 seconds at f/11 1/2, one second at f/11 and 1/2 second at f/8. I usually find that an exposure of 1/2-1 second works well on fast-flowing waterfalls.

The rate of flow in rivers is slower than a waterfall, even when in full spate, so you can use longer exposures. When I shoot with my panoramic camera, exposures of 30-60 seconds aren't uncommon, though five to ten seconds will usually be enough. The river scene on page 53 was exposed for longer than a minute and you can see how this has recorded a beautiful effect in the river, especially where the flow is diverted by partially submerged rocks and branches.

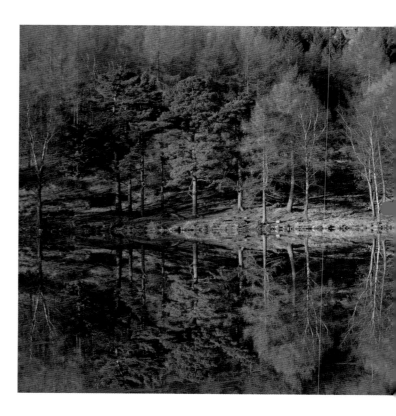

USE A POLARIZING FILTER

A polarizer can serve two purposes when photographing water. It can remove the hazy glare you often see on the surface of calm water so that the reflections in it are enhanced, and it can eliminate reflections completely.

If it's a lake scene with reflections, your aim will be to make those reflections as vivid as possible. A polarizer will either do this, or it will have the opposite effect, so try it and see. To gauge the effect, attach the polarizer to your lens, and then rotate it slowly while looking through the viewfinder. Whether or not you get the desired effect depends on the angle between the water's surface and the lens axis.

To eliminate reflections the angle should be about 30°. The more you deviate from 30°, the less effective a polarizer is.

My advice when photographing water is to see what effect your polarizer has. If it improves the shot, use it; if it doesn't, then leave well alone.

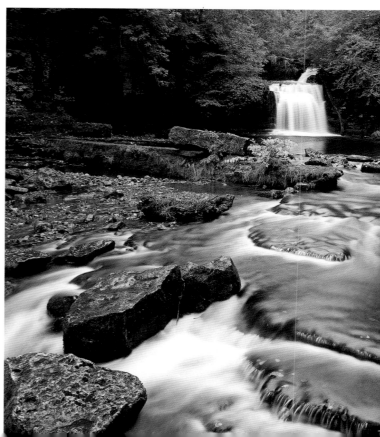

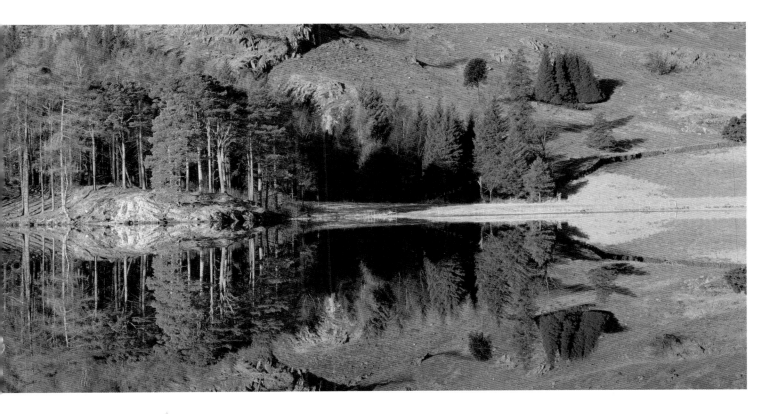

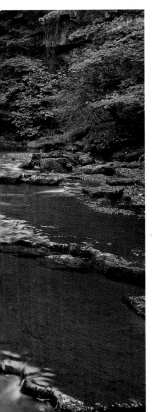

△
BLEA TARN, LAKE DISTRICT, ENGLAND

Having captured wide views of the tarn and distant mountains, I decided to close in on smaller section of the scene with a telephoto lens. Over in the shelter of the trees, the edge of the tarn remained unfrozen, so in the still morning it offered me a perfect mirror image. Thanks to the warmth of the sunlight enhancing the rich colours of the bracken and foliage the scene looked autumnal, but was in fact shot midwinter.

Camera: Fuji GX617 / Lens: 180mm / Filters: 0.45ND hard grad / Film: Fujichrome Velvia 50

◁ ### WEST BURTON FALLS, NORTH YORKSHIRE, ENGLAND

In dull weather, head for woodland and waterfalls: both subjects benefit from the soft light and low contrast. No matter how grim the day, you can still take successful photographs. In the case of waterfalls, dull weather also means low light levels, so you can use long exposures (in this case around 10 seconds) to record motion. A polarizing filter cuts through glare on wet foliage and rocks, so colour saturation is increased.

Camera: Pentax 67 / Lens: 55mm / Filters: Polarizer / Film: Fujichrome Velvia 50

Overcast or dull days provide the best conditions for photographs of waterfall and rivers because the light is soft and the contrast is low, so you won't have bright highlights and glare on the water, or deep shadows to contend with. Light levels will also be much lower than in bright sunshine, so by shooting at a low ISO – 50 or 100 – and stopping your lens down to f/11 or f/16, you should get a shutter speed of at least one second.

If not, you can increase the exposure time by using a neutral-density filter, which will reduce the light entering your lens. A 0.6ND will require a two-stop exposure increase and should be strong enough in most situations, while a 0.9ND will lose three stops and a 1.2ND filter four stops. Alternatively, use your polarizing filter, which will cut the light by two stops.

Before dawn and after sunset are great times of day to push exposures to the limit when shooting water in the landscape, if only to see what happens when you use exposures of several minutes. Motion will not only record in the water itself but also in anything else that's moving in the scene, such as trees and clouds. The results can be amazing, partly because you just never know how the picture will turn out. Reciprocity Law Failure (see page 71) can also cause colour shifts, which usually add to the effect.

COASTAL LANDSCAPES

If there is a heaven on Earth, for me it would probably be a beach on the coast of northern Northumberland, overlooked by a magnificent castle and raked by golden light from the rising sun. Failing that, I'd settle for the uninhabited island of Taransay in Scotland's Outer Hebrides – a pocket-sized paradise with more than enough scenic variety in its few miles of coastline than you could ever hope to find.

Ever since childhood I have loved to be by the sea – hearing the pounding of the waves and the squeal of seagulls; smelling the fresh salty air; feeling the warmth of the sun and the bite of the cold wind. In my late teens I was lucky enough to live on the southern coast of Devon and though spare time was limited by my studies, I toured Devon and Cornwall with a camera, walking the cliff paths and beaches, watching the sun rise and set over the sea and basking in the sense of freedom and open space that my new home provided.

After working in Nortumberland for a short time, we decided to make it our home and, for the last five years, some of England's most unspoilt coastline has been on our doorstep. Dunstanburgh Castle and Embleton Bay are no more than 20 minutes away by car. Alnwick Castle is four miles (6.5km) up the road; Bamburgh is 15 miles (24km) north. In less than 45 minutes, tide permitting, I can be on Holy Island, photographing its magnificent medieval fortress or unique fishermen's huts made from decommissioned herring boats. I have taken more

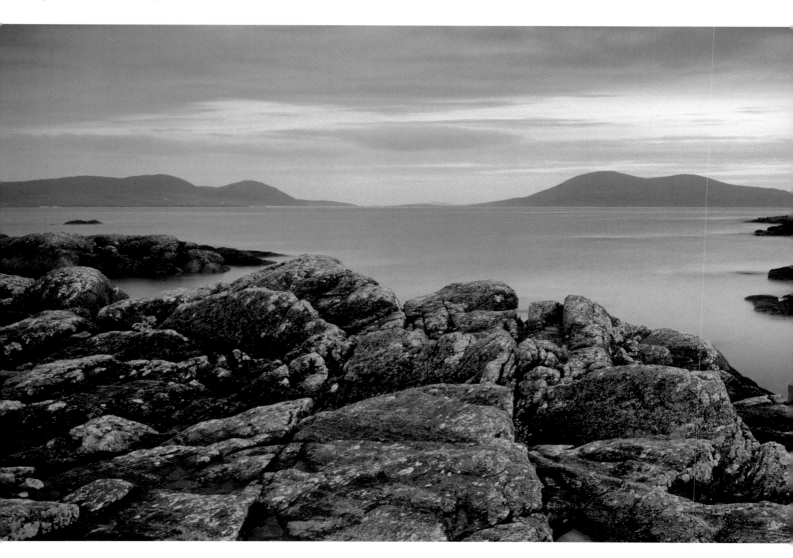

photographs along the stretch of coastline between Berwick-upon-Tweed and Alnmouth than anywhere else in the UK, but I am still in awe of its beauty and never take any of it for granted – I feel blessed to live in such a place, and be doing a job that allows me to enjoy it in full, and share its beauty with other people through my work.

Being so far north in England also makes Scotland easily accessible, and the more trips I make over the border, the more I realise how big the country is – and how little of it I know. Recent expeditions have taken me to the islands of Harris and Lewis in the Outer Hebrides, while my family and I holiday every summer on the uninhabited island of Taransay off the coast of Harris. Looking at Taransay's location on a map gives a clear idea of how remote it is; a small dot on the edge of a vast ocean. It is steeped in history, and for centuries it was inhabited by crofters. As recently as 1974 a family still lived on the island, fishing and tending sheep. Since then the only inhabitants have been sheep, red deer, sea otters and mink – and the occasional film crew!

VIEW FROM TARANSAY, OUTER HEBRIDES, SCOTLAND

Twilight is an ideal time to shoot coastal views. Light levels are low, which means long exposures can be used to blur the motion of the sea, while the light itself is very soft and colours are muted, characteristics that produce tranquil, atmospheric images. For this panorama, taken around 9.30pm on a summer's evening, an ND grad was used to tone down the sky so I could expose for the foreground and record a full range of detail in the rocks. I also needed to stop the lens down to its minimum aperture of f/45 to achieve sufficient depth of field. This resulted in a 90-second exposure, which blurred both the sea and the drifting clouds.

Camera: Fuji GX617 / Lens: 90mm /
Filters: 0.3 centre-ND and 0.75 ND hard grad /
Film: Fujichrome Velvia 50

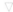

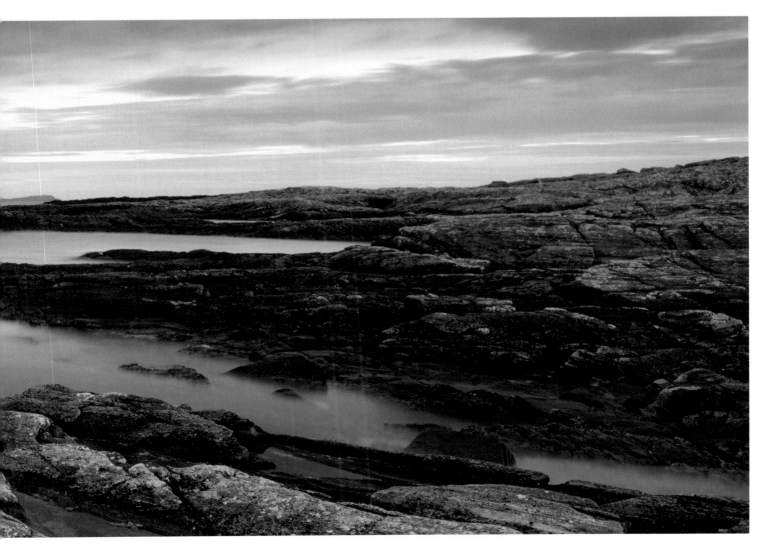

ALL CHANGE

What attracts me most to the coast is the fact that it's in a constant state of flux. Even variations in the tide can make a huge difference to the appearance of a scene – when it's high, beaches disappear and waves wash against the shore; when it's low a fascinating intertidal zone is revealed, complete with ripples, shells, rockpools, pebbles and a myriad of flotsam and jetsam that make great natural still-life and detail shots, as well as useful foreground interest.

Heavy seas slice into beaches and change their shape overnight, shifting thousands of tonnes of sand to create temporary banks and shelves, diverting the course of outflows and rivers that flow through estuaries to the sea. If you placed your tripod in the same spot and photographed the same view once a day for a month you would see just how much the coastal landscape changes thanks to the action of the sea. Photographer Andrew Nadolski took this idea a step further and spent almost a decade documenting one small beach in Cornwall – Porth Nanven. His collection of images has now been brought together in a fascinating book, *The End of the Land*, which anyone interested in coastal photography will find hugely inspiring.

Of course, while the state of the tide can be a help in your pursuit of successful photographs, it can also be a hindrance, so it's always worth checking tide times before travelling any distance. There's no point going to a location at low tide if you want to capture waves crashing against the rocky shoreline, for example. Similarly, if you want to photograph ripples on a sandy beach you need to be there as the tide is receding so the sand is still wet and the ripples more pronounced. There's also less chance of those ripples being ruined by footprints if you're there to catch them while they're fresh, though because high and low tide times change by roughly one hour each day, you may have to wait several weeks before the tide and light are right at the same time.

Getting your timing right is well worth the effort though, because light is the single factor that defines the character of the coastline at any given time, and its quality is determined not only by the time of day and prevailing weather conditions but also the time of year. The position of sunrise and sunset – and the course taken by the sun from horizon to horizon – varies significantly from one season to the next, which in turn affects the angle from which a scene is lit and consequently the impact of your photographs.

For a dawn shoot I aim to reach my location at least 40 minutes before sunrise. If a great sunrise is going to happen, the strongest colours often appear on the eastern horizon well before the sun actually rises, so you need to be set up and ready to catch them. Once up and out I also tend to stick to my plans, so if I arrive at my chosen location and conditions aren't looking promising, I'll hang around just in case.

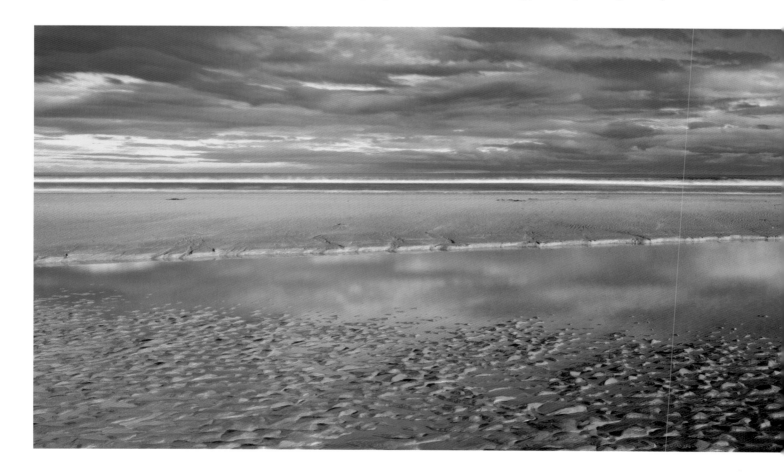

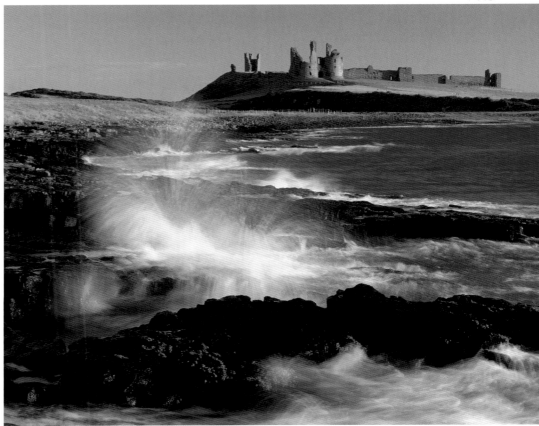

DUNSTANBURGH CASTLE, ▷ NEAR CRASTER, NORTHUMBERLAND, ENGLAND

I took this photograph of Dunstanburgh Castle on only my second visit to the location. The first had been a quick look, which established that the best time to be there would be dawn on a clear morning as the sun rose over the sea. With nothing to block its path, first light would illuminate the castle. Several months later, I returned to find not only clear weather but also a high tide, with waves crashing against the shore. Setting up in a suitable spot, I simply waited for the sun to rise, then started shooting, timing each exposure to coincide with a wave breaking in the foreground. Using a short telephoto lens helped compress perspective and make the composition more dramatic.

Camera: Pentax 67 / Lens: 165mm / Filters: Polarizer and 81C / Film: Fujichrome Velvia 50

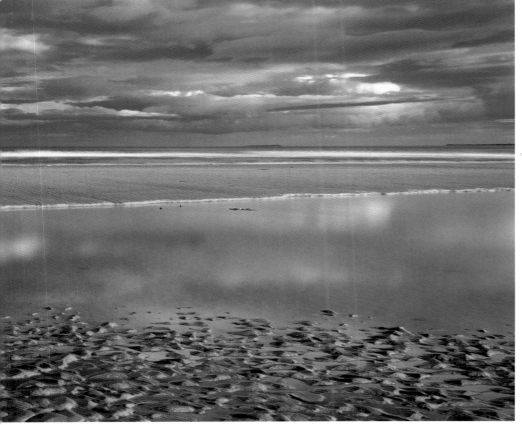

◁ ALNMOUTH BEACH, NORTHUMBERLAND, ENGLAND

Beaches never stay the same from one day to the next. Heavy seas sculpt and shift the sand, creating islands and hollows, while the flotsam and jetsam create an ever-changing canvas. This was captured during a family walk one autumnal evening. Within minutes of arriving, the weather improved. I sensed great light wasn't far away so I dashed home to grab my camera pack. I was in luck with the light. It came and went in a matter of minutes but I was able to compose a couple of successful photographs. What I like about this one is the fact the different elements that create it – the sky, the tide, the shape of the sandbank, those ripples in the foreground and the angle and colour of the light – will never be the same again. It's a unique image.

Camera: Fuji GX617 / Lens: 90mm / Filters: 0.3 centre-ND and 0.6ND hard grad / Film: Fujichrome Velvia 50

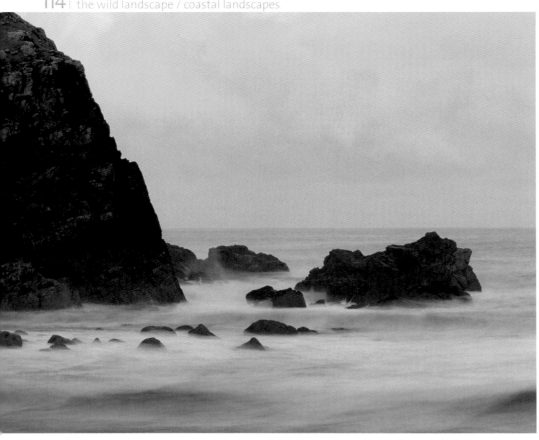

◁ **HARRIS FROM PAIBLE, TARANSAY, OUTER HEBRIDES, SCOTLAND**

My favourite photographs were all taken during a week's stay on Taransay with my family during late August. It wasn't a photographic trip but I couldn't resist packing some equipment. As on previous trips, I wasn't disappointed. On two or three evenings for maybe an hour I was treated to great light, and with our cottage located just yards from the sea I never had to walk far to find a great shot. This photograph shows the view across the Sound of Taransay toward the Isle of Harris. The sun had already dropped too low to light the foreground but this helped emphasize the sunlit hills in the distance and I knew that an ND grad filter would balance things out enough to get perfect exposure across the whole scene.

Camera: Fuji GX617 / Lens: 90mm / Filters: 0.3 Centre-ND and 0.6ND hard grad / Film: Fujichrome Velvia 50

DALBEG BEACH, ISLE OF LEWIS, ▷ **OUTER HEBRIDES, SCOTLAND**

Dalbeg is considered a prime location for sunsets.It's on the northwest coast of Lewis and throughout the year the setting sun can be photographed from the beach. I tried a dawn visit instead, hoping the rising sun would light up the dramatic headlands either side of the beach. Conditions were at their most photogenic when I first arrived not long before sunrise, and the western horizon was glowing with pink-tinged clouds, while the sea was reflecting soft colours from the sky overhead. This pastel palette looked beautiful and, combined with a long exposure to blur the sea, produced a very atmospheric image of a savage stretch of coastline.

Camera: Mamiya 7II / Lens: 150mm / Filters: 0.6ND hard grad / Film: Fujichrome Velvia 50

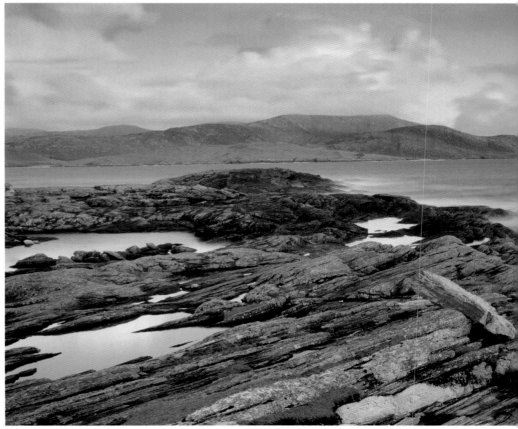

DAWN TO DUSK

I prefer to shoot coastal views at either dawn or dusk, when the light is at its most magical, although in stormy weather it's possible to take great pictures at any time of day. Living on the east coast, dawn tends to be the most productive time, but not in all cases due to the way the topography of the coastline changes. The Aln estuary at Alnmouth is a fantastic location at sunset, for example, while the beach, just a few hundred metres away, works at both dawn and dusk.

Sunny, blue sky days are perhaps the least welcome for coastal landscapes – especially between the middle hours of 10am and 4pm when the sun is high. Lack of cloud renders the sky empty and monotonous, while its blue colour is reflected by the sea and this in turn lends a blandness to the scene that fails to bring out its character. I usually refer to such weather as 'picture postcard' or 'chocolate box'. It's simply too perfect – great for walking and enjoying the scenery, but useless for photographing it. Far more preferable is dull, overcast weather. It may not suit sweeping coastal views, but the soft light and low contrast that's characteristic of such conditions is ideal for coastal close-ups of rocks, pebbles, driftwood and other natural details. The image on page 102 is a good example of this. It was taken in the most appalling weather you could ever expect – in fact, conditions were so bad that after making just a single exposure to record the image, I was forced to pack my equipment away and seek shelter. However, the detail that I was able to record in the diffuse light is incredible, and for that type of image the prevailing weather was perfect.

PLAN OF ACTION

You can deduce a lot about coastal location by checking maps, so whenever I'm planning to visit an new area I always buy a map and study it closely, marking locations of interest and working out if they're likely to work best at dawn or dusk. This can never be as effective as a site visit, but by pre-planning, that initial visit may produce some great picturesand allow you to familiarise yourself with a new location.

For a dawn shoot I aim to reach my location at least 40 minutes before sunrise. In winter this often means heading out in darkness, but if a great sunrise is going to happen, the strongest colours often appear on the eastern horizon well before the sun actually rises so you need to be set up and ready to catch them. Once up and out I also tend to stick to my plans, so if I arrive at my chosen location and conditions aren't looking promising, I'll hang around just in case. It can be raining hard one minute, clearing the next. Also, it only takes a small window in the sky to let a little colour through and suddenly the scene is transformed. At the other end of the day I try to be on-site an hour or two before sunset – the last hour of daylight can be stunning.

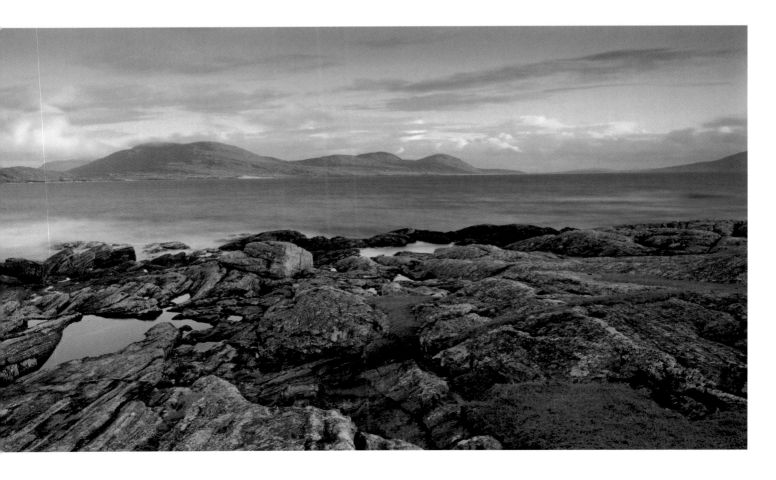

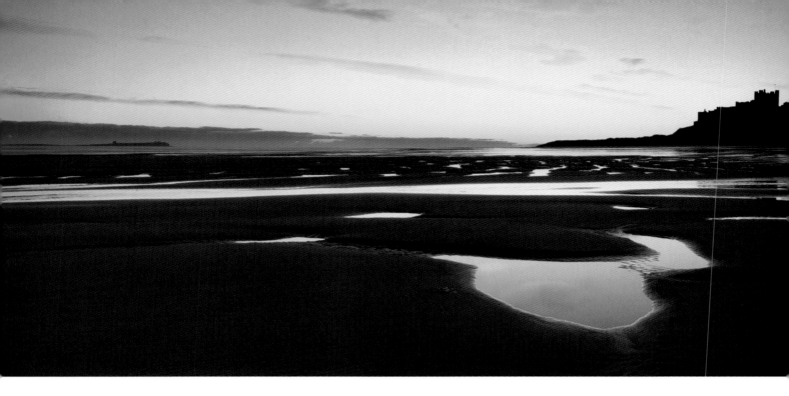

MOTION PICTURES

A great benefit of shooting coastal scenes at dawn and dusk is also that light levels are low, so you can use a long exposure to record the sea as an atmospheric mist.

When I set-up my Fuji GX617 panoramic camera at dawn I'm often forced to use exposures of a minute or two, as small apertures are required to give sufficient depth of field (f/32 and f/45 are common), plus the 90mm wide-angle lens I favour is fitted with a one-stop centre ND filter which doubles the exposure time. However, I'm happy to do this because as well as recording motion, such long exposures also tend to draw more colour out of a scene than the naked eye can resolve – simply because it's allowed to build-up slowly on the film.

The only downside of such long exposures is that I don't have the chance to make many of them before the light changes, and on a wet sandy beach the longer the exposure is, the greater the chance of camera shake caused by the tripod legs slowly sinking while the image is recording. I have lost great shots due to this in the past so I always give the tripod a good shove down to make sure the legs are well bedded. Of course, you don't need to use exposures that are minutes long, and in normal circumstances 10–20 seconds will be more than enough.

If stopping your lens down to its smallest aperture doesn't give you an exposure that's long enough, you can always fit a neutral density (ND) filter over your lens to force an exposure increase. A 0.3ND filter will increase exposure by one stop, a 0.6ND by two stops and a 0.9 by three stops. I even carry a 1.2ND filter which increases the exposure by four stops, so if the metered exposure is 4 seconds, with a 1.2ND on the lens it becomes 64 seconds.

Recording motion in the sea works best if you include something solid and stationary in the foreground. Rocks are ideal because they divert the flow of water and their solidity contrasts well with the misty effect created by the blurring of the water. Driftwood also works well, as do old jetty and pier supports. When shooting at beach level I often look for a rocky shelf where I can capture waves flowing by, and I have been known to take my boots off and wade in to get the right view.

KEEP IT CLEAN

The sea air is clogged with salt and tiny particles of spray, so one thing you'll notice when shooting coastal views – especially on a windy day – is that the front element of your lens, or any filter attached to it, ends up covered in a salty film. If you don't clean this off it will damage the delicate optical coating on the glass, degrade image quality and increase the likelihood of flare.

I always carry a microfibre lens cloth with me and check the lens or filter every minute or so. In bad weather I even clean it after each exposure because the salt and moisture can build up very quickly.

If you're shooting near crashing waves, saltwater on your cameras and lenses infiltrates the delicate circuitry, and corrosion is likely. The same applies to sand, tiny particles of which can get inside the narrowest gaps and cause damage to focusing and zooming mechanisms. They usually work free after a while, but it's rather disconcerting to hear a nasty grinding sound every time you focus a lens, or to find the zoom control has been jammed by sand. You can avoid this by keeping your camera pack zipped shut and protect your camera with a waterproof bag of some kind even when you are using it, as much as possible.

◁ BAMBURGH CASTLE, NORTHUMBERLAND, ENGLAND

My earliest memory of Northumberland is seeing Bamburgh Castle, a magnificent fortress that dominates the village and coastline from its elevated perch on the great Whin Sill. Photographically it deserves star status, being one of those rare locations that looks amazing throughout the year and from dawn to dusk. This panorama was captured at dawn in late autumn when the castle is thrown into silhouette by the glowing sky, but in spring and summer the sun rises further to the north. At end of the day, the dying embers of the sun now illuminate the castle, as shown by the smaller picture below.

Camera: Fuji GX617 and Pentax 67 / Lens: 90mm and 55mm / Filters: 0.9ND hard grad (panorama) and 0.6ND hard grad / Film: Fujichrome Velvia 50

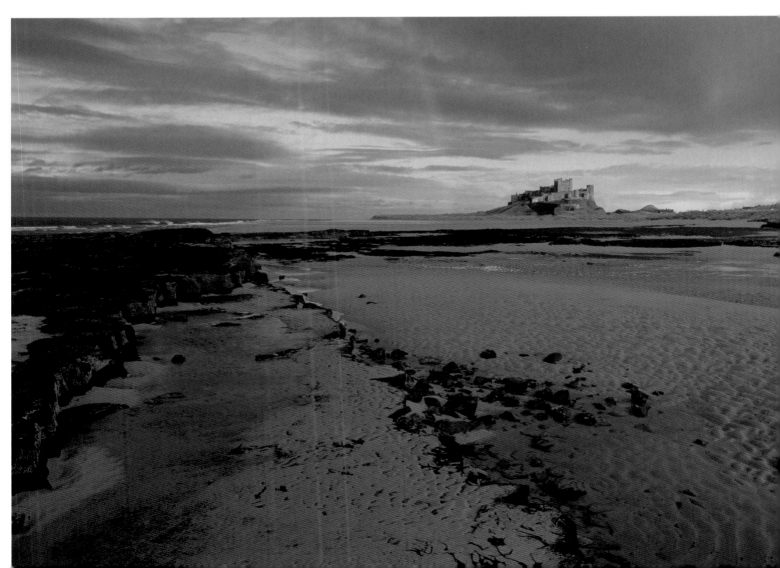

TROPICAL ISLANDS

Crystal-clear aquamarine seas gently lapping pristine, white-sand beaches, palm trees swaying in the breeze against a velvet-blue sky and the crash of waves on a distant reef... tropical islands conjure up all kinds of exotic images. Having visited a fair few, I can say with confidence that every single image rings true.

I made my first tropical photographic trip in the late 1990s when I travelled out to the Maldives to shoot stock images. Back then, shots of leaning palm trees on desert-island beaches had the potential to be big sellers. They were used by the tourist trade for brochures and posters, and to advertise things like pension plans and savings schemes. The subliminal message was that if you were careful with your cash, one day you could be enjoying life's luxuries. And what better luxury than lounging on a tropical beach? Keen to boost my stock sales, and to spend time working in a warm environment rather than the wind and cold, I used this as a perfect excuse for a trip.

As it turned out, that first visit wasn't a great success photographically. Travel in the Maldives is quite limited because tourists are only allowed on resort islands, so the only access I could get to any culture was on short island-hopping trips to islands where the locals lived and worked, and I was rarely there at the best time of day.

Despite seeing lots of classic images of leaning palm trees on deserted beaches in brochures and picture-library catalogues before the trip started, I struggled to find many myself. Leaning palm trees are a danger to the public because they're likely to topple over. So, in this litigious age, they tend to be chopped down before anyone gets injured and sues. I'd even heard stories of desperate stock photographers trying to topple palm trees after shooting them so no one else could get the same picture. Whether that's true or not I don't know, but when a picture can earn seriously big money, not all photographers care about fair play or the environment.

Despite my disappointments, I enjoyed the experience of shooting in an environment and climate so far removed from the one in which I usually work. It was a treat to get up each morning knowing the sky would be clear and the light quality good, instead of half expecting gales and rain. I also enjoyed wandering around barefoot in shorts and t-shirt, feeling the warmth of the sun instead of being cocooned in layers of thermal clothing.

ANSE SOURCE D'ARGENT, ▷ LA DIGUE, SEYCHELLES

I took many photographs of Anse Source d'Argent, but this is my favourite. I began shooting wider views with a panoramic camera, then edged closer to this outcrop. The strong light, bold shapes and lack of shadows suited this graphic approach, and using a polarizing filter added to the impact.

Camera: Pentax 67 / Lens: 55mm / Filter: Polarizer / Film: Fujichrome Velvia 50

TROPICAL TIPS

The most obvious thing I learned on that first trip was that light levels are significantly higher in the tropics than they are back home. When I first started taking exposure readings in full sun I thought there must be a problem with my lightmeter – I just wasn't used to it being so bright. The average tonality of a scene is also much higher than the usual 18% of reflected light that lightmeters are calibrated for, especially when shooting white-sand beaches that are almost as reflective as snow. Thus there was a great risk of underexposure, especially with my preferred film stock, Fujichrome Velvia 50. To avoid this I made sure every shot was bracketed at least one stop over the metered exposure in 1/3 or 1/2 stop increments.

A polarizing filter became an almost permanent fixture on my lenses, because it made a huge difference to the impact of pictures taken in bright sun. It deepened the blue sky, emphasized white clouds, saturated the green of palm trees and eliminated glare on the sea.

I also discovered that the best time of day to photograph beach scenes was during the middle hours of 11am–2pm. Normally this is the worst time of day to shoot landscapes, but the glare of the overhead sun on the white sand helped hide any footprints. Tourists tended to abandon the beaches in favour of lunch or a break from the heat so I had them to myself. Stock images of tropical beaches are always likely to sell more when there are no people visible. The sea also looked amazing because it was reflecting the deep blue of the sky.

Condensation was a nuisance. Staying in an air-conditioned room, I found that as soon as I stepped outside into the heat and humidity, my lenses, filters and viewfinders were fogged by condensation. To avoid this, I placed my camera pack outside the room an hour or so before heading off so the equipment had a chance to acclimatize before I needed to use it.

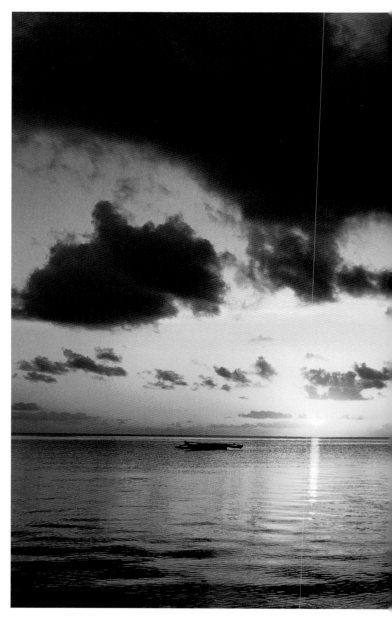

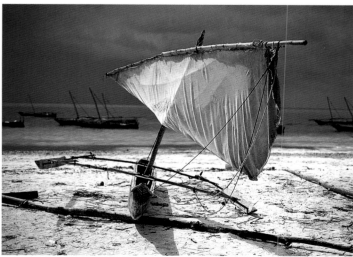

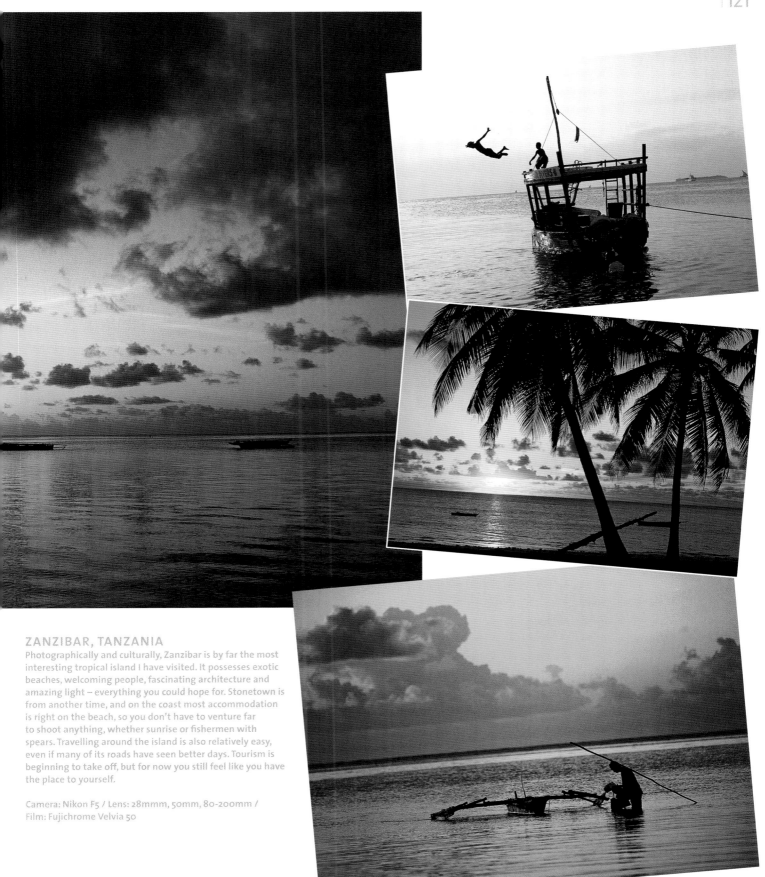

ZANZIBAR, TANZANIA

Photographically and culturally, Zanzibar is by far the most interesting tropical island I have visited. It possesses exotic beaches, welcoming people, fascinating architecture and amazing light – everything you could hope for. Stonetown is from another time, and on the coast most accommodation is right on the beach, so you don't have to venture far to shoot anything, whether sunrise or fishermen with spears. Travelling around the island is also relatively easy, even if many of its roads have seen better days. Tourism is beginning to take off, but for now you still feel like you have the place to yourself.

Camera: Nikon F5 / Lens: 28mm, 50mm, 80-200mm / Film: Fujichrome Velvia 50

SOMEONE'S GOT TO DO IT

A year or so after the Maldives trip I headed to the Seychelles and spent ten days exploring the islands of La Digue and Praslin. Photographically they were much more inspiring than the Maldives, especially the beach of Anse Source d'Argent on La Digue with its sculptured granite outcrops. It was a magical place, and I managed to photograph it in relative solitude.

The one thing still missing was culture. Many of these tropical island destinations are so geared up for tourism that local culture seems to have disappeared behind the facades of hotels, restaurants and diving schools. I needed somewhere that was untouched, and still a little rough around the edges. I found all that and more on the island of Zanzibar.

At times Zanzibar was ruled by Portugal, Great Britain and most significantly, by the Omanis, who grew rich through their trade in cloves, ivory and slaves. They left a legacy of imposing forts, beautiful palaces and narrow, winding streets packed with wonderful nineteenth-century mansions. Tourism is now taking a hold on the coast and it has become a popular place to relax on the beach after a Tanzanian safari. Numbers are still quite low and Zanzibar remains very much a working island, just managing to survive in the face of economic hardship.

The capital, Stonetown, is a wonderful maze of narrow winding streets and home to a daily fishmarket of biblical proportions, where dozens of primitive fishing boats unload their catch at dawn. Down on the waterfront, dhows with flapping canvas sails can be captured against the setting sun as they head for shore while local boys dive into the sea off moored boats or somersault and cartwheel along the sand. Local men still head out toward the reef to fish with spears at low tide, while women harvest seaweed and collect seashells. I felt as though I was witnessing scenes that hadn't changed in hundreds, maybe thousands, of years. Photographically the island is fascinating, and full of colour and character. The local people are also friendly and inquisitive, but it's still the kind of place where if you turn up unannounced in a small village, children are likely to run away shrieking because they have never seen a white face before.

HEALTH CONSIDERATIONS

Although tropical islands look like paradise they're not always the safest places to travel from a health point of view. Always consult your local doctor or travel clinic before embarking on a trip and check if any precautions are necessary.

You will almost certainly need a variety of vaccinations that may include Yellow Fever and a course of malaria pills. It's also wise to stay away from stray dogs and cats – as cute as they look they could carry all sorts of diseases, including rabies. Take special care when walking in the sea. I learned this on my first trip to Zanzibar. I waded into the shallows, without any footwear, only to notice when I was well away from the shore that the whole seabed was littered with sea urchins. It took me almost an hour to dig their sharp spines out of my feet.

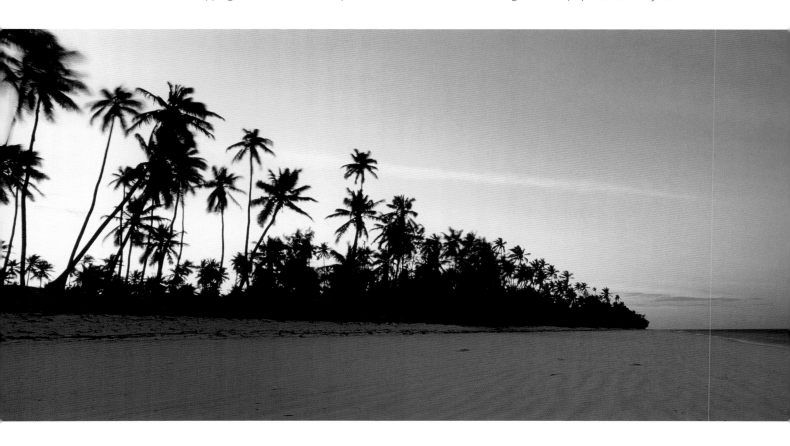

JAMBIANI, ZANZIBAR ▷

Swaying palm trees on a deserted beach perhaps sum up the dream of tropical islands more than anything else, so when I spotted this scene while exploring Jambiani on Zanzibar, I couldn't resist taking a few shots. Conditions were perfect: not a person in sight, strong, crisp light, the sun at the perfect angle to use a polarizing filter and stunning colours. I used my widest lens so I could include both the trees and their shadows and shot hand-held. When light levels are this high, a tripod is not so important because the exposures are so short.

Camera: Nikon F5 / Lens: 20mm / Filters: Polarizer / Film: Fujichrome Velvia 50

BWEJU, ZANZIBAR

The sun sets very quickly close to the equator and nightfall descends at an alarming rate, but the very short twilight period when the sky turns purple and pink is well worth waiting for. I set up this shot just one minute away from my beachside hotel and continued shooting until all colour had drained from the scene. Exposures ran into many seconds, but this enabled me to record movement in the swaying palm trees, drifting clouds and the sea gently lapping at the edge of the beach.

Camera: Hasselblad Xpan / Lens: 45mm / Film: Fujichrome Velvia 50
▽

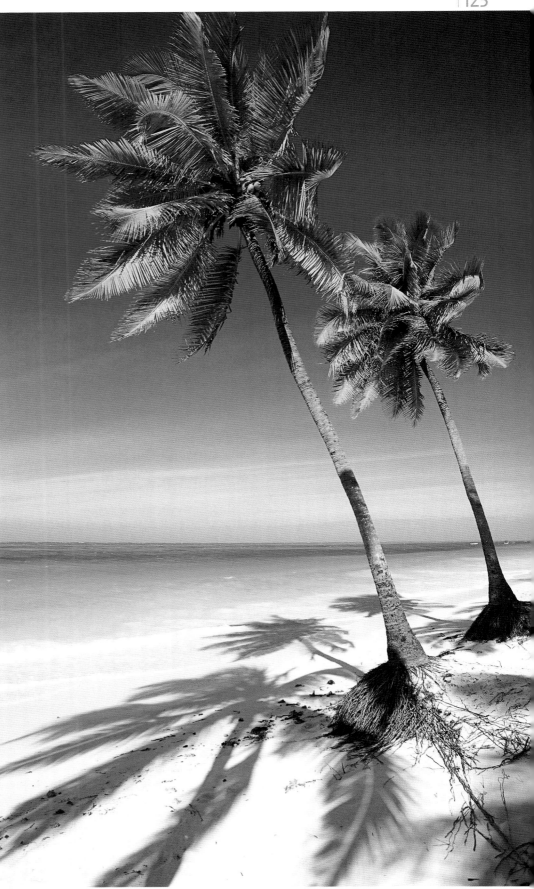

THE URBAN

Busy towns and cities offer the landscape photographer as many visual opportunities as the countryside and coastline. I really enjoy the challenge of working in cities surrounded by the hustle and bustle of traffic and people. It's a totally different world – chaotic, noisy, aggressive and impersonal. Creatively, the urban landscape is full of possibilities, offering subjects from architecture to abstracts. And cities aren't always busy. Head out before dawn and you feel like the place is yours, slowly coming to life and preparing to face the day under the watchful gaze of your lens.

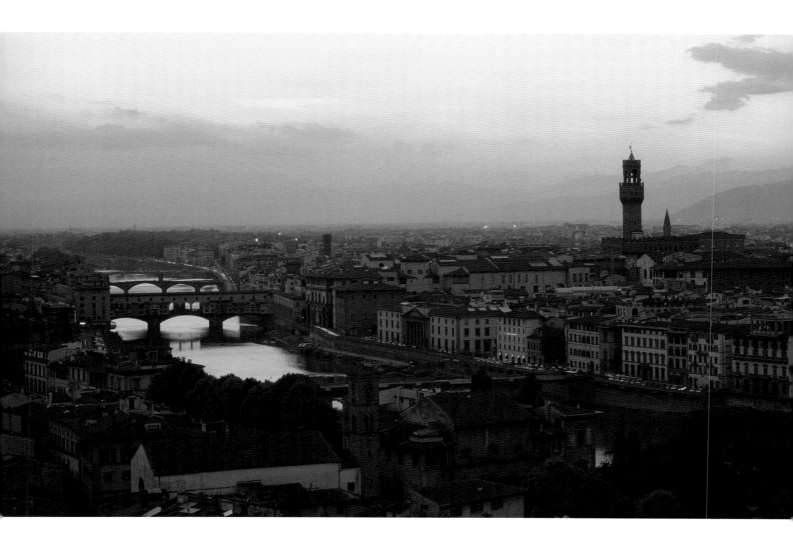

LANDSCAPE

My fascination with low-light photography began in Torquay, and I spent night after night attempting to capture the wonderful flashing neon signs, hundreds of lightbulbs strung along the pier and the colourful reflections in puddles on parked cars. My first published photographs were shots of Torquay at night and I still enjoy shooting towns and cities at night.

Later a move from Devon to Cambridgeshire and regular visits to London offered urban scenes on a much bigger scale, like Big Ben, St Paul's Cathedral, Tower Bridge and Canary Wharf. These iconic buildings and monuments were the subjects upon which I honed my new skills.

That's the great thing about the urban landscape – it offers a wealth of different subjects and encourages us to try something new. I remember leading a creative photography workshop in London several years ago and over the course of just three days we shot architecture, night scenes, abstracts, patterns, sunrises and action. We visited Speaker's Corner to try our hand at reportage and candid photography, and experimented with panning, differential focusing, using filters and infrared red film. Only a city could ever provide the breadth of subject matter to present us with such a challenge.

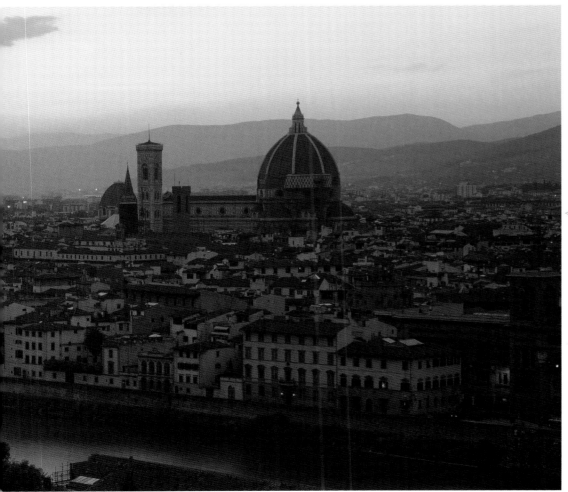

◁ **FLORENCE, ITALY**
Historic towns and cities appeal to me far more than modern urban developments. Their ageing buildings and narrow streets are so full of atmosphere and character. Italy is home to some of the most beautiful cities in the world. Venice has to be top of the list, but Florence isn't far behind, and this view of the city from the Piazza Michelangelo illustrates why. Shot at sunset not long after I flew into the city, it shows many of the city's key landmarks, from the ancient Ponte Vecchio over the River Arno on the left to the Uffizi gallery and the magnificent Duomo. The panoramic format was ideal for capturing this view.

Camera: Fuji GX617 / Lens: 180mm / Filters: 0.6ND hard grad / Film: Fujichrome Velvia 50

SHOOTING ON THE MOVE

I prefer to travel light when shooting urban landscapes, and I choose 35mm equipment because it's quick to use on the move. I rarely carry a tripod, except when shooting in low light. This allows me to work with a much broader range of compact and fast lenses, from ultra wide to long telephoto, so I can experiment with composition and produce more varied and exciting images.

In cities where the architecture is old and characterful (the type of locations I prefer) I favour warm light. Therefore early morning and late afternoon, when the sun is low the angled light gives texture to buildings and streets, are prime times. I will often shoot into the light to capture people, cars and buildings in semi-silhouette, hiding the sun behind a lamp post if necessary to avoid flare. Bracketing exposures up to two stops over the metered reading will produce a range of effects. When the sun is low and the light warm, I like to shoot details because such light reveals the texture of old stonework and crumbling masonry. If you are using a digital camera, you have the benefit of instant feedback and can use this to determine the ideal compromise between highlight and shadow, even when shooting in highly contrasted light.

Modern architecture, with its bold lines and graphic design, is more suited to stronger, neutral light, so I am happy to shoot this through the middle of the day when the sun is high in the sky, contrast is up and shadows are dense. A high sun also puts more light at street level because it isn't obscured by tall buildings as much and this can make a big difference when shooting street scenes. It is normal in cities of high-rise buildings for half of the street to be in shadow and the other half lit, creating an exposure and contrast nightmare. This is where digital always wins because you can check as you shoot.

I often take pictures from dynamic angles, moving in close with a wide lens and looking up to capture the building against the sky, maybe using a polarizer to deepen the sky and add impact. Or I will switch to a telezoom and fill the frame with the patterns created by repeated architectural features. I also like shooting cities from high or distant viewpoints and make a point of checking out guidebooks and postcards to see if such a viewpoint exists. If it's any good, there will be reference to it somewhere.

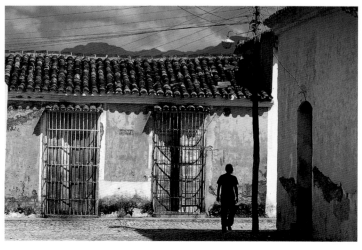

HAVANA, TRINIDAD, CUBA

Cuba is a place where cliches come alive on a grand scale. There really are vintage American cars parked on every street or cruising the elegant boulevards. Lively music really does emanate from every bar and balcony. And there really are cigar-chomping taxi drivers, cowboys on horseback and faded murals of Che Guevara. Walk down any street in Old Havana and you won't know what to photograph first. It's the same in such towns as Cienfuegos, Vinales and Trinidad. Cuba is one of those places where the more you return the more inspired you feel.

Camera: Nikon F90x and Nikon F5 / Lenses: 28mm, 50mm, 80-200mm / Filters: Polarizer / Film: Fujichrome Velvia 50

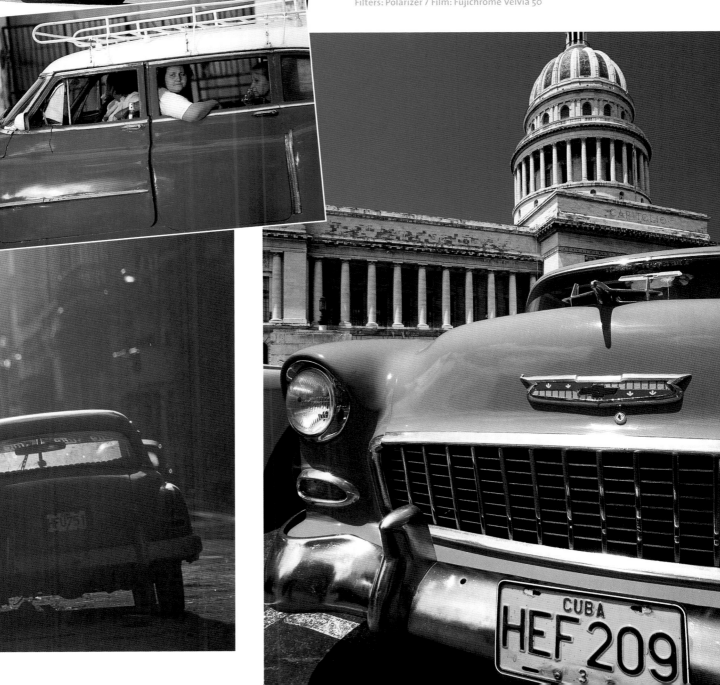

PLACE DJEMMA EL FNA, MARRAKECH, MOROCCO

Marrakech is another city I have visited on many occasions and the Place Djemma el Fna at the heart of the Medina never fails to impress. Relatively quiet by day, it turns into a exotic and noisy spectacle every evening when thousands of people form a sea of bodies flowing around outdoor food stalls, storytellers, acrobats and dancers. Café terraces around the square provide a perfect view for photographers and for this shot I used an exposure of several seconds to record the scene as caught by the dying embers of the setting sun.

Camera: Nikon F5 / Lens: 80-200mm / Film: Fujichrome Velvia 50

SANTA MARIA DELLA SALUTE, VENICE, ITALY

You can't really fail to take successful photographs in Venice. Perhaps the most romantic and atmospheric city on Earth, it looks amazing at any time of day and in any weather condition. My advice is to visit during the winter when the crowds are smaller and the low sun produces truly magical light. This view was captured at sunrise in February from the Academmia Bridge.

Camera: Nikon F5 / Lens: 80-200mm / Film: Fujichrome Velvia 50

GO WITH THE FLOW

I don't have a game plan when shooting the urban landscape. Out in the countryside I spend a lot of time in one spot, but in the city I tend to move around much more and respond to anything that catches my eye.

In the Cuban capital of Havana, one of my favourite cities, I remember taking some shots of an old American car early one morning. Then, as I looked up, I noticed a pig's head hanging outside a butcher's shop across the street. How could I resist? Moments later I was shooting street scenes into the light as the sun came up, then more cars, then architectural details and then a few portraits. This was before breakfast! This fast pace and huge variety is exhausting and after a few days I'm ready for the countryside again. But it's a great antidote to pure landscape photography because it sharpens the senses and helps me to keep my eye in.

If I spent all my time shooting pure landscape I think I'd go slightly mad because there are only so many times you can hang around for hours and take no pictures. In the city that's never a problem. Rarely a moment goes by without at least a few clicks of the shutter. When I return from a trip I'm always excited about seeing the results because, with so much subject matter on hand, I've usually forgotten what pictures I took that morning. By the end of ten days and 50 or more rolls of film, it's all a complete blur, until I lay those sheets of freshly processed Velvia on my lightbox and the memories coming flooding back.

REMEMBER – IT'S A JUNGLE OUT THERE!

If you can cope with the noise, traffic and crowds, then photographing busy cities is an exciting and challenging experience. However, cities can be hostile environments, especially at night, and wandering around laden down with expensive camera equipment is likely to attract attention from the wrong people. I have been lucky so far and never encountered problems, but I have heard numerous stories from photographers who have. To avoid problems, always stay in busy and well lit areas at night, avoid straying into unknown neighbourhoods at any time and minimize the amount of equipment you carry. Always keep your camera packed away when it's not in use and, if you can, travel around with someone else and that will give you added security. It's common sense really, but it's amazing how easily photographers become distracted and forget it when they see the chance to take a great picture.

◁ **LLOYDS BUILDING, CITY OF LONDON, ENGLAND**
Modern architecture seems to look its best at night, when it's lit up by colourful manmade illumination against the fading twilight sky. Wide-angle lenses are essential when shooting tall buildings from close range and this inevitably leads to converging verticals. On the right subject this creates a dizzying perspective and adds drama and impact to the composition.

Camera: Nikon F90x / Lens: 17-35mm at 17mm / Film: Fujichrome Velvia 50

FAMOUS VIEWS

Wherever you travel today, it's difficult to avoid famous landmarks and classic views – or to resist the temptation to photograph them. What trip to Paris would be complete without a few shots of the Eiffel Tower, Arc de Triomphe or Notre Dame, for example, or in London, Big Ben, St Paul's Cathedral and Tower Bridge? But it's not just capital cities that offer us such iconic images. Thanks to cheap air fares and growing disposable incomes, the world has become a much smaller place, and even the remotest corners are ever more easily accessible.

Of course, many of the most famous views in the world are made so by tourism, and the vast majority of them are historical monuments created long before the birth of photography. However, photographers can be very influential too and a growing number of locations around the world have attained legendary status simply because of their photographic appeal.

Even the most obscure view can become famous among photographers over a period of time. All it takes is a few images appearing in a photography magazine. Those images inspire more photographers to visit the same location and then a slow trickle turns into a flood.

Take Namibia in southwest Africa. A decade ago few photographers had even heard of the place, but now if you put an image of skeletal trees against orange sand dunes in front

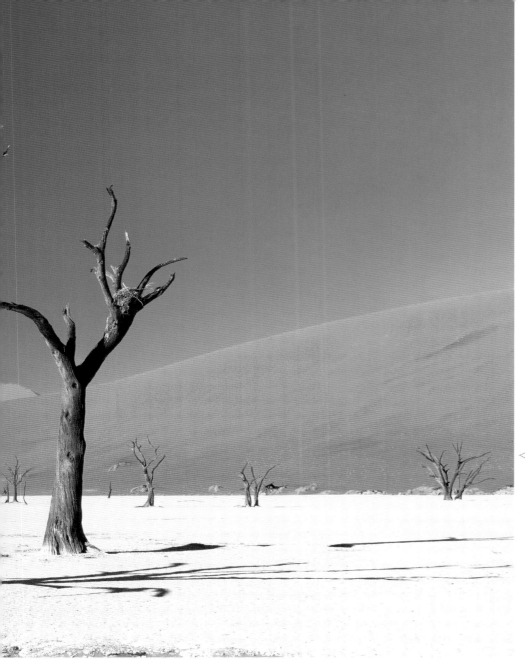

◁DEAD VLEI, NAMIB DESERT, NAMIBIA

Not those damned dead trees again! Despite being located in the middle of nowhere, 50 miles (80km) from the nearest signs of human habitation, these skeletal trees have become an iconic image of the magnificent Namib Desert, instantly recognizable to photographers throughout the world. Should this familiarity rule them out as a worthy landscape location? Only you can decide that, but having visited Dead Vlei several times already I would return without hesitation because it is, to my mind, one of the most magical places on Earth.

Camera: Fuji GX617 / Lens: 90mm / Filters: 0.3 centre-ND and polarizer / Film: Fujichrome Velvia 50

of them, nine out of ten photographers will know the country, and be able to give you the name of the exact location – Dead Vlei, among the towering dunes of the Namib Desert.

It's the same with pretty much every country around the world. Think of Belvedere in Tuscany, Delicate Arch or Antelope Canyon in Utah and for those living in the UK, for example, Lochain na h'Achlaise in Scotland, or Bamburgh Castle on the Northumberland coast. Most serious photographers could identify images of these places with little hesitation, despite never having being there.

I'm perhaps more guilty of encouraging this than most through my workshops and photographic tours. By taking groups of photographers on location and helping them produce inspiring pictures, I'm not only introducing those individuals to areas they had perhaps never heard of, but to the people who see their photographs through competitions and exhibitions. Personal websites and image-sharing sites are also growing in popularity and for the first time ever a global audience is available to all of us in a matter of seconds, thanks to the power of the internet.

When I first started photographing Northumberland ten years ago, very few photographers knew the area because, being so far north, it tended to be bypassed in favour of Scotland and better-known regions such as Rannoch Moor and Glencoe on the Isle of Skye. Now, however, all the key locations in the region are well known and it's rare for a month to go by without images of Northumbrian castles or the region's untouched beaches being scattered around on the pages of a photography magazines. Such a rise in the region's popularity is not solely down to me, but I think I might have helped!

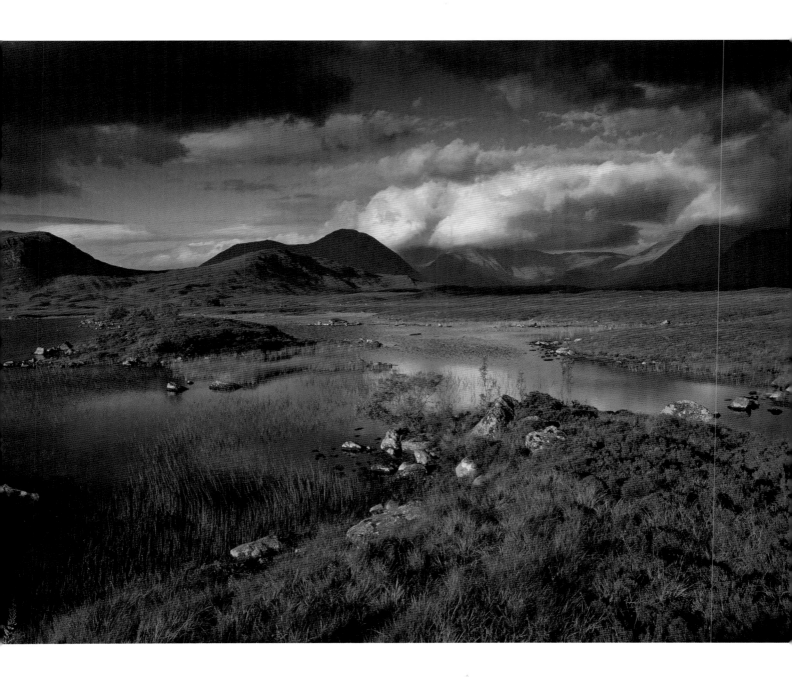

ICON OR CLICHE

At what point does an iconic view become a cliche? And even when it does, should it make any difference?

Several years ago I remember a well known landscape photographer in the UK stating in a magazine article that he would never visit or photograph a certain scene in the Lake District because it had been vastly overshot. What he didn't mention was he had photographed that very scene on several occasions in the past and so had probably helped create the very same cliche he was condemning.

I agree there is no point going out and spending all your time

LOCHAIN NA H'ACHLAISE, RANNOCH MOOR, SCOTLAND

This has become one of the most popular locations in the north of Scotland. It's easily accessible yet the view over the lochain toward the Black Mount hills is truly magnificent. When I took this photograph many years ago, I didn't realize the view was quite so famous. Months later I discovered I wasn't the first – or, for that matter, the thousandth –to capture the scene. This didn't dampen my enthusiasm and I have returned to Rannoch Moor many times.

Camera: Pentax 67 / Lens: 55mm / Filters: 0.6ND hard grad / Film: Fujichrome Velvia 50

shooting the same scenes as everyone else, and that every photographer should try to find their own creative voice. But at the same time I also think there's a lot to be learnt from visiting and photographing popular locations.

If nothing else, it allows you to put the images you have seen into context and decide if they were obvious interpretations any photographer with a reasonable level of experience and skill could have taken, or something special that took real vision.

This can be a huge confidence booster. When we see amazing images, we assume we could never produce something that good ourselves simply because we're not talented enough. In some cases this is true. There are photographers out there whose technical and creative ability, combined with absolute dedication to their art, puts them on a different plane from mere mortals. But often this is not the case, and the scene itself offers everything on a plate: all you need to do is get there at the right time of day with the right sort of equipment, and capture the image in great light. I discovered this for myself when I visited Utah and Arizona

for the first time in 2005. I had spent years admiring the work of such photographers as Tom Til, David Muench and Michael Fatali (still do) and dreamt of photographing the Red Rock country of Utah and Arizona they had made their own. When I finally got there I was completely overwhelmed by the grandeur and natural beauty of the scenery, but a small part of me felt disappointed because I realized that taking stunning photographs in such locations actually isn't all that difficult if you get the light right. Because the weather is fairly predictable for much of the year, all you need to do is set your alarm clock early or to stay out late, depending on the location.

The main appeal of shooting popular locations is the opportunity to pit your own talents against the photographers who came before you. Despite my conviction that taking great shots in amazing locations isn't difficult, (providing you have the right equipment and know how to use it) I've always been one for putting my camera where my mouth is. I would never make such statements without also being willing to put my own work up for scrutiny, which I do all the time in books and magazines.

ASHNESS BRIDGE, BORROWDALE, LAKE DISTRICT, ENGLAND

It may be famous but also happens to be a pretty dramatic view when the bracken-clad hills glow orange, and dark clouds frame the distant Skiddaw Fells.

Camera: Pentax 67 / Lens: / Filters: / Film: Fujichrome Velvia 50

VAL D'ORCIA, TUSCANY, ITALY

Instead of capturing a sweeping wide-angle view of the valley and famous hilltop farmhouse, I used a moderate telephoto lens to isolate details.

Camera: Pentax 67 / Lens: 165mm / Filters: 0.6ND hard grad / Film: Fujichrome Velvia 50

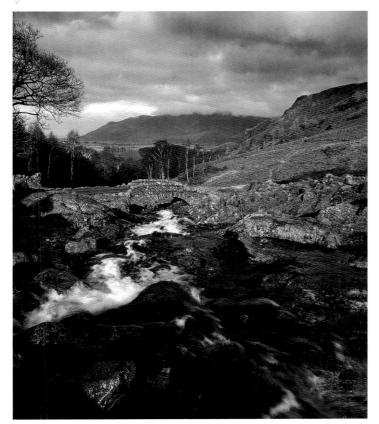

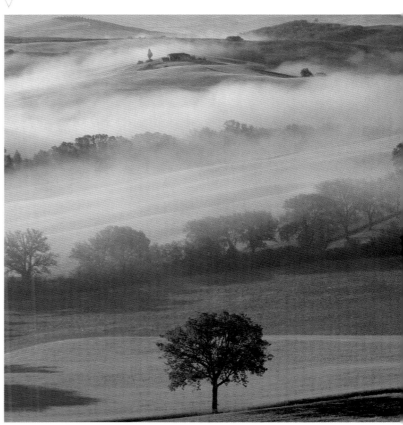

MAKE IT YOUR OWN

The worst thing you can do is to go out and copy the work of another because doing so achieves nothing. As ridiculous as it sounds, it's not unheard of for photographers to be seen walking up and down at a famous viewpoint, clutching a postcard or tearsheet of an image by someone else, and trying to find the exact spot from where it was taken. Why bother? Surely there's more to be gained from trying to put your own stamp on a location and produce images that are original?

Achieving that isn't actually as difficult as it sounds. In the UK at least, no two days are the same in terms of weather and quality of light, and that factor alone means every picture you take will be different, even if the location has been photographed a million times before. I have photographed Bamburgh Castle from the same beach on many occasions, but no two images are the same. One of the things that inspires me to keep heading there is that unpredictability, and the hope that the best is yet to come.

There was a time when the profession would have encouraged new photographers to use as many techniques as possible as a means of producing original images of well documented locations, experimenting with various coloured filters, trying different types or speeds of film and creating special effects by using multiple exposures.

With famous monuments, especially buildings, such an approach can be very successful, and as more and more photographers abandon film in favour of digital the fact that you can experiment without wasting money has to be a good thing creatively. However, when it comes to landscape you don't need to dress up a photograph to make it a success.

Just as the best chefs can rustle up amazing dishes using simple, basic ingredients, so the best landscape photographers can do the same with their raw ingredients – time, light and composition.

DELICATE ARCH, ARCHES NATIONAL PARK, UTAH, USA
Getting to Delicate Arch is no stroll in the park. It's a two-mile (3km) hike over slick rock, and because the light is at its best in the evening you need to head off in the afternoon when temperatures are high. On the day I took this shot I arrived a good two hours before sunset, set up my camera and just waited. But when the reward is a scene like this, what's a wait and a long hike there and back?

Camera: Fuji GX617 / Lens: 180mm / Filters: Polarizer / Film: Fujichrome Velvia 50
▽

LOOK BEHIND YOU!

When photographing famous views, it's easy to get wrapped up in what you're doing and forget to take in the landscape around you. It's a good idea to have a quick glance over your shoulder every now and then because there could be something even more interesting going on in the opposite direction.

I witnessed this first-hand while leading a photographic workshop in the Lake District in the autumn of 2006. I'd taken my group up to the famous stone circle at Castlerigg, hoping the ancient stones would be bathed in evening light. Unfortunately, the sun sank behind a bank of cloud just at the wrong time and the shots I'd hoped for faded away. We could have shrugged our shoulders and given up, like another group of photographers who headed for their minibus. Being optimistic, we decided to stay put and within 30 minutes were rewarded with a spectacular sunset over the distant fells. The view has no name and is unlikely to become iconic, but we had salvaged something from the evening because we looked behind us.

NEAR CASTLERIGG STONE CIRCLE, LAKE DISTRICT, ENGLAND

Be willing to change plans when conditions aren't what you expected. My intention was to photograph Castlerigg Stone Circle in evening light, but the sunset in the opposite direction was far more interesting.

Camera: Fuji GX617 / Lens: 180mm / Filters: 0.9ND hard grad / Film: Fujichrome Velvia 50

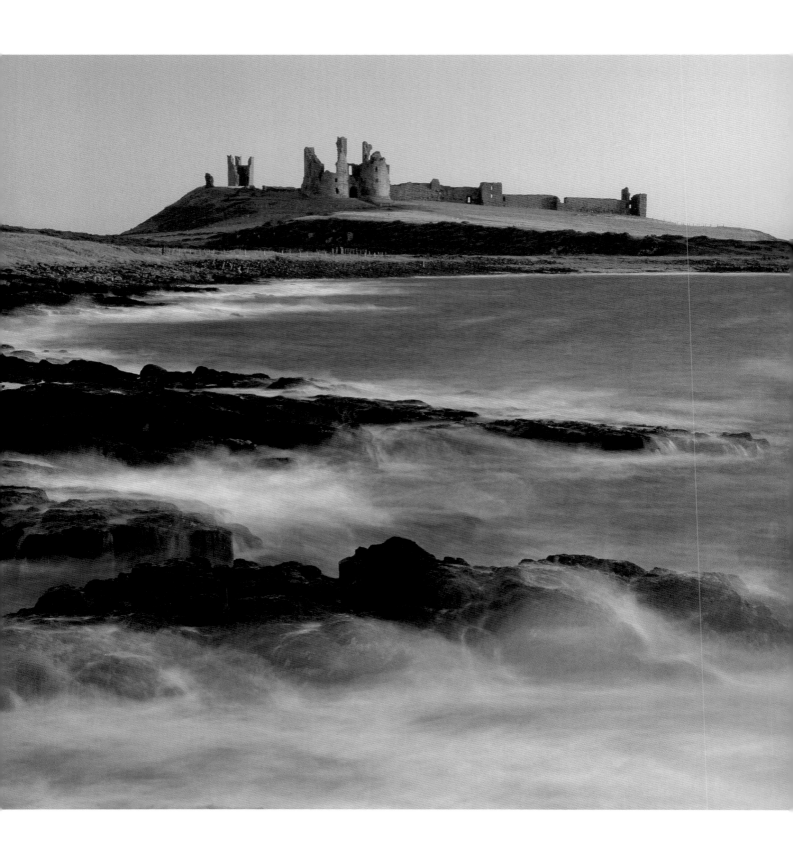

ANCIENT HISTORY

The more I travel, the more I find myself seeking out evidence of mankind's earlier existence, not just relics such as stone circles, burial mounds and ancient settlements, but also legends and folklore that link certain sites to events in history. These stories contribute to the narrative value of an image, helping the photographer capture more than just a memorable view. When I am in these locations I often find myself pondering how life must have changed between then and now, even though the landscape remains the same.

The more remote the location, the more evidence there seems to be of ancient history – simply because their very remoteness means there has been less destruction in the name of progress.

In the United Kingdom, the further north you travel, the more obvious this becomes. Population density dwindles while relics of the past increase. My home county of Northumberland is a good example of this. As well as being the least-populated county in England, it's also this country's most northerly county, and throughout history has acted as a defensive barrier between England and Scotland.

Almost 2000 years ago, Hadrian, the Roman emperor, commanded a wall to be built across northern England from the Solway Firth in the west to Newcastle-upon Tyne in the east. The best-preserved remains of the wall can be found today in Northumberland near the towns of Hexham and Haltwhistle. Northumberland is also home to some of the country's most magnificent castles – Bamburgh, Dunstanburgh, Alnwick and Warkworth to name but a few – while in and around the Cheviot Valleys you can find standing stones, burial chambers and ancient cup-and-ring stones, dating back thousands of years.

◁ **DUNSTANBURGH CASTLE, NEAR CRASTER, NORTHUMBERLAND**
Dunstanburgh Castle was built in the early fourteenth century, and abandoned after suffering heavy damage during the War of the Roses. I have photographed the castle many times, from Embleton Bay to the north and, as here, from Craster on the south side. Using an exposure of ten seconds I recorded the motion of the sea as it washed over rocks on the shoreline, adding atmosphere and mystery to the ancient ruin.

Camera: Pentax 67 / Lens: 105mm / Filters: 0.6ND Hard Grad / Film: Fujichrome Velvia 50

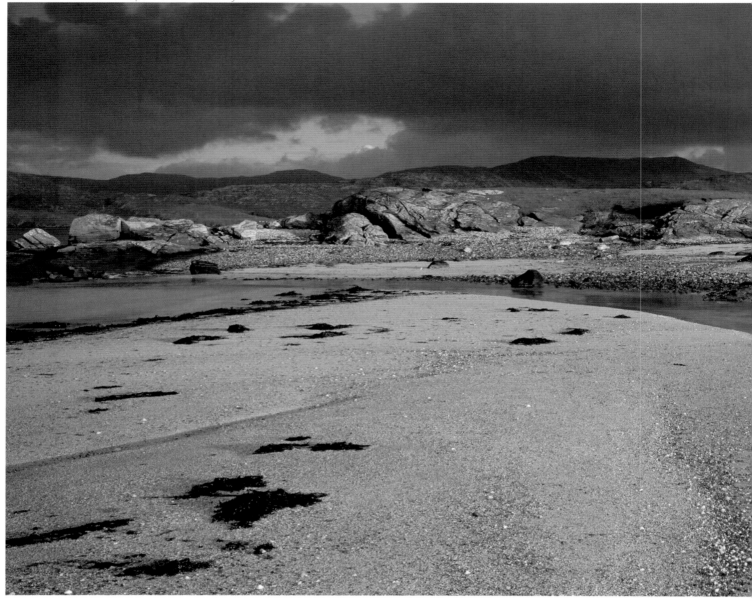

ISLAND LIFE

Head further north into Scotland and you will find that relics from ancient civilizations are even more abundant.

On the small uninhabited island of Taransay in the Outer Hebrides, for example, there is clear evidence of mankind's habitation from the third century until the early 1970s when the last family left. Taransay remained uninhabited until 2000 when the island was revived in order to host the television programme *Castaway 2000*. During the ensuing uninhabited years, the island had been used as a sheep-farm, run from the Harris mainland.

From 2001, when the *Castaway* show ended, Taransay has been a tourist resort, with the buildings being let as holiday accommodation, and boat trips to the island.

Every summer my family and I head north and spend a week on Taransay. We enjoy the peace and solitude and exploring its many ancient relics. There is the Dun (protective enclosure) up in the hills on Loch an Duin where women and children would take refuge during frequent invasion by warring Vikings or Scottish clans, and there are remains of the island's many Blackhouses (thatched cottages) where up to 200 people once lived. Even the old millstones where the island miller used to grind corn using the power of a mountain stream can still be found, while the beach is often littered with fragments of ancient Beaker pottery.

In the winter of 2005, the Outer Hebrides were battered by severe storms that unearthed so much evidence of pre-history that it would take the islands' archaeologist years to document it all. On Taransay itself, heavy seas sliced into sand dunes close to the ancient burial ground at Paible and when we visited the island in August 2005 the beach was littered with human bones and half-buried skulls.

Photographically these relics were of little interest, but contextually they were hugely inspiring to me because I felt as though I was photographing a living museum. Evidence of ancient man surrounded

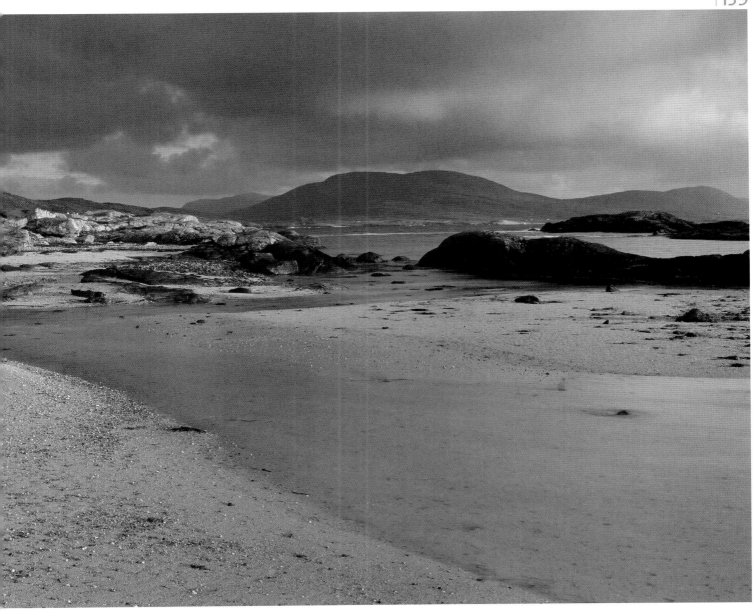

SGEIR BHUAILTE, TARANSAY, OUTER HERBRIDES, SCOTLAND

This panorama was captured one August evening, and shows the view from the beach at Paible towards Harris. Legend has it that in 1544 the Morrison Clan invaded Taransay and murdered every man, woman and child living on the island. On hearing this news, the chief of Berneray and his men sailed for Taransay and mounted a revenge attack. The Morrisons retreated to the rock, seen centre in the middle distance, and all but one was massacred. The sole survivor was Eoghainn Mac Gille Maithrail, who swam the Sound of Taransay to Harris with nine arrows in his back. Ever since, the rock has been known as Sheir Bhuailte (Smitten Rock). It is said that at low tide after a heavy sea, human bones can still be seen around its base!

Camera: Fuji GX617 / Lens: 90mm / Filters: 0.3 centre-ND and 0.6ND hard grad / Film: Fujichrome Velvia 50

me, and little had changed geographically in the area since the island was first inhabited in 300AD. This meant I was photographing a scene that looked much the same when the inhabitants of those graves were still alive.

Dartmoor in the southwest of England is another amazing region. This is the place where my fascination with history in the landscape began, as well as being the first area I documented with a camera when I became interested in landscape photography.

Merrivale on Dartmoor has the largest concentration of prehistoric relics in Europe –menhirs (standing stones), stone circles and stone rows. Grimspound is home to the remains of Bronze Age hut circles dating from 1700BC. The moor is also dotted with ancient carved crosses and waymarkers, and if you're willing to get away from the beaten track, there are many more magnificent relics to be discovered in more remote locations where no road or track travels.

Nothing on Dartmoor is on the scale of somewhere like Stonehenge

so it will never enjoy the same international fame or attract so many visitors. However, because the landscape of Dartmoor has changed little since prehistoric times, it provides us with a clear and telling picture of how early man existed in his environment. Dartmoor is also a magical and mystical place to photograph. It's desolate and wild rather than being crowded and over-commercialized. I never felt completely along when I was out on Dartmoor in the half light or dawn or dusk. Fuelled by legends of headless horsemen, savage hounds and haggard witches, my imagination tended to get the better of me, and though I never saw evidence of anything untoward, there was always a strange feeling in the air!

No such luck at a place like Stonehenge. Population density has soared in southern England since the industrial revolution, and though ancient relics do exist, their magic and mystery is all-too-often destroyed by the close proximity of busy roads, housing estates or crowds of tourists. I did try photographing Stonehenge many years ago, but a continual stream of ice cream-eating visitors not only spoiled the experience, but the view as well, while the perimeter fence that surrounds the stones means that you can't get close enough to actually take any meaningful photographs.

TIME, LIGHT, COMPOSITION

My approach to photographing ancient relics depends on the nature of the subject and the scene. My aim is usually to show them in context, as part of the landscape rather than as self-contained subjects.

As you can see from the examples here, light and composition are my main priorities. Light defines the character and mood of the subject so timing is important. As is so often the case, I find the rich, warm light of dawn and dusk to be the most successful at bringing out the magic of ancient relics, the marks of man on the landscape. The soft colours and gentle atmosphere are incredibly evocative. I try to be on location well before sunrise so I can witness the scene before the light of dawn. If it's an evening shot I stay on after the sun has set to see how changes in strength and colour of the light affect the mood of the scene.

I rarely give the main subject centrestage in my photographs and instead prefer to stand further back or use a wider lens. Think of it as taking an environmental portrait of a person, rather than a frame-filling mugshot. The latter reveals all the lumps and bumps in great detail and may have strength in its immediacy and closeness, but the former provides much more information about the subject by revealing it in its natural setting and telling a more rounded story.

AIT BENHADDOU, NEAR ▷ OUARZAZATE, MOROCCO

I have visited Morocco more than a dozen times now, but no trip there is complete without a stop-off at Ait Benhaddou, perhaps the best-preserved kasbah (fortified village) in North Africa. Over the last 50 years the village has appeared in numerous blockbuster movies, including *Jesus of Nazareth*, *The Jewel on the Nile* and more recently *Gladiator* and *Alexander*. Historically, the kasbah was once one of the most important villages in southern Morocco, standing at a strategic point along the Sahara-Marrakech trade route south of the High Atlas Mountains. This photograph was taken moments after sunrise with the mud walls of the kasbah glowing in the early morning light and the gently-flowing water of the Ouarzazate River filling the foreground – an unforgettable place.

Camera: Hasselblad Xpan / Lens: 30mm / Filters: 0.45 centre-ND and polarizer / Film: Fujichrome Velvia 50

◁ **STANDING STONES AT CALLANISH, ISLE OF LEWIS, OUTER HEBRIDES, SCOTLAND**

Set on a windswept hill overlooking Loch Roag, the Callanish stone circle is the most mysterious and haunting of its kind in the UK – and photographically by far the most interesting. The stones have been there for almost 4000 years and standing among them at sunrise or sunset is a magical experience, even for an old cynic like me. This photograph was taken on a September evening when the stones were bathed in warm light from the setting sun. Finding an angle that reveals the drama and grandeur of the stones is tricky but I felt this view did them justice and revealed the wonderful texture on the foreground stones.

Camera: Mamiya 7II / Lens: 43mm / Filters: Polarizer / Film: Fujichrome Velvia 50

INDEX